CAMBRIDGE STUDIES IN THE HISTORY OF ART

GIOTTO
AND THE LANGUAGE
OF GESTURE

CAMBRIDGE STUDIES IN THE HISTORY OF ART

Edited by FRANCIS HASKELL

Professor in the History of Art, University of Oxford

and NICHOLAS PENNY

Keeper of Western Art, Ashmolean Museum, Oxford

Cambridge Studies in the History of Art will develop as a series of carefully-selected original monographs and more general publications, aimed primarily at professional art historians, their students, and scholars in related subjects. The series is likely to embrace a broad range of topics from all branches of art history, and to demonstrate a wide variety of approaches and methods.

Titles in the series:

El Greco and his Patrons
RICHARD G. MANN

A Bibliography of Salon Criticism in Second Empire Paris
Compiled by CHRISTOPHER PARSONS and MARTHA WARD

Giotto and the Language of Gesture
MOSHE BARASCH

The Oriental Obsession: Islamic Inspiration in British and American Art and Architecture 1500–1920
JOHN SWEETMAN

Power and Display in the Seventeenth Century: The Arts and their Patrons in Modena and Ferrara
JANET SOUTHORN

GIOTTO
AND THE LANGUAGE OF GESTURE

MOSHE BARASCH

JACK COTTON PROFESSOR OF ARCHITECTURE AND FINE ARTS
THE HEBREW UNIVERSITY OF JERUSALEM

The right of the
University of Cambridge
to print and sell
all manner of books
was granted by
Henry VIII in 1534.
The University has printed
and published continuously
since 1584.

CAMBRIDGE UNIVERSITY PRESS

CAMBRIDGE
NEW YORK NEW ROCHELLE
MELBOURNE SYDNEY

Published by the Press Syndicate of the University of Cambridge
The Pitt Building, Trumpington Street, Cambridge CB2 IRP
32 East 57th Street, New York, NY 10022, USA
10 Stamford Road, Oakleigh, Melbourne 3166, Australia

First published 1987
Reprinted 1988

Printed in Great Britain by the University Press, Cambridge

British Library cataloguing in publication data
Barasch, Moshe
Giotto and the language of gesture –
(Cambridge studies in the history of art)
1. Giotto – Criticism and interpretation
I. Title
759.5 ND623.G6

Library of Congress cataloguing in publication data
Barasch, Moshe.
Giotto and the language of gesture.
(Cambridge studies in the history of art)
Bibliography.
Includes index
1. Giotto, 1266? – 1337 – Criticism and interpretation.
2. Gesture in art.
3. Symbolism in art.
I. Title.
II. Series.
ND623.G6B3 1987 759.5 86–26441
ISBN 0 521 32454 8

CONTENTS

v

FIGURES

PREFACE

In writing a book, even a small one, the author incurs many debts. It is a pleasure to express my gratitude to those who helped me in carrying out the work for this volume.

The study here presented was undertaken during my tenure as a fellow of the Institute for Advanced Study at the Hebrew University, Jerusalem. Professor Creighton Gilbert, of Yale University, has read the whole manuscript with his usual critical acumen and attention; his comments have saved me from errors and helped in seeing more clearly some aspects of the themes discussed. My colleague and former student, Dr Luba Freedman, has assisted me in procuring literature as well as in many other ways. To Mrs Mira Reich, our chief librarian, I am grateful for advice and assistance. Ms Susan P. Moore, of Cambridge University Press, has gone over the manuscript with much attention and learning, and has helped in clarifying matters large and small. A special debt, of a different nature and of long standing, I owe to Dr Bernard Lown. His medical care as well as his friendship are a constant source of encouragement.

M. B.

ACKNOWLEDGEMENTS

The author and publisher are grateful to the following for permission to reproduce illustrations: Foto Alinari, Florence (figs. 1, 3, 4, 5, 8, 15, 25, 27, 34, 36, 42, 60, 61, 65 and 73); the Trustees of the British Museum (fig. 39); the Staatliche Museen, Berlin (figs. 54, 69 and 70); the Deutsches Kunsthistorisches Institut, Florence (fig. 77).

ABBREVIATIONS

W Kurt H. Weigelt, *Giotto. Des Meisters Gemälde* (*Klassiker der Kunst*, Band XXIX), Stuttgart–Berlin–Leipzig, 1025.

S Roberto Salvini, *All the Paintings of Giotto*, New York (Hawthorn Books), 1963.

INTRODUCTION

In the present slim volume I shall undertake to discuss the gestures Giotto depicted, their character and history, and the role they play in his work. Giotto is not a neglected artist, and there is surely no dearth of studies of his work. At a first glance it would therefore seem that no significant aspect of his art could have remained untouched by scholarly industry. Yet not all its components have received an equal share of attention; gestures have fared less well than such subjects as the body image, the illusion of volume, and the suggestion of space. Many of the educated general public will know something about the master having given his figures a sense of volume, and of his having placed them in an illusionary, three-dimensional space, yet even the advanced student will not know where to look for information about the gestures he employed, whether he found them readily available in pre-cast patterns or invented them himself, and what functions he assigned to them in his murals. It is enough merely to mention these questions to become instantly aware of how much still remains to be done in the study of Giotto's work.

So far as I know, the present study is the first attempt to discuss, more or less systematically, the theme of gestures in Giotto's paintings. The study of gestures in the visual arts in general, though of almost venerable age, has remained rather intermittent, and thus has not developed a system of categories to be applied in the analysis. The present brief introduction does not intend to fill this gap. Yet I may be excused for introducing my discussion of the images by a few observations about the questions to be asked and the notions employed in the following chapters.

The language of gestures

The notion that gestures form a comprehensive system of communication that may properly be called a 'language' was explicitly formulated and theoretically based mainly in the seventeenth century (Knowlson, 1965). In the rhetorical and scientific

traditions of that century, gesticulation was, *expressis verbis*, described as the 'universal language', a means of communication inborn in human nature. In the early years of that century Giovanni Bonifacio, a student of Renaissance rhetorical tradition, deplores the variety and diversification of the languages we speak, a condition which causes difficulties and constantly makes us misunderstand what both foreigners and our neighbours say. Could we only translate, he wishes, what they say in different languages into one visible, natural speech, into gestures: then all people would speak the same language. The signs composing the language of gestures, if universally adopted, could break down the barriers raised at Babel (Bonifacio, 1616, pp. 11ff.).

The English physician, John Bulwer, inventor of the deaf-and-dumb language, also suggests an international language of gestures, a kind of Esperanto without words. Man has two fountains of discourse, we read in his *Chirologia : Or the Natural Language of the Hand*, 'his mouth and his hand', words and gestures (Bulwer, 1644, pp. 1ff.); '…the Hand, that busie instrument, is *most talkative*, whose *language* is as easily perceived and understood as if Man had another mouth or fountaine of discourse in his Hand'. Moreover, gesture of hand is 'the only speech that is natural to man', and therefore 'it may be called the tongue and the general language of human nature, which without teaching, men in all regions of the habitable world do at first sight more easily understand'.[1]

The historian, of course, knows that the Renaissance artist preceded the seventeenth-century physician. Leonardo da Vinci advises the painter to observe and depict 'the motions of the dumb, who speak with movements of their hands and eyes and eyebrows and their whole person, in the desire to express the idea that is in their minds' (Leonardo, 1956, no. 250, 248). Leonardo comes back to speaking of the language of gestures in one of his best-known passages:

The details of particular individual actions are very well seen in the case of the dumb, who do not know how to draw, although there are few of these who do not aid themselves by drawing figures. Learn, then, from the dumb to make those gestures with the limbs which express the ideas in the minds of speakers. (No. 403)

But the story of defining gestures as a language begins much earlier; in antiquity gesticulation was already seen as a universal language. In Lucian's dialogue *Of Pantomime*, one of the interlocutors tells how a prince of Pontus, when promised a gift by Nero, requested that he should be granted the services of a well-known mime, who could replace the various interpreters that the prince needed in order to communicate with the notables of neighbouring lands. The mime 'could discharge

[1] For Bulwer, see Hodgson and Norman, 1943; Hodgson, 1953, pp. 95ff. For a discussion of Bulwer as a source for the study of seventeenth-century acting technique, see Joseph, 1951. What Bulwer may disclose about pictorial traditions has not yet been investigated.

that office perfectly, as often as required, by means of gesticulation' (Lucian, 1905, II, p. 256.

The comparison of gesture to a language – a comparison whose life story has not yet been written – does not belong to a distant past only; it comes up time and again, and it is quite well known to modern man. That interesting eighteenth-century student of gestures and physiognomics, Johan Jacob Engel, queries the basis of the superiority of vocal language as compared with pure gestural language (1785–6). Whatever we may think of the solution he proposes to his question, it is obvious that he takes the metaphor of a gesture language seriously (Bühler, 1933, pp. 38ff.; Gombrich, 1972, pp. 375–6). In 1900, the well-known philosopher and scholar Wilhelm Wundt asked (in a theoretical work of considerable historical consequence) whether and in which sense the language of gestures can form sentences, and to what extent that language can have a grammar (Wundt, 1921, pp. 143–251; cf. Bühler, 1933, pp. 128ff.). Here I need not go into a thorough discussion of what Wundt means (even if I were competent to do so), but what I can say is that, again beyond doubt, this academic scholar takes the comparison of gestures to a language quite seriously. Even in our time this metaphor has been used on occasion. Let me mention just one example: an interesting recent book on *A Psychology of Gesture* opens by maintaining, as a matter of common belief which need not be further substantiated, that 'Gesture is a pre-verbal language which starts at birth' (Wolff, 1948, p. 1).

Human gesticulation, particularly when seen as a medium of communication, must be divided into two essential parts: movements we believe to be part of 'Nature', and movements based on a (more or less) deliberate use of available cultural conventions. It may well prove impossible to establish a watertight division between the two types, particularly as far as the artist is concerned, yet for our present purpose it will be useful to comment on them separately.

Gestures of the first kind are performed spontaneously, involuntarily, and perhaps even without our being aware of the fact that we are performing them. Blushing or turning pale, jerking back before a danger suddenly revealed to us – these are examples we know from everyday life. Instinctive gesticulation pervades the animal kingdom. Some of these movements seem altogether intelligible to the human race as well as to the beasts. Thus, the instinctive gestural features indicative of aggression among animal – the heightened muscular tension, rigid posture, raised head with forward thrust of the chin, bristling hair, etc. – have been described in a masterly fashion for the general public by a well-known scientist (Lorenz, 1963; see also Gombrich, 1965). Features of this kind are altogether spontaneous. Though they clearly indicate the creature's condition (a state of anger) and are understood as such by other animals, the aggressive beasts themselves do not perform these acts

deliberately, and it is surely questionable whether they are aware of their appearance in this state.

In the human realm such bodily manifestations of intrinsic conditions (or structures) are often treated as symptoms; they betray something about us. A 'symptom' – as follows from the Greek origin of the term – is something that has 'befallen' us, not something we bring about deliberately and intentionally. It is precisely because the symptom is not controllable that it is of such important diagnostic value. No wonder, then, that medicine and psychology have focused their interest on these involuntary manifestations. In psychology, especially in the school of Personality Psychology, an attempt has been made to use gestures as criteria for the classification of human types (Allport and Vernon, 1933). In so doing, modern scientists have been following in the steps of observers and interpreters of 'nature' during many centuries or ages. Everyone familiar with the history of European imagery knows that symptomatic stances, gestures, and movements have for long periods served to identify temperamental types: the Melancholic inclines his head, his face is 'black', his posture is introverted; the Sanguine man stands upright, his walking is light, his face uplifted, his glance is free (Klibansky, Panofsky and Saxl, 1964, pp. 291ff.). One can easily add further examples of spontaneous stances and gestures which are symptomatic of the figure's nature and condition. (One should add that we have no systematic study of temperaments as reflected in stance and movement.)

The other type of gesture may be termed conventional. As 'symptomatic' gestures are derived from nature, the conventional gesture is considered as a product of what we call culture. It is man-made, it emerged in history (and for many gestures we can know fairly precisely when they emerged). Most important in our context is that conventional gestures are in the first place conceived as means of communication. The readability of the natural gesture is a side- or after-effect; it has little to do with the aim of the gesture. The conventional gesture is – at least in its origins – performed in order to convey a message. We are, then, fully aware that we are performing the gesture, and we are aware that it is supposed to carry a specific meaning. The very fact of performing the gesture is, therefore, not relentlessly enforced upon us, as is the case with the symptomatic gesture. When we shake hands to confirm a deal, we do so deliberately, and we know what our movement 'means'. This is also the case when we lift our hat to greet an acquaintance on the street, and so it is with countless other gestures with which every one of us is familiar. All these symbolic acts emerged at certain stages in history, they are often peculiar to a certain culture, and therefore unintelligible in another.[2] They seem not to be

[2] Panofsky, 1939, p. 4, opens his famous discussion of the historical determination of iconology (and of almost every system of symbols) with such an example: an Athenian of the fifth century B.C. would not understand our everyday gesture of lifting the hat to greet an acquaintance on the street.

informed by blind necessity and are not as unavoidable as those we have called 'symptomatic'.

Areas of gesture articulation: the courts and the Church

Gesticulation, natural or deliberate (or, in the terminology used so far, 'symptomatic' and 'conventional'), pervades our life. Conventional gesticulation has a history, and in its development and concentration it has a rhythm of its own. In certain periods, cultures, and areas of activity conventional gesticulation is more articulate than in others. We have also come to develop a typology of certain gestures as related to certain civilizations. Most of us live under the impression that in Roman imagery gestures of a military character (such as victory, submission, etc.) are particularly abundant, and for the stance of the victor in a game or of the philosopher or poet we shall look to Greek art. Surely such preconceptions should not be taken as the absolute truth; the fact that certain monuments survived while others perished may have something to do with our conventional views. And yet few will doubt that certain realms of gesticulation were actually more important in Rome than in Greece, and that the Roman artist was therefore prone to depict these rather than others. Turning to our subject I now ask: were there such focal and typical areas of gesticulation in Giotto's time or in the period immediately preceding him? Where, in which provinces of life, could he find major sources of inspiration for the depiction of gestures?

One area of gesture articulation which, in my view, is of particular significance for our subject is the legal court, especially the judicial procedures. In the twelfth and thirteenth centuries, as is well known, a revival of legal studies was one of the remarkable intellectual movements. This revival drew from both ancient texts and local or regional customs. Probably the most detailed and most famous (but by no means the only legal text composed in the early thirteenth century) is the *Sachsenspiegel*, a text to which we shall frequently return in the following chapters. This work is, in fact, a quite detailed – and probably faithful – record of legal practice in certain areas in Germany. The *Sachsenspiegel*, like other legal treatises of the period, does not excel in strict analytical distinctions; as a rule, they combine different aspects, and tell the reader about legal procedures in addition to legal theory proper. In fact, many legal procedures were established and codified in this period. In Canon Law a special procedure was established, the 'Inquisitional Procedure'; in other areas – canon as well as civil – procedures were fixed in writing (Haskins, 1957, pp. 217ff.; Calisse, 1928, pp. 101ff., 177ff.). Some of the manuscripts containing these formulations were also illuminated. The art historian's interest in this process of codification of procedures derives from the fact that in the course of

the comprehensive process many visual features,[3] such as colours, were also firmly codified. Not the least among those features were symbolic gestures.

About the codification of legal gestures we learn from various sources, most prominently from the illuminations of legal manuscripts. The *Sachsenspiegel*, the primary source, has come down to us in four illuminated manuscripts, all of them going back to the same (lost) model. Historians of law rather than art have studied these illuminations, and the questions they had in mind indeed pertained to legal custom rather than to artistic representation. Yet, it is not surprising that these legal historians encountered some of the basic and typical questions of art historical research. They started with the somewhat naive assumption that every depiction has a precise model in reality, that gestures pictorially represented faithfully reflect gestures actually performed. Soon enough they had to ask themselves how much of what can be seen in the illuminations is the 'invention' of the artist (as one of them put it), or possibly derives from older artistic conventions, which do not necessarily overlap with legal practice. Inevitably some of these careful scholars reached the conclusion that, so far as the actual legal practices of the thirteenth century are concerned, the *Sachsenspiegel* miniatures are a source of rather limited value.

It is not our task to enquire how far each symbolic gesture, as we know it from the *Sachsenspiegel* miniatures or from other pictorial renderings of judicial scenes, actually and faithfully reflects the practices common at the time. For the purpose of our investigation we can draw two important conclusions from the artistic depictions of such scenes. First, the depiction of legal gesture – whether or not they were faithful to actual reality – attests to a full awareness of gesture as a symbolic form. Whether or not the judge in court, when performing a divorce, actually pushed husband and wife apart, in different directions, the public in the thirteenth century obviously believed that this was what happened in court, and that this gesture was part and parcel of the legal procedure itself. Images were read in the same light.[4] Did everybody who declared in court his refusal to do something actually grasp his right hand with his left, immobilizing the hand that does the job,

[3] The significance of the visual aspects is further strengthened by the fact that certain legal proceedings had to take place in public. A good example is the transfer of ownership ('*traditio*'). In order to transfer a good, 'contract alone would not suffice... The contract, or other juristic act, was the source of the obligation to bring about a passage of ownership from one person to another; but in order to bring about such a passage, an external act, consequent upon the contract, was necessary...' See Calisse, 1928. The good transferred could be represented in two ways: in a natural representation (a clod of earth for land, branches of trees for woods, etc.) or a symbolic one (a *festuca*, a small rod, for power, the glove as symbol of guarantee, etc.).

[4] *Sachsenspiegel* ed. Koschorreck, 1976, fig. 100. See also fig. 98, for a similar illustration. And cf. pp. 150ff. The manuscript reproduced in this publication, the Codex Palatinus Germanicus 164 in the University Library of Heidelberg, is assumed to be closest to the (lost) original of the *Sachsenspiegel* manuscripts that have survived. Unfortunately it has fewer illustrations than the other manuscripts, which are later, and less faithful to the original.

and thus manifesting his inability to act? A modern reader may doubt it. Yet, obviously this is how such actions were imagined in the Middle Ages (*Sachsenspiegel*, 1976, fig. 8). Such gesticulations were conceived as symbolic acts, their shape and configuration fully determined, their meaning supposedly unequivocal.

Had such codified gestures only symbolic value, or were they also assigned some practical purpose in social reality? So far as we have been able to see, historians of law have not explored this subject; we surely do not feel competent to do so. The fact that in Giotto's depiction of *St Francis Renouncing his Father* in the Bardi Chapel young children are seen at both ends of the scene, has attracted Professor Creighton Gilbert's attention, and he was kind enough to communicate to me his explanation.[5] In a society where the ability to read was not taken for granted, many 'archival' functions were fulfilled by living memory. In such a society young children were taken into the courts in order to witness the procedures and be able to attest, later in life, to what they had seen. (Sometimes their attention would be forcefully drawn to what was going on around them.) These children would obviously much more easily remember gestures performed than sentences spoken. This custom would indeed greatly enhance both the significance of gestures and their casting into conventional patterns.

The other conclusion one reaches is that, in the course of the process of codifying legal gestures, a concrete vocabulary of individual symbolic gestures was established, their specific forms clearly outlined, and the meanings communicated by them unequivocally (as far as this is possible) articulated. The range of this vocabulary remained, of course, limited to what can happen in court. But even so the span was wide enough to include a variety of gestures, and their articulation was sufficient to distinguish between some that strike us as quite close to each other. This vocabulary of specific symbolic gestures naturally served the pictorial tradition, providing it, at least within a limited field, with a structure on which an artist could confidently rely. A gesture borrowed from such a vocabulary, every artist must have thought, would be understood by the spectator.

Probably even more important than the tribunal for the crystallization of gestures in the Middle Ages was another area, liturgy. We run no danger of exaggeration when we say that in medieval society no institution or symbolic act had the dignity and model character of liturgy, and none could impress itself as powerfully on intellectual and artistic life. As the text, the tone, and the actions of Mass were well known, orthodoxly performed, and endowed with sacred and symbolic meaning, so were the gestures of the priest and of the other participants. The twelfth and thirteenth centuries, a period which directly provided Giotto with models and ideas,

[5] Professor Gilbert correctly points out that – from a legal point of view – St Francis renouncing his father is a transfer of property rights, that is, one of the acts that had to be performed in public.

was also a period in which liturgy, in its different aspects, was fully established, explicitly formulated, and allegorically interpreted. The literature on liturgy – a literature which undertook to explain the hidden meanings of every small detail of the Mass and of other liturgical performances – emerged and flourished in these centuries. In our context it is worth mentioning that this literature was intimately connected with Italy. Honorius of Autun, the Frenchman who can be seen as the founder of the liturgical literature of that period, was active in the early twelfth century (Suntrup, 1978, with rich bibliography). His important follower, Sicardus, later became bishop of his home town, where he wrote his liturgical handbook, the *Mitrale* (Migne, *Patrologia Latina*, vol. CCXIII; cf. Ohly, 1977, pp. 32ff., 254ff.). Durandus, whose work probably represents the climax of allegorical interpretation of Christian liturgy, was born in Montpellier, in southern France, but he studied in Bologna, taught law in Modena, and stayed in Italy until 1291. His discussion and interpretation of the Mass, the famous *Rationale*, was one of the most popular books of the early Renaissance (cf. Sauer, 1902). Even these few facts attest the central significance of Italy in the investigation of liturgy in Giotto's time.

When looked at from the point of view of gestures, Christian ritual – and particularly its central feature, the Mass – is a complex structure. Some of the parts pertinent to our investigation are the plain performance of real acts. The deacon unfolding the corporal when the *Credo* is said is performing a whole and real act. This is also what happens when the deacon presents patena and host to the priest. Bringing the *lavabo*, the washing basin, to the officiating priest, so that he may perform the symbolic action of washing his hands, is also a real and complete act. These and similar actions are more than gestures, they are deeds. And yet we cannot disregard their bearing on the gestural character of the Mass. It may be difficult to trace a clear dividing line between real act and symbolic gesture. In any case, the traditionally established, narrowly prescribed execution of these actions brings them close to the domain of conventional symbolic gesture.

When we now turn to the individual stances and body movements – that is, to a realm that strikes us as the proper domain of what we are accustomed to call 'gestures' – we also have to make distinctions. Some of the movements employed in liturgy were simply understood as representations of events, abbreviated renderings of central sacred acts. When the priest, standing upright, raised both his hands, palms turned toward the community – that is, when he performed the *orans* gesture, the oldest and most common gesture of prayer – he was believed to re-enact Christ's crucifixion. In taking this stance, medieval commentaries to the liturgy tell us, the officiating priest stands *in modum crucis*, he repeats what Christ did when he spread his arms on the cross (Tertullian, *De oratione* 14; Suntrup, 1978, pp. 172ff.; Jungmann, 1962, II, p. 275). Already in the early twelfth century, Rupert of Deutz,

a mystical interpreter of the liturgy, uses the term 'depiction' in explaining the gesture. The priest's *orans* posture 'depicts' Christ's movement (Suntrup, 1978, pp. 175ff.). The concept of the 'depicting gesture' (*malende Gebärde*), which J. J. Engel used in the late eighteenth century (1785–6, II; 28th letter) and Karl Bühler (1933, pp. 36ff.) in our own time, was clearly present in the medieval mind.

One other example may be adduced. The *supplices te rogamus*, an entreating passage, concludes the prayer of offering. During this passage (to which we shall return in the following chapters) the priest bows deeply and humbly. His body-movement did not go unnoticed. One of the many interpreters saw in the priest's bowing a re-enactment of the phase concluding the Passion. Christ on the cross, fulfilling Scripture (Psalms 30:6), recommends his spirit to the Father, and, bowing his head, gives up the ghost (John 19:30). The priest's bow once more enacts Christ bowing his head.[6] Other authors have seen in the priest's bowing the re-enactment of Christ's impulse in Gethsemane: he fell on his face, entreating the Father that the cup might pass from him (Matthew 26:39).[7]

Reading liturgical gestures as abbreviated depictions of sacred events must have contributed greatly to the formal articulation of these movements; it must also have promoted an attitude of orthodox adherence to the shapes of the gestures thus endowed with dignity. In addition to the formal articulation, such reading clearly contributed to heightened awareness of the meaning of these, as well as of other, gestures. One cannot help imagining how an artist, profoundly concerned with communicating significance by means of gestures, and attempting to suggest narration with the aid of rather restricted movements, must have looked to the Mass, to that remarkable sight, daily performed, intensely venerated, and highly prominent in both social and emotional life. Whether its influence was manifest or hidden, the Mass must have been a source of continuing inspiration.

But ritual not only provided the artist with 'depicting gestures'; it also yielded gestures which, though less narrative, articulated the structure of space, and made manifest its dimensions. A great deal of the priest's symbolic movements emphasize the centre of space, which in the Mass is marked by the altar (Suntrup, 1978, pp. 182ff.; Sauer, 1902, pp. 155ff.). His movements towards, around, and away from the

[6] So interpreted by the ninth-century author Amalar of Metz (of whom we know little, except that he died between A.D. 850 and 853) in his *Liber officialis* III.25.7. The text reads: 'Sacerdos inclinat se, et hoc, quod vice Christi immolatum est, Deo Patri commendat.' Suntrup, 1978, sees Amalar of Metz as the founder of medieval allegorical interpretation of liturgical gestures. For our particular gesture, see especially Suntrup, 1978, pp. 147, 468.

[7] See the interpretation by Pope Innocent III in his *De sacro altaris mysterio libri sex* (cf. Migne, *Patrologia Latina*, vol. CCXVII, cols. 773–916). Particularly important for our purpose is the sentence (Migne, vol. CCXVII, col. 890c) which reads: 'Jesus igitur quia procidit orans et dicens: "Pater si fieri potest", sacerdos inclinans orat, dicens: "Supplices te rogamus".' A similar interpretation is found in the authoritative work of Durandus, 1614, IV.44.2–3. Additional passages in Suntrup, 1978, p. 148, n. 35.

altar were also considered as carriers of meaning. The procession of the priest or the bishop from the sacristy to the altar re-enacts Christ's way from heaven (or from the Virgin's womb) to earth, or from earth to heaven.[8] The bishop ascends to the altar as Christ ascended to Jerusalem, the place of his crucifixion (Honorius, *Sacramentarium*, 34, in Migne, *Patrologia Latina*, vol. CLXXII, col. 767a). In Christian liturgical thought, the symbolic interpretation of the altar is intimately connected with the interpretation of the clergy's movements and deeds during Mass.

Among the other features of the space structure is the (generally so evasive) difference between right and left. The priest's liturgical actions often point to that difference, bringing the symbolic character of right and left into prominence, and investing them with meanings. Examples of both ritual acts and symbolic interpretations are well known; I shall therefore mention only two small details, which are often overlooked by students of art. At the height of the Mass, when the priest reaches for the Gospel, he approaches the altar from the left. In Durandus' explanation, which is probably based on ideas accepted in his time, the priest does so in order to show the *tristitia passionis* (Durandus, 1614, IV.15.3f.; Suntrup, 1978, p. 211). The priest's direction of movement, then, is not meant to invoke the memory of an event, but to evoke a feeling; quite explicitly it is a symbolic, expressive gesture. Our second example is slightly different, but belongs to the same category. A great deal of thought and attention have been spent on establishing the precise shape and meaning of the priest's making the sign of the cross. He is supposed to make this sacred sign by moving his hand from up to down, to left to right. These prescribed steps are explained by the inherent meanings of the spatial directions: the movement from up to down signifies Christ's way from the Heavenly Father to this, the terrestrial, world; the left indicates the earthly world, the right the Heavens to which Christ will eventually ascend (Suntrup, 1978, pp. 256ff.; Franz, 1902, pp. 733ff.; Righetti, 1964, I, pp. 367–73). Right and left do not depict anything here, they are purely symbolic connotations. The priest's gesture – to the left and then to the right – is not, in any way, narrative. And yet both the priest and the community were supposed to know what was being invoked by these gestures which articulated the directions of space.

In emphasizing the two areas of gesture codification – prescribed behaviour in the judicial court and the closely regulated comportment of those conducting an ecclesiastical ritual – I do not wish to exclude any other fields that may have offered an artist working in Italy around A.D. 1300 models and inspiration. Codified

[8] For the first interpretation, see Amalar of Metz, *Liber officialis* III.5.1, and *Ruperti Tuitiensis liber De divinis officiis* I.28. The priest's leaving the main hall of the church after Mass is completed and his retiring to the sacristy was considered a re-enactment of Christ's Ascension: as Christ was 'parted' from his apostles (Luke 24:51), so the priest is 'parted' from his community.

gesticulation is pervasive. It is found in everyday life, in established institutions (such as the court and the church) and in the highly advanced forms of culture (as in the different arts). Gesticulation as a means of emotional expression is found in several arts, and it may be useful to mention some of them briefly.

Theatrical performances in the period here discussed – that is, mystery plays – may be pertinent to our study. As is well known, beginning with the twelfth century theatrical performances were enacted in several European countries. From the middle of the thirteenth century they were well known in Italy, and it is interesting to note that the Franciscans played a significant part in bringing them there. It is not for us here to go into the thorny question as to whether or not many of the iconographic departures that characterize the sculpture and painting of the period originate in what the painter and the sculptor (as well as their audiences) could see in the mystery plays. Emile Mâle's well-known attempt to trace many of the original inventions – in iconography as well as in composition – of twelfth- and thirteenth-century art to theatrical performances has launched an enduring and vivid argument. So far as I can see, this debate has not resulted in any generally accepted conclusions. But whatever the case may be regarding a general explanation of origins, in the attempt to follow the evolution of individual gestures the plays, as far as they can be reconstructed, often bear important testimony. They were a significant area of gesture codification. In the following discussion I shall therefore refer to texts that speak of gesticulation in theatre plays (e.g. chapter 4).

The comparison of plays and murals may afford us some insights into the latter in another respect as well. Careful observation shows that a certain parallelism in conditions and constraints prevailed between murals and mystery plays. Medieval theatrical performances, lacking a set stage, could rarely be watched in close-up; most of the audience could only look on from a distance at what was being enacted. These conditions, one imagines, must have entailed certain consequences for the actors' gestures. To make these gestures intelligible (and thus convey the whole play) the performers had to stick to a strict economy of expressive movements: gestures had to be reduced to a few stereotypes, they had to be presented without anything obscuring them from sight, and they had to be broad, continuing into space. Now, a rather similar situation obtains for murals, such as Giotto's, and consequently the constraints were also similar. Murals, as a rule, could also not be looked at from nearby (and this is well reflected in their style). Many of them would be placed high up on the wall, and there was not always enough floor-space to allow the spectator to step back and look at them in comfort. In churches and chapels, lighting conditions were often also very far from ideal. In view of these difficulties, and always at a distance from the beholder, the selection and representation of gestures (as well as of other features) was subject to severe constraints. To be

comprehensible, gestures had to be well selected, to represent some kind of 'primary' movement, and they had to have something of that large, expanding character that was a permanent challenge to the actors of the mystery plays. How Giotto rose to these requirements will, I hope, become a little clearer in the following discussion.

Gestures also played a significant part in other arts that could be considered as a general background and source of inspiration for Giotto. From among the countless examples that could here be adduced let me take only one, which is particularly illuminating. I mean the tradition of illuminated Terence manuscripts (Jones and Morey, 1930–1), a pictorial tradition that persisted almost unbroken throughout the Middle Ages. In this tradition violent, dramatic emotions are continuously represented in images, and the central means of representing them is by gestures. Although the medieval illuminators of the texts by the Roman satirical poet Terence did not work under the constraints of the mural painter, they also exaggerated body-movements, chose a few strong gestures, and contributed both to emphasizing the significance of gesticulation in the pictorial arts and to the formulation of some essential gestural idioms. Giotto was heir to all these developments.

Giotto

In the preceding section of this introduction I have suggested – perhaps a little too boldly – a basic distinction in the realm of gestures, and I have also attempted to outline some of the characteristic features pertinent to our subject in our master's social and cultural background. In the following study, I hope, the categories and rituals mentioned may prove useful in the description and analysis of the gestures represented by Giotto. Before turning to a discussion of individual gestures, I will attempt to indicate some broader aspects of our specific subject, gestures in Giotto's work.[9]

In Italian culture of the thirteenth and fourteenth centuries – the literary sources strongly suggest – a high degree of awareness of the shape and meaning of gestures prevailed. Giotto's work offers ample witness that the master shared this awareness. Giotto, it has been said time and again, was a careful observer of 'life'. It may be difficult to say what precisely 'life' means, but gestures were clearly conspicuous among the features he observed and represented. This seems to have been recognized already in the Renaissance; authors of the period, writing about Giotto, used to stress the role of gestures in his work. In *Della Pittura*, Leone Battista Alberti mentions only Giotto as a representative of 'modern' painting, and describes only one of his works, the *Navicella* in Rome. What he emphasizes as Giotto's most important achievements are facial expression and gesture. Each apostle, Alberti

[9] See, in general, Gosebruch, 1962, and Barasch, 1976.

(1956, p. 78; 1950, p. 95) says, 'expresses with his face and gesture a clear indication of a disturbed soul in such a way that there are different movements and positions in each one'. A century and a half later, Vasari still stresses similar qualities in Giotto's work. In the frescoes in the Upper Church of St Francis in Assisi there is 'wonderful variety...in the gestures and attitudes of all the figures shown'. What is striking about Giotto's gestures is not only the aesthetic quality of variety, but their ability to show the figure's inner life. In 'one of the most beautiful scenes' – it is *The Miracle of the Spring* (fig. 37) – Giotto depicted 'a man showing signs of great thirst kneeling down to drink eagerly at a fountain' (Vasari, 1878, I, p. 377). The lifelike quality of Giotto's work, so often emphasized in Renaissance literature, must also have included the fullness, variety, and articulation of gestures.

Following the suggestions made, in passing comments or descriptive sentences, by Renaissance authors, one would assume that the gestures Giotto depicted were primarily natural gestures, those we have defined as 'symptomatic'. What Alberti and Vasari describe are indeed involuntary movements of the body which originate in, and reveal to the eye, mental states, or *movimenti d'animo*, as the Renaissance formulation had it. That Giotto should have concerned himself mainly with the depiction of natural gesticulation accords well with his historical image as the artist who brought painting 'back to nature', freeing it from the dead, dried-out conventions of the Middle Ages, as a famous Renaissance stereotype has it. Yet a careful, scrutinizing analysis of Giotto's work leads to an altogether different conclusion. Our artist's primary source was not uncontrolled nature, carefully and independently observed; it was rather the gestural patterns provided by established social acts. The major part of the expressive gestures that Giotto represented can be shown – as we shall see in the chapters to follow – to have been taken from highly crystallized patterns of ritualized movement and behaviour. It is true that Giotto did not distinguish, in the manner of depiction, between 'natural' and 'conventional' gestures. He infused gestures that appear to be 'conventional' with the spirit of life, of an immediate, often urgent, psychological reality. On the other hand, he often imparted the quality of emotional restraint, usually characteristic of conventional gesticulation, to movements representing natural reactions, expressing agitated minds and turbulent experiences. In his style Giotto tended to level the difference between the two modes. To a large extent he shaped even gestures and stances used in dramatic, emotional scenes, such as lamentation over the dead, after social patterns common in lamentations. The great sources, then, that provided him with models for gestures were the social conventions, the established, not the spontaneous, forms of expressing inner experience or communicating sacred or secular contents in premeditated shapes. It would be trivial to say that Giotto was a great observer of human nature (though here, as in so many similar cases, a trivial

statement may express a profound truth). What concerns us in the present study is not so much his general psychological leanings as the fact that the most important looking-glass through which he observed human nature was the behavioural convention that prevails in our social world.

It is precisely when we assume that Giotto was intimately familiar with the distinct patterns and levels of gesticulation as accepted social acts that we are astonished to see how freely he handles conventional gesticulation. Though he drew from live conventions, current in his time, he often detached an individual gesture from its original social context, secular or ritual. The priest's blessing hand is frequently represented in narrative themes and in scenes which, at least at first glance, have little to do with ecclesiastical ritual. The movement performed by the defendant (or witness) in the late medieval court and meant to indicate his (or her) inability to interfere in the course of an event, is employed by Giotto in a dramatic biblical event which has nothing to do with a judicial court. Familiarity with conventional gestures does not mean preservation of the gesture in its original context.

Yet when Giotto removed conventional gestures from their original cultural matrix and used them in a new context, the gesture's original character was not altogether obliterated. The gesture does not become simply a purely visual configuration, devoid of any thematic or emotional connotation. Transplanted gestures, as we shall have occasion to see in the following study, retain their meaning and character, though they do so in a hidden, submerged way. A characteristic feature in Giotto's employment of transferred conventional gestures is his use of these half-articulated, submerged meanings and connotations.

CHAPTER 1

THE SPEAKING HAND

The gestures Giotto most frequently represented are those accompanying and indicating speech. It is natural that students should have observed them a little more specifically than most other gestures, and art historians, as far as they have paid any attention to gestures at all, have occasionally commented on these. In the art of other, mainly earlier, periods speaking gestures have been explored in some detail.[1] The student of Giotto's gestures is, therefore, uncertain whether he should start a review of his subject with the movements indicating speech. Yet, even if we cannot hope to adduce many new observations concerning these specific gestures, the fact that Giotto depicted them so often in different contexts makes it possible for us to learn something from them about the master's use of the language of gestures in general. In this chapter I shall limit myself, first, to distinguishing the major types and contexts of speaking gestures in his work; secondly, I shall ask what degree of consistency in the form and application of these gestures prevails in Giotto's work. A correct reading of speaking gestures sometimes sheds light on iconography and the interpretation of religious modes. Can one, for instance, clearly distinguish between a speaking and a benedictory gesture? The basic problems of learning a 'language of gestures' are clearly reflected in the realm of gestures of speech.

There is no need to show how central is the significance of speech in European culture. Both the ancient Hebrew and the Christian faiths were religions of the word, spoken and written. In the classical world training in speech became the major form of education. As the Middle Ages progressed and their culture and opinions became fully articulated, the aura of the spoken word became even stronger (Curtius, 1953, pp. 302–47). Painting and sculpture were necessarily affected by this power of speech; nobody is surprised to see artists searching for means to represent

[1] The most detailed study remains Amira, 1909, who deals with these gestures as sources for the study of medieval German law. For antiquity see Sittl, 1890, pp. 48, 284ff., 302ff., and Brilliant, 1963.

speech visually. What is the visual equivalent of speech? How does one show that a figure is speaking? It is perhaps surprising that no serious attempt was made to visualize speech in the shape of the face (as there was to show singing in the form of the mouth, the cheeks, etc.).[2] The organ visually showing speech was, and still remains, primarily the hand. The hand can show a great variety of moods: the pointing hand can be sharp and shrill, the caressing hand can be soft and flexible.

That the hand is an organ of speech, capable of communicating different shades of meaning and emotion, was well known in antiquity. It will suffice here to quote a famous passage by Quintilian (*Institutio oratoria* XI.3.85–7), teacher and codifier of ancient rhetorics. The old orator's words are so classic that they deserve to be quoted here *in extenso*.

As to the hands, without the aid of which all delivery would be deficient and weak, it can scarcely be told of what a variety of motions they are susceptible, since they almost equal in expression the powers of language itself; for other parts of the body assist the speaker, but these, I may almost say, speak themselves. With our hands we ask, promise, call persons to us and send them away, threaten, supplicate, intimate dislike or fear; with our hands we signify joy, grief, doubt, acknowledgement, penitence, and indicate measure, quantity, number and time. Have not our hands the power of exciting, of restraining, of beseeching, of testifying approbation, admiration, and shame? Do they not, in pointing out places and persons, discharge the duty of adverbs and pronouns? So that amidst the great diversity of tongues pervading all nations and people, the language of the hands appears to be a language common to all men.

What Quintilian stresses in this important passage is the ability of the hand to intelligibly communicate different emotions, and its power to bring about definite emotional results (it excites, restrains, etc.). What he did not say was how the hand should communicate the very fact that the figure is speaking. For the orator this question does not arise; his voice calls the public's attention to his speaking. But for the artist in the visual media, the painter and sculptor, this can be a central problem. It has occupied the minds of artists in many periods, and it is also a problem Giotto had to solve.

I cannot review here, even in broad outline, the gestures of speaking in classical and medieval art. I shall mention only a few aspects which may have had a direct bearing on Giotto's manner of representing them. What the student enquiring into the context of such gestures in ancient art discovers first is – to his surprise – that hand movements intuitively understood as speaking gestures do not, usually, identify groups or types of people. The depiction of orators in Greek and Roman art is an instructive example. To be sure, sometimes figures with raised, 'speaking', hands

[2] The example that instantly comes to mind is of course the singing angels in the Ghent altarpiece. But here, too, Van Eyck's realism seems to be exceptional. In most renderings of singing angels, the mouth is closed.

depict orators, as in certain Etruscan statuettes (Riis, 1953, pp. 109ff.; Brilliant, 1963, p. 31, fig. 143). But in representative monumental renderings of rhetoricians, the posture of the hands is different. The well-known figure of Demosthenes (fig. 22), so often copied in the ancient world,[3] has folded hands. Aeschines the Orator, the fourth-century B.C. opponent of Demosthenes, praises the orators who, like Pericles, Themistocles, and Aristeides, keep their hands covered by their cloaks.[4] The speaking hand, then, is not simply an attribute of the speaker, but it is typical of a situation, it shows the act of speech. In Roman life and art there were two situations which became speaking themes *par excellence*, and which left their imprint on the shape and expressive quality of speaking gestures in European art. These situations were that termed *adlocutio* and, perhaps to a lesser degree, *acclamatio*. As we know, *adlocutio* – an address – was the emperor's address to his army, given while he was standing on the *suggestus*, an elevated platform, in the centre of the army camp (Pauly–Wissowa, 1894–1937, I, 1, cols. 375–6, s.v. 'adlocutio'). The emperor would start his *adlocutio* by raising his right hand, requesting quiet and attention. The speaking emperor, his right hand raised, is one of the best-known images of Roman art. We know it from practically all media, from small coins to huge marble statues. Everybody knows that this image was not forgotten in European art. What is of primary importance in our context is that the gesture of speaking is here intimately connected with one of the most imposing official functions of the emperor. This fact placed speech, and everything visual expressing speech, on an elevated level, it endowed any speaking gesture with a dignity and sublime character that was not easily forgotten. When the raised 'speaking hand' was detached from an actual speaking situation, it retained its original mode, the sublimity originally pervading it (L'Orange, 1953, pp. 139–70).[5] For this reason the speaking hand was closely related to official imperial imagery. In our context it is also of importance that the precise posture of the speaking hand, the configuration of the fingers, was not decisive. What counted in *adlocutio* representations and in the motifs derived from them was the idea of speech itself rather than any specific formulation. One

[3] Of the whole statue two copies have been preserved; of its head no fewer than forty copies have come down to us. Cf. Schefold, 1943, pp. 106, 208.

[4] See the statue of *Aeschines* in Naples (Schefold, 1943, p. 103), a marble copy after a bronze original erected in Athens between 322 and 307 B.C. The famous statue of *Sophocles* in the Lateran Museum in Rome is cast in the same stance. In Athens, it seems, they believed that the actor, and the orator, should be restrained in diction and movement. 'Such is the practice of actors', says Quintilian (11.10.13), '...they exalt the simplicity of familiar discourse with a certain scenic grace'. Later Quintilian directly refers to holding the hand in the garment. 'Accordingly they must have used at the commencement of their speeches a kind of gesture different from ours, as their arm, like that of the Greeks, was confined within the garment.'

[5] L'Orange stresses the magic power of the king's raised hand. He quotes the sixth-century Greek historian Procopius (*De aedif.* 1.2.12): 'Stretching forth his right hand towards the Orient and spreading out his fingers, he commands the barbarians in that quarter to remain at home and to proceed no further.'

might say that in the actual *adlocutio* what was important was the very fact that the emperor was speaking, and clearly perceived as doing so, rather than what he said.

Acclamatio is another speaking situation (Alföldi, 1934 and 1935; Delbrück, 1932; Straub, 1939; Kantorowicz, 1946). It differs from *adlocutio* in many respects. *Acclamatio* is less individualized than *adlocutio*. It is also less formalized. Acclamation is performed by the crowd, and therefore it is inherently less distinctly formulated. It can also be performed in a variety of ways, by calling, shouting, elevating the acclaimed on a shield.[6] Late antique and medieval art, especially in the Byzantine East, was inventive in forms of acclamation. Yet in most varieties we find the speaking gesture as the core. A fine example, to mention a most famous work, is the early fifth-century A.D. ivory plaque representing the enthroned Probianus (Delbrück, 1926–9, II, no. 65), and two figures acclaiming him. The acclaimants raise their right arms and hold their hands in that particular position that we know in another context: thumb and two first fingers raised, the two other fingers bent, so that the thumb touches them. This gesture, now familiar as the sign of blessing, is attested as a gesture of speech. Though acclamation is less exalted in mode than the emperor's address, an historical event of great significane, it is also an action of state, an event carrying historic connotations. Through both these forms, *adlocutio* and *acclamatio*, antiquity bequeathed to later periods the notion that speech is associated only with an elevated context. In Giotto's work, too, the gestures of speech invariably carry the connotations of elevated, sublime action.

In medieval artistic language, as revealed both in works of art and in highly formalized social acts, movements indicating speech played a central part, surpassing the status of such gestures in ancient art, and probably overshadowing all other gestures in the Middle Ages themselves. It is not surprising that they are among the motifs most frequently found in the sacral art of the period. 'In the iconography of Christ', according to a formulation by L'Orange (1953, p. 171), 'the imperial gesture of omnipotence [the raised hand with open palm turned towards the beholder], inherited from the oriental gods and rulers, had to yield' to the gesture of speech.

The specific speaking gestures, as crystallized in the Middle Ages, can still be observed today in Christian worship, mainly as the ritual signs of benediction: the *benedictio latina* in the Roman Catholic Church, the *benedictio graeca* in the Greek Orthodox Church (and in some Protestant forms of workship) (Cabriol and Leclerq,

[6] For ancient acclamations, from the point of view of art history, see Delbrück, 1926–9. See also Peterson, 1926, pp. 141ff. For the elevation on the shield cf. L'Orange, 1953, pp. 103ff. For the legal connotations of this ceremony, and for the dates, see also Alföldi, 1935, p. 54. For the shield as a theological and political symbol, see Winkes, 1969.

1913–53 s.vv. 'bénir', 'bénédiction grecque'; Eitrem, 1966, p. 35ff.). In the *bene-dictio latina* the three first fingers (thumb, index, and middle finger) are stretched out, the two remaining ones (ring and little finger) are flexed against the palm of the hand. The thumb is not always straight, it often touches the ring finger. This gesture was well known in ancient life and art. For the latter we have just seen it in the Probianus panel. Ancient literature shows how aware people were of the details of the gesture. Apuleius reflects this awareness in the second century A.D. A certain Telephron, Apuleius (*The Golden Ass* II.21) tells his readers, prepared to make a speech. Leaning on a cushion, he raised his right hand, and 'like the orators' presented his case 'closing the last two fingers together and stretching out the other supported by the thumb'. Fulgentius the Mythographer, the fifth-century A.D. grammarian from Carthage, shows that his period also knew the gesture and related it to official speech. Of somebody wishing to present his case, he says (*Virgiliana continentia*, 143), 'so, settling into a manner of orator, with two fingers held up straight like a capital letter "I" and pressing the third finger with the thumb, he began to speak...'

There is no need to stress the wide occurrence of the *benedictio latina* in medieval art. Everybody knows the image of the Pantocrator holding his right hand in this posture. In this form the *benedictio latina* also appears in the Arena Chapel (fig. 1). But the same formula, and many variations of it, were also used in narrative scenes. Ottonian manuscript illumination probably provides the most striking examples. In King Henry II's Book of Pericopes (Munich, Bayerische Staatsbibliothek, Lat. 4452), Christ announces the Coming of the Holy Ghost by performing the *benedictio latina* (fig. 2; Weisbach, 1948, p. 42). The gesture is not a blessing: it is performed in the empty space between Christ and his followers, it is not directed towards anybody, and only a piece of fluttering drapery accompanies it, enhancing its expressive power. Another Ottonian miniature, a Gospel Book of Otto III (Grabar and Nordenfalk, 1957, pp. 203ff.) shows Christ explaining the mystery of the washing of the feet to St Peter by making the same gesture. In these, as in many other examples, the gesture means solemn speech (Gombrich, 1965).

The *benedictio graeca* resembles the *benedictio latina*, except that the little finger is also raised. The origin of both gestures must be the same. The catalogue of finger positions which Quintilian formulates presents the reader with almost all possible variations; the orator should choose his gesture according to the subject matter and the intention of his speech. The most common speaking gesture, Quintilian (*Insti-tutio oratoria*, XI.3.92) says, is that 'in which the middle finger is drawn in towards the thumb, the other three fingers being open'. In the early Middle Ages the two gestures, the 'Latin' and the 'Greek' were obviously freely practised and this is also reflected in the art of the period. In the Codex Rossanensis, a well-known sixth-

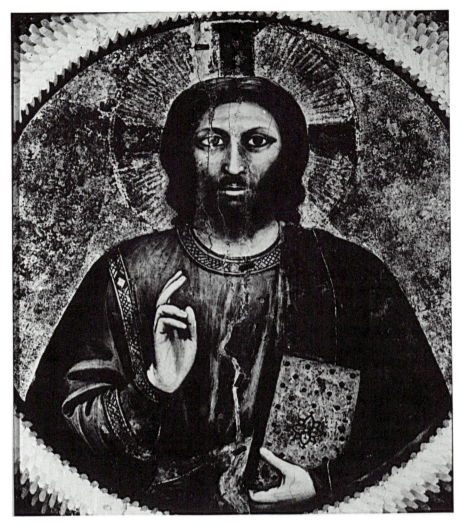

1 Giotto, *Pantocrator*, Padua, Arena Chapel, ceiling fresco

century manuscript, Old Testament prophets and kings expound their words by making either the 'Latin' or the 'Greek' speaking gesture (Zarnecki, 1975, fig. 66). Both kings and prophets perform both gestures. But the further development, as we know, caused a division of the two gestures, so that the Greek form was found only in the Byzantine ritual, the Latin gesture in Western Christianity.

Christian benedictory gestures developed from the Roman movement of speech and retained an important feature of their Roman origin – they invoked an atmosphere of solemnity, they belonged to an elevated level of forms.

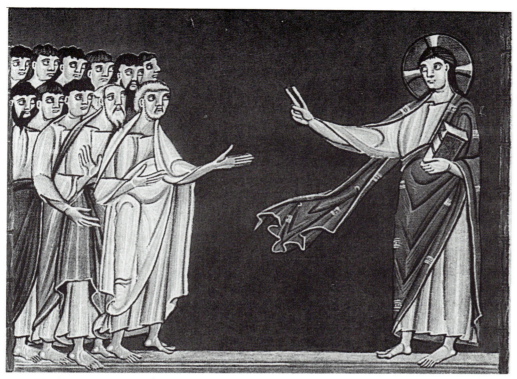

2 Munich, Bayerische Staatsbibliothek, Lat. 4452, *Christ Announces the Coming of the Holy Ghost*

It is against this background that one should see Giotto's use of speaking gestures. As I shall suggest, Giotto used several basic gestures of speech, yet it is difficult to trace clear borderlines between the different types, and often the spectator cannot decide to which type a particular movement belongs. Giotto used traditional models, and those were usually crisply shaped. But since he endowed them with life, and translated them into his own style, the original, clear-cut steretype of the model does not always emerge. It is characteristic of Giotto's painting in general that he produces clearly articulated, typical images of whatever he represents,[7] but the speaking gestures – even though they do not merge with one another – cannot be kept sharply apart. In spite of these difficulties some primary speaking gestures are distinguishable and I shall deal with them in the present chapter. In differentiating

[7] This is how most scholars have seen Giotto. See for instance, Rintelen, 1923, p. 14: 'Die Grösse, mit der Giotto seine Bilder angelegt hat, lässt ihn nichts darin dulden, was sich nicht vollkommen rein darstellte.' Rintelen correctly stresses that it would be wrong to explain this as a restriction to what is 'necessary'. Toesca, 1941, p. 107 says: 'the compositions are reduced to specifics and to indispensable "personages"'. See also Hetzer, 1981, pp. 251–7 (the chapter called 'Ueber Giottos Einfachheit').

3 Giotto, *The Annunciation to St Anne*, Padua, Arena Chapel (detail)

between one type and another we must ask ourselves whether these primary speaking gestures are only variations of one basic formula, introduced to avoid the monotony of constant repetition, or whether each of these gestures has a distinct expressive character. Can each gesture be employed in every context, or are some appropriate in one context, others in a different one? The answer is not easily given, but the questions are worth asking.

One type of speaking gesture in Giotto I should like to call 'the announcing hand'. Although it necessarily forms part of the whole figure, this motif is essentially limited to the hand proper and it consists mainly of a configuration of the fingers. The 'announcing hand' is seen in profile, thumb and index finger are fully exposed, and usually also sharply illumined; in the shadow, one perceives the stretched-out middle finger, while the two remaining fingers, usually in deep shadow, are curved towards the palm. This posture is in fact very close to the *benedictio latina* seen in

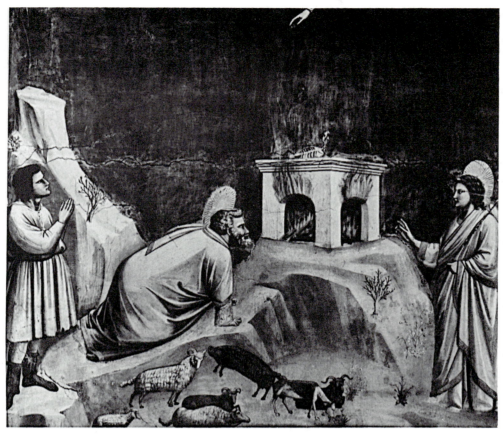

4 Giotto, *The Sacrifice of Joachim*, Padua, Arena Chapel

profile, a view in which it was never rendered as a ritual movement, except that the blessing gesture is here represented in a free and dynamic form. The context of the announcing hand may tell us something of its character. The gesture appears several times in Giotto's work. In *The Annunciation to St Anne* (fig. 3) the angel, entering through the window to make his announcement to the praying saint, stretches forth his hand. This hand, the carrier of the message, is held in the pure 'announcing' shape. In *The Sacrifice of Joachim* (fig. 4) the gesture is rendered in a slightly modified version. The angel bringing the old Joachim the good news raises his announcing hand, the palm slightly turned towards the beholder. The stories represented show that these are gestures of speaking. But their character can perhaps be defined a little more specifically, these movements of the hand accompany the making of favourable and solemn announcements. In the *Noli me tangere* (fig. 5) the angel on the left, sitting on Christ's tomb, holds his outstretched hand in the same

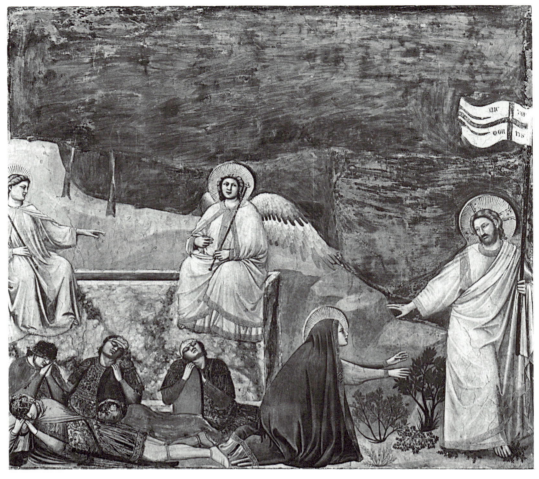

5 Giotto, *Noli me tangere*, Padua, Arena Chapel

posture, although in a horizontal position: his finger seems to point at the empty
tomb, and thus to announce Christ's resurrection.

Giotto used the announcing hand also at a later stage of his development. In
Zacharias in the Temple (fig. 6) on the left wall of the Peruzzi Chapel in Santa Croce,
he closely follows the text (best represented by the *Golden Legend* (W 124)). Joachim,
burning incense at the altar, is frightened by the sudden appearance of the angel and
shrinks back (a sudden emotion represented in his posture): the angel himself,
turning towards Joachim, is bringing his saving message to the desperate old man.
The angel's mouth is closed, the lips firmly tightened; that he is speaking, is
communicated in the gesture of his hand. The angel's announcing hand is the same

6 Giotto, *Zacharias in the Temple*, Florence, Santa Croce, Peruzzi Chapel (detail)

as that of the announcing angel in *The Sacrifice of Joachim* in the Arena Chapel, painted many years earlier. The hand is kept in an almost perfectly vertical position, the palm slightly turned towards the beholder, all the fingers are seen, though some are covered by shadows. This is a second version of the announcing hand.

The announcing hand, as we have seen in the frescoes mentioned, can actually be treated as a self-contained, isolated motif. Once, in fact, Giotto actually isolated it – as the hand of God emerging from the sky in *The Sacrifice of Joachim*. This is Giotto's rendering of the hand of God, and it is represented as the 'announcing hand' seen in pure profile. It is the same hand as that of the Angel in *The Annunciation to St Anne*, and very close, though at a somewhat different angle, to that of the angel seated on the extreme left in the *Noli me tangere*. In casting God's hand in the profile view of the 'announcing hand', Giotto was deviating from tradition. God's hand appearing in the sky is, as everybody knows, a common motif in medieval art,[8] though unfortunately one that has not been carefully studied. As

[8] We do not have a monographic study of this important iconographic motif. For the isolated hand in sculpture (though not necessarily the hand of God) see Janson, 1981. For the traditional iconographic context, see Kraus, 1879–86, I, p. 629; Cabrol and Leclerque, s.v. 'main', esp. the section 'main divine'.

far as can be said without a systematic collection of the material, the isolated hand
of God in medieval art either performs a clearly definable action – grasping the
outstretched hand of the ascending Christ,[9] holding a wreath or a crown above, or
placing it on the head of an emperor,[10] putting a scroll in Moses' hands (e.g. the
Bible of Moutier-Grandval – British Museum, Add. MS 10546, fol. 25v), etc. – or
it fulfils a symbolic function by its very presence. In the first group the position of
the hand is obviously determined by what it does; drawing Christ up to heaven
differs from the movement of crowning a king. In the second group (important in
the present context) the hand's posture was firmly established by tradition. The
whole hand is always presented, no part or finger shielded or concealed; usually the
palm is seen, all fingers stretched out, though occasionally one also finds such a
hand, also showing the palm, in the *benedictio graeca* position. (For an early example,
see the wooden door of Santa Sabina in Rome; see Grabar, 1968, fig. 338.) God's
hand was represented in the fullest, most unobscured attitude, probably for the
same reason that led medieval artists to represent God's face in a full, symmetrical
frontal view.[11] The hand so seen is the symbol of God's unimpeded presence.

Since we have no systematic discussion of God's hand in medieval art, we cannot
be sure where and when the changes in position occurred, and when, if at all, God's
isolated hand was conceived not only as a revelation of his presence. It seems to be
evident that when Giotto used the profile view instead of the frontal one he wanted
to convey a different interpretation of God's hand. The divine hand here is not just
an indication of God's presence, but it visualizes God's word, the act of his speaking.
What the angel says on earth is visibly God's word.

The announcing hand can also be understood as a speaking gesture devoid of that
particular solemnity which has characterized the examples we have described so far.
In *St Francis Honoured by a Citizen* (fig. 7), a fresco in the Upper Church of St

[9] Even within this narrowly defined theme the hand of God varies, as just a few examples will show. In the
Drogo Sacramentary (frequently reproduced; see Leroquais, 1924, I, pp. 16–17, pl. IX) God the Father's
huge hand grasps Christ, almost completely closing the fist. In a ninth- or tenth-century ivory in Liverpool
(Goldschmidt, 1914, I, fig. 127) God's hand, ready to receive Christ's, is still free; we see the palm and
the slightly curved fingers. In the Evangeliar of Henry III, of the eleventh century (Bremen, Municipal
Library, Cod. 21) the hand, seen in a three-quarter view, is stretched forth towards Christ, speaking or
blessing. Cf. Gutberlet, 1934, pp. 72ff., and Schrade, 1930, pp. 6ff., esp. pp. 109ff.

[10] Again only a few characteristic examples. The hand is often seen from the back, frontally, with curved
fingers holding the crown. See, for example, the eleventh-century manuscript, Venice, Cod. Marc. 17
(Grabar, 1936, pl. XIX.2). Sometimes the hand placing the crown on the emperor's head is seen in profile,
as in the mosaic in Palermo representing Christ crowning Roger (see Grabar, 1936, pl. XXVI.1). In the
profile position it is sometimes difficult to say whether Christ is placing the crown on the king's head or
is blessing the king already crowned. See the *Coronation of Constantine VII*, an ivory in the Historical
Museum in Moscow (Grabar, 1936, pl. XXV.1).

[11] The frontal view of God's face may sometimes derive from the intention of representing him as addressing
the spectator, but can this also be true for a rendering of God's hand? For a discussion of frontal and
profile in Giotto's work, see below, pp. 158ff.

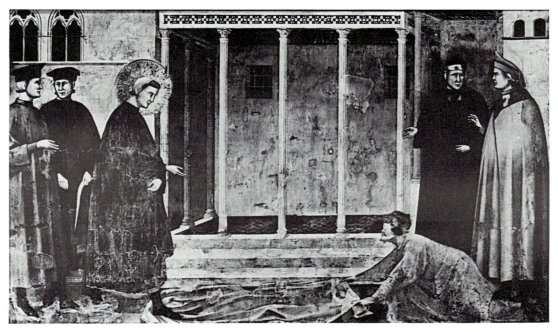

7 Giotto, *St Francis Honoured by a Citizen*, Assisi, Church of St Francis, Upper Church

Francis in Assisi, behind the respectful citizen who is spreading the carpet for St Francis to walk on, two bystanders are talking among themselves. One of them, in the lighter garment, in addressing his neighbour raises his hand in the announcing gesture. His talk is not casual, but its tenor is probably less elevated than in scenes where the angel is bringing a message of salvation. One should also note that this seems to be the only case where the gesture is performed by a really anonymous marginal figure. Since our knowledge of who created the indivdual frescoes in the Upper Church is so limited, we cannot draw any conclusions from this gesture for Giotto's general use of it.

We now turn to another speaking gesture also frequent in Giotto's work. It begins with the arm, which is either altogether extended or with raised forearm; the hand, seen from the back, usually prolongs the direction of the forearm, the fingers are held together but in a light, slightly open form, and the thumb is not seen. In *Joachim's Dream* (fig. 8), an angel sweeping down from heaven thus extends his hand towards the sleeping old man. It is immediately evident what the gesture is meant to convey: it expresses in visual terms the angel speaking and delivering his message. In the *Nativity* (W 25; S 110), also in the Arena Chapel, the angel hovering above the roof of the hut turns towards the shepherds at the right, making this movement which I should like to call the 'open speaking gesture'; the angel is telling

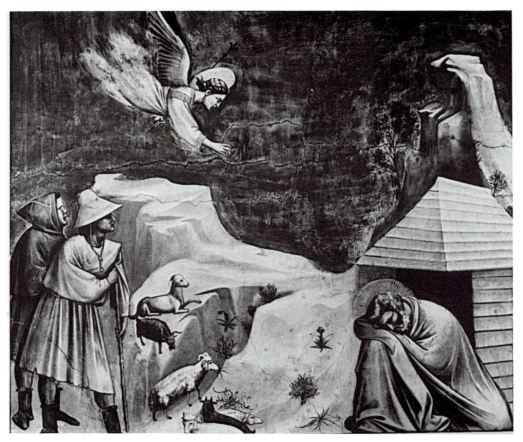

8 Giotto, *Joachim's Dream*, Padua, Arena Chapel

the shepherds of the birth of the saviour. In *The Washing of the Feet* (fig. 9),[12] Christ explains the mystery of the new rite to St Peter by performing exactly the same gesture. This hand is a little more open than in the other frescoes, and it demonstrates how appropriate this movement is as a teaching gesture. But it occurs also in other variations. In *The Annunciation* (fig. 10), the large fresco on the tribune wall of the Arena Chapel, the archangel Gabriel raises his forearm, and his hand is seen from the back, the fingers extended. Since the ring and little finger are slightly curved (and the thumb is not seen) the posture in a subtle way evokes the image of

[12] In the thirteenth- and fourteenth-centuries the concept of the Washing of the Feet as a mystery – that is, an event that should be explained, i.e. spoken about – was particularly common. Cf. Richter, 1967, pp. 89ff. For earlier interpretation of the Washing of the Feet, cf. Kantorowicz, 1956. Christ's speaking gesture in Giotto's rendering of the scene may indicate this trend of thought.

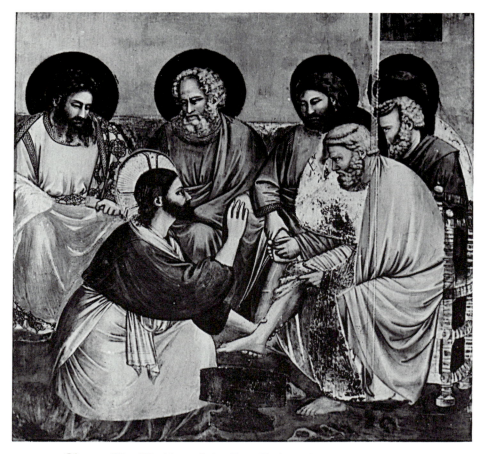

9 Giotto, *The Washing of the Feet*, Padua, Arena Chapel (detail)

blessing. It is not a benedictory gesture, however; it clearly retains the shape and meaning of a speaking hand, the hand that makes the announcement.

This speaking gesture does not carry any well-defined moral or religious connotations, and it is not reserved for divine or holy figures. The same gesture that serves the angels to make their redemptory announcement to the desperate Joachim or to inform the shepherds of the Saviour's birth is also performed by King Herod in *The Massacre of the Innocents* (fig. 11) in the Arena Chapel. It is not immediately evident whom the wicked king is addressing; the gesture probably represents his order to slaughter the infants. Our open speaking gesture is clearly not limited to a certain sphere or level of figures. Nevertheless, Herod's cruel command, though in content opposed to the holy actions mentioned in the other scenes, is also full of significance. The 'open speaking gesture' thus also carries great weight.

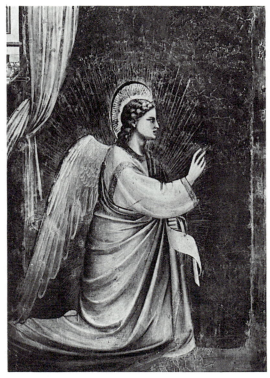

10 Giotto, *The Annunciation*, Padua, Arena Chapel (detail: The Angel)

The open speaking hand, like the announcing hand we discussed earlier, can largely be isolated from the whole figure; in fact, it has little influence on the figure's overall comportment. It requires no accompanying gesture. The figures raising their hands in the open speaking gesture may employ their other hand very differently – holding a symbol, grasping an object or another human figure – with no bearing on the principal gesture.

By infusing life into inherited forms and sometimes by minute deviations from established models, Giotto often makes a classification of his representations difficult. But the rather limited freedom he takes with regard to his models also shows us how a great artist handles tradition, and what his attitude is towards the motifs transmitted to him by the past, which he obviously wished to preserve. His benedictory gestures are particularly suitable for the study of this general problem and some of its facets. From both the announcing hand and the open speaking hand Giotto derived gestures of blessing. In fact, looking at his frescoes one often cannot tell with certainty whether a hand is announcing or speaking, or whether it is blessing. Even when we derive the identification of a gesture from the subject matter

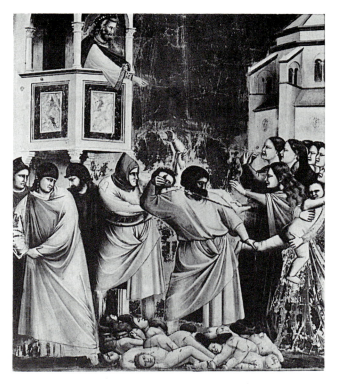

11 Giotto, *The Massacre of the Innocents*, Padua, Arena Chapel (detail)

of a fresco it may be almost impossible to be sure which specific shade of a gesture is represented. What a discussion of this problem shows us is, first of all, how fluid the borderline between seemingly different gestures can be.

From the open speaking hand Giotto developed a gesture of blessing which can best be seen in *The Wedding at Cana* (fig. 12). The seated Christ raises his hand and forearm, the index and middle fingers are extended, though they are not rigidly stretched out, the ring and little fingers are curved into the palm, the thumb is not seen. This is how the Saviour addresses the girl standing opposite him. The shape of the hand suggests blessing, though it does not explicitly represent this. One imagines that if we could see the hand from the other, inner side, it would closely approach the *benedictio latina*. But did Christ bless somebody or something during the Wedding at Cana? Neither the Gospel of John that tells the story (2:1–8) nor the apocryphal and even later sources relating the miracle speak of benediction.[13]

[13] John only tells the reader that Christ 'said' to the servants to fill the water pots. An early Coptic narrative of Christ's ministry and passion relates that Christ 'ordered' the water pots to be filled. See James, 1926, p. 147.

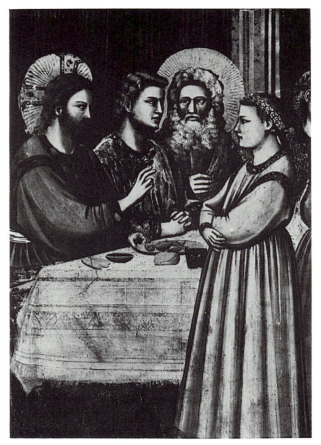

12 Giotto, *The Wedding at Cana*, Padua, Arena Chapel (detail)

One can perhaps infer, however, that the medieval mind imagined the performance of the actual miracle – the turning of water into wine – as an act of the highest liturgical intensity, and thus embodied in (or accompanied by) the most prominent of liturgical gestures, the blessing. If this was indeed how Giotto thought, what he painted is an interesting comment. Liturgical gestures, as we know, are characterized by a very high degree of formalization. Even if it can be shown (as is undoubtedly the case) that most liturgical gestures developed from 'natural' gestures of speech and other types of communication, it still remains true that once a regular movement becomes part of the liturgy it acquires an almost deliberately artificial, premeditated character. Giotto of course knew the ritual gestures of Western Christianity, and he clearly followed established usages. In this context it is worth noticing that he never represented the *benedictio graeca*, which was not in use in his Italy, though he surely

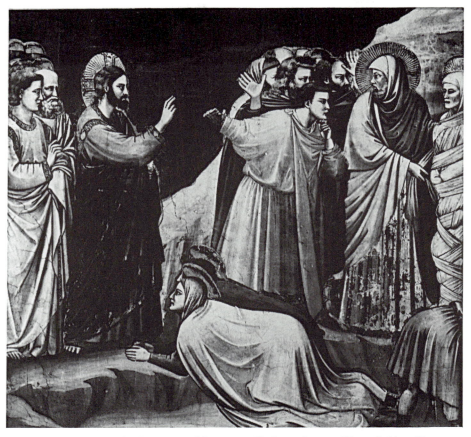

13 Giotto, *The Raising of Lazarus*, Padua, Arena Chapel (detail)

knew it from earlier monuments. He used ritual gestures, yet he made them appear 'natural', spontaneous. Thus the blessing gesture again becomes a gesture of speech, though it accompanies speech of great solemnity and significance.

In *The Raising of Lazarus* (fig. 13),[14] next to *The Wedding at Cana*, the same gesture occurs in a similar context. The composition is based – as in so many earlier representations – on a confrontation of the two central figures, Christ and Lazarus, who are seen in almost pure profile. Christ, turning towards Lazarus, raises his hand in a gesture identical to that of *The Wedding at Cana*: the index and middle fingers are comfortably extended, ring and little fingers are curved under, the thumb is not

[14] Among the other scenes in which the juxtaposition of profiles plays an important part are *The Visitation*, *The Slaughter of the Innocents* (the group in the centre), *The Baptism of Christ* (juxtaposing John the Baptist and Christ), *The Hiring of Judas* and *Judas Kissing the Lord*. In the later stages of his work Giotto also used this compositional pattern. See, e.g., *Zacharias in the Temple* (juxtaposing the profiles of Zacharias and the angel), and the *Resuscitation of Drusiana*, both in the Peruzzi Chapel in Santa Croce, in Florence.

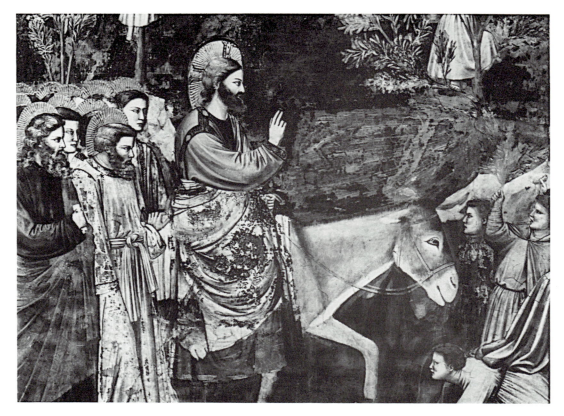

14 Giotto, *Christ's Entry into Jerusalem*, Padua, Arena Chapel (detail)

seen. Again it is easy to reconstruct the *benedictio latina*. Giotto was here following pictorial traditions, though he clearly deviated from the text. The text explicitly tells us that Christ spoke when he raised Lazarus from the dead, but nothing suggests that he blessed. John is the only Evangelist who tells the story.

And Jesus lifted up his eyes and said, Father, I thank thee that thou has heard me... And when he thus had spoken, he cried with a loud voice, Lazarus, come forth. And he that was dead came forth... (John 11:41–4).

Giotto, like many of his predecessors, omits the one gesture that the Gospel mentions, the lifting up of the eyes, and replaces the crying with a loud voice by the hand gesture so close to benediction. The blessing hand here surely does not represent a ritual act. It rather indicates an elevated and intensive level of speech.

The same hand posture is again represented in a great mural in the Arena Chapel, *Christ's Entry into Jerusalem* (fig. 14). That Christ makes the benediction is a piece

of traditional iconography, and it is not surprising in a representation by an artist who did not openly revolt against tradition. What is more interesting is that Giotto here slightly, almost imperceptibly, transformed the gesture he used in *The Wedding at Cana* and *The Raising of Lazarus*. This transformation, though minute, is sufficient to suggest some conclusions. In *Christ's Entry into Jerusalem* Christ's hand is raised in precisely the same manner as in the two other frescoes, but here the thumb is also seen, even if only as a slight segment. Even this little indication gives the whole gesture a more outspokenly ritual character. A close examination of Christ's hand shows that, although the *benedictio latina* is strongly suggested, there is no real ritual blessing gesture. In order to perform the *benedictio latina* the thumb should have been placed diagonally, so that it could touch the curved ring finger. But in Giotto's representation the thumb is kept upright, parallel to the raised index finger. Christ, then, does not employ the traditional benedictory gesture, although this is the impression one gets at first glance; his hand is a solemnly speaking hand.

In a later stage of his work Giotto came back to another version of the same gesture. In *The Resuscitation of Drusiana by St John the Evangelist* (fig. 15) (Peruzzi Chapel, Santa Croce) St John, performing the miracle, extends his arm and hand towards Drusiana, who is being carried on her bier. The apostle's hand, held in an almost perfectly horizontal position, is seen from the back; the position of the fingers, though freely moving, reminds the beholder of the *benedictio latina*. Yet it is obviously a speaking gesture, explicating the words of the apostle that make the dead Drusiana come to life again. The slight similarity to the blessing gesture probably helps to emphasize the solemnity of the apostle's words.

An unusual and surprising speaking hand is represented in *The Flight into Egypt* (fig. 16) in the Arena Chapel. Three youths here follow the donkey carrying the Virgin and the Child. The youth on the first plane, obviously explaining to his companion the mystery of the event they are witnessing, extends his hand in a noble, highly rhetorical gesture, again approaching in a general manner the configuration of the *benedictio latina* (though the hand is held horizontally rather than vertically). The index and middle fingers are extended, freely and elastically, the ring and little fingers are curved under. The gesture strikes us as artificial and affected, and this character is enhanced by the fact that the bright hand, with its twisted outlines, stands out on the dark background of the other figure's garment. The intrinsic nobility and preciosity of the hand is perhaps also enhanced by its juxtaposition to the donkey's tail. Nowhere, it seems, has Giotto so isolated a noble speaking gesture and treated it as a self-contained motif. Both nobility and configuration make it feasible that the young man is indeed blessing – that is, that he is in some way establishing the connection between the event and its liturgical

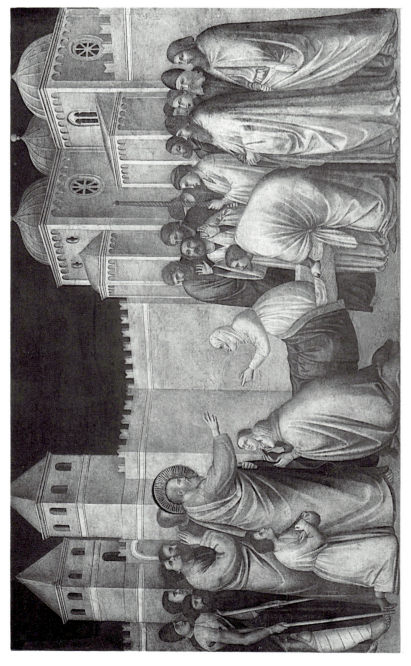

15 Giotto, *The Resuscitation of Drusiana by St John the Evangelist*, Florence, Santa Croce, Peruzzi Chapel

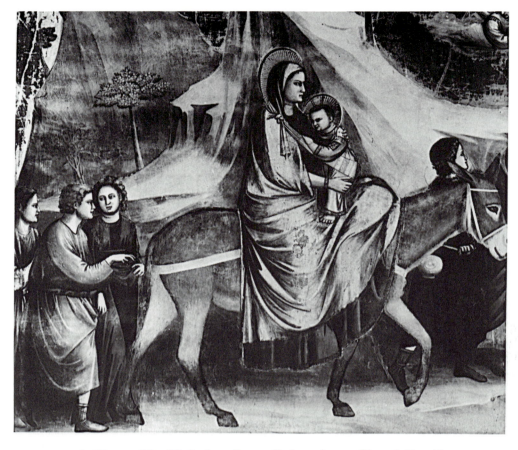

16 Giotto, *The Flight into Egypt*, Padua, Arena Chapel (detail)

consequences. But if Giotto had some connotations of blessing in mind, he left the gesture deliberately ambiguous.

In Giotto's work the *benedictio latina* never appears in its original, ritual form – the hand seen in frontal view, the palm turned towards the beholder, the thumb touching the ring finger. Only once do we encounter the full blessing gesture, and it is seen in profile. On the ceiling of the Arena Chapel Christ, bust-length within a medallion, raises his profiled hand in the benedictory gesture. This image follows the pattern of the tradition known from such famous examples as the monumental 'Pantocrator' mosaics in Palermo and Cefalu. Yet Giotto's part in the ceiling decorations is problematic, and it is difficult to infer anything from them concerning the work done mostly by his hand or the images available in his workshop.

In the frescoes of the Upper Church of St Francis in Assisi some of the

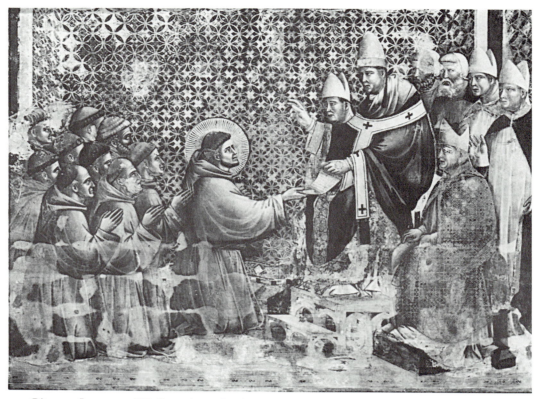

17 Giotto, *Innocent III Sanctions the Rules of the Order*, Assisi, Church of St Francis, Upper Church

'announcing hands' are so close to the *benedictio latina* that one occasionally wonders what one is actually looking at, speaking or blessing. Consider *Innocent III Sanctions the Rules of the Order* (fig. 17). The Pope holds in his left hand the scroll that he is presenting to the kneeling St Francis, and he raises his right hand in what can be either a speaking or a blessing gesture. It is the typical posture of the announcing hand, but all the fingers are clearly seen, the thumb touching the ring finger. Is the Pope speaking to the saint, or is he blessing him? Both the details of the hand and the overall context of the theme seem to suggest the latter, yet one cannot tell with certainty. The very fact that we cannot be sure shows how closely the artist related a dynamic action (speaking) to a highly formalized ritual act (benediction). In other words, it shows how much the ritualized gesture was reinterpreted as a spontaneous human movement.

This can be seen even more clearly in *The Glory of St Francis* (fig. 18), also in the Upper Church in Assisi. St Francis is being carried to heaven on a cloud, spreading his hands in what must be understood – as we shall see in a later

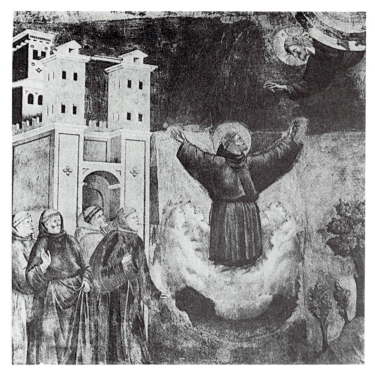

18 Giotto, *The Glory of St Francis*, Assisi, Church of St Francis, Upper Church

chapter – as an archaic prayer gesture. Christ, emerging from the sky, sends forth his blessing hand towards the ascending saint. But is he blessing St Francis in a ritual form, or is he welcoming the saint to heaven? The hand is represented in the profile typical of the announcing hand, the curved ring and little fingers are clearly seen, the thumb touches the ring finger – in other words, we see the *benedictio latina* form the unusual viewpoint of the announcing hand. One would like to know how the artist himself understood the gesture, as blessing or as speaking welcoming words. Or did the two meanings imperceptibly merge in his mind?

Many of Giotto's representations of speaking or benedictory gestures pose serious problems of interpretation. Besides raising such problems, however, they also offer an important testimony. Many of Giotto's speaking gestures, even if they ultimately originate in classical sources, were not directly developed from an encounter with works of Roman art. His immediate sources, one ventures to say, were liturgical experience itself and the many contemporary, or near-contemporary, representations of the blessing, or – more rarely – the speaking, Christ or saint. The affinity to classical conceptions of speech, so far as they exist in his work, derives from the artist's own surroundings, sensed and felt, rather than from ancient sources.

CHAPTER 2

AWE

A motif common in Giotto's work is comparatively easily described in its general structure: a figure always standing (with one exception to be discussed later), seen either in profile or in three-quarter view approaching close to profile, with hanging arms, the hands either crossed or folded, usually in front of the lower part of the stomach.

Several characteristics are common to all the figures rendered in this position. The gesture is never performed by the figure whom the spectator would consider the most sacred, the most worthy or the most dignified of the scene. The central figure of a scene is here cast in this posture (again one apparent exception will immediately be discussed). The figure clasping its hands is usually placed at the margins of the composition, it never occupies the middle.

When comparing the different figures in Giotto's work presenting this attitude one notices that although the general configuration remains stable, the 'gesture' in the narrow sense of this term – the specific position of the hands, the precise action they seem to perform – often varies widely. These variations allow for several readings of the same gesture, for it appears that Giotto, while taking over the general shape of this posture from tradition, revealed his originality and inventiveness in the variations and nuances of the hands. What does this gesture stand for? And what was it meant to convey?

In *The Lamentation over the Dead Christ* (fig. 19) in the Arena Chapel everything revolves around the Saviour lying on the ground. Huddling mourners forming a closed group surround the dead body. This inner group is enclosed by another concentric ring consisting mainly of figures vehemently mourning Christ; prominent among these figures of the second ring are St John, inclining towards the dead Christ and violently throwing back his arms in a classical lamentation gesture, the Virgin raising her hands to her cheek in a climactic wailing gesture, and the woman next to her, angularly lifting up her hands in a loud crying. Even the angels hovering

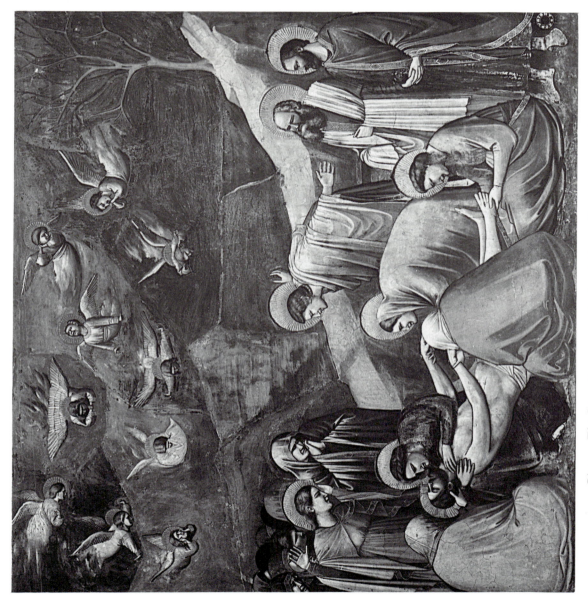

19 Giotto, *The Lamentation over the Dead Christ*, Padua, Arena Chapel

in the sky mourn, tearing at their hair and cheeks, as they converge towards
Christ.[1] Only two figures at the extreme right, haloes surrounding their heads, are
set apart both from the agonized mourning and from the concentric movement
pervading the whole composition; neither physically nor, it seems, emotionally, do
they participate in the general lamentation. They stand upright, and while their
faces express a certain sadness, they seem restrained in expression as well as in
gesticulation. The figure to the left, one of his hands veiled, raises the other to his
chest (or heart?). The other figure, looking at the scene with a quietly melancholic
face, lets his arms drop, folding the hands and intertwining the fingers. This
voluntary self-immobilization which so clearly sets the two figures apart from the
others, who are actively engaged in the event, turns them into representatives of
another world. They are contemplating from the outside an event which fills them
with awe, and before which they feel their humility. Is the gesture of the clasped
hands, hanging down without any activity of their own, a formula for expressing the
witnesses' meekness?

Let us look at another example. In *The Virgin's Wedding Feast* (fig. 20), also in
Padua, the wedding procession is organized in several groups; in the centre is the
Virgin, holding the edge of her mantle in a gesture which, in general configuration,
resembles the gesture we are here discussing. Behind her are the maidens of honour.
Their typical gesture, shown particularly clearly by the maiden in black directly
behind the Virgin, is an almost precise replica of the gesture of the marginal figure
in the *Lamentation*. Seen in profile, the maiden lets her arms hang down in front of
her body, one hand clasping the other. Again the gesture is not performed by the
central figure, but by one of a lower rank, and again it seems an expression of
humility before a sacred, mysterious event.

Let us look at one additional example, which indicates the internal span of this
gesture in Giotto's work. In *Joachim Retires to the Shepherds* (fig. 21) the figure most
endowed with dignity, Joachim, is placed on the left margin of the picture. He is
bowing his head meekly and folding his hands on his stomach. Here we find some
deviations from the regular scheme. His arms are not held as low as those of the
figures in the *Lamentation* and the *Wedding Feast*; one hand is covered by his rich
mantle, and the other grasps it over the cloth. The overall position, however, is close
enough to the other examples to subsume Joachim under the same group. In
meaning, too, the gesture fits the general context. Though Joachim is a figure of
great religious dignity, he is here represented at the moment of his deepest humilia-
tion. From the earliest Apocrypha to texts as close to Giotto's time and world as
the *Golden Legend*, Joachim's withdrawal to the shepherds is interpreted as combin-

[1] Burckhardt, 1869, p. 764 has stressed the expressive character of the composition: Christ is 'umhüllt' by
the other figures. For the wailing motifs see Barasch, 1976, pp. 57ff.

20 Giotto, *The Virgin's Wedding Feast*, Padua, Arena Chapel (detail)

ing two elements: the humiliation suffered in the Temple, and the expectation – in fear, hope, and belief – of a divine revelation.[2] Giotto's gesture fits this reading.

Another interesting example is the girl facing Christ in *The Wedding at Cana* (fig. 12). In this fresco different stages of the story, as told by John, chapter 2, are represented. The Virgin, raising her hand in a speaking gesture, seems to say: 'Whatsoever he saith unto you, do it' (John 2:5). The girl facing Christ may be a representative of the servants to whom Christ says: 'Fill the waterpots with water' (John 2:7); to the right is the chief steward who tastes the wine (John 2:9). Giotto

[2] In the earlier stages the humiliation is more strongly emphasized. *The Book of James or Protoevangelium* (see James, 1926, p. 39) stresses that 'Ioachim was sore grieved and showed not himself to his wife'. *The Golden Legend*, 1969, p. 522, though also stressing the insult suffered by Joachim ('At this Joachim was ashamed to return to his home, lest he have to bear the contempt of his kindred'), devotes more attention to the angel's announcement; the latter takes up the question of humiliation when he says to Joachim: 'I have seen thy shame, and heard the reproach of barrenness wrongfully cast upon thee. For God indeed punishes not nature, but sin.' This formulation is an interesting testimony to the new spirit of (partly) secular explanation of what was conceived as a punishment by God.

21 Giotto, *Joachim Retires to the Shepherds*, Padua, Arena Chapel (detail)

obviously strove at precision in his rendering of the story; note that he painted six large waterpots, the exact number that John (2:6) gives. In the report given in the Gospel of John, Christ addresses only one secular figure, the waiter. The girl, then, is the figure expecting the word of the holy man who is going to perform the miracle. We see her in pure profile, her arms folded on her stomach, one hand grasping the elbow of the other arm, as if to emphasize her voluntary and complete passivity. As compared with the other versions of our gesture, the arms are held higher, but this detail cannot change the basic structure and meaning of the gesture. All the essential elements of the gesture – a figure of lesser dignity, the standing posture, profile

view, self-immobilization – are here present, and therefore one can accept this gesture as another version of the humility posture.

Giotto's use of this gesture – as of many others – is so consistent that one is always tempted to read it as part of a conventional vocabulary. One wants to know, therefore, whether this particular gesture, in one version or another, was common in the art of Giotto's time. Was it in any other domain of life? Where did Giotto find it?

Turning with these questions in mind to the thirteenth- and fourteenth-century painting, we are faced with a surprise: our specific gesture does not seem to have been popular among the artists of the time. True, as long as we do not have a full census of gestures in the art of the period we can only rely on impressions, yet what we remember tells us that the gesture is lacking. In the works of such representative and formative masters as Cimabue and Duccio, we shall look for it in vain; even configurations vaguely suggestive of this posture do not occur in this work.

A comparison of depictions of scenes by Giotto containing this gesture, and by earlier artists, is instructive. We shall look only at the Lamentation, a theme of major religious significance and traditional form. In earlier representations of the Lamentation (Weitzmann, 1961) no group of figures is detached from the main event. All the figures concentrate around Christ, they bow down, they are included among the active mourners, and they seek physical contact with Christ's dead body. One particularly remembers the expressive, almost grotesquely bent backs of such figures in Byzantine *threnos* representations.[3] It has been suggested that Giotto, in his *Lamentation*, was following the model established by Coppo di Marcovaldo in his Pisan Cross. (For a different hypothesis, see Rosenthal, 1924, p. 197.) If this is indeed so, Giotto's deviation from the established model becomes strikingly manifest. While Coppo di Marcovaldo did indeed presage many features in Giotto's composition, he has no spectators, and no indication of our gesture. In certain late Byzantine depictions we can perhaps observe the emergence and formation of the marginal group. In a panel in Perugia (Venturi, 1901–40, v, fig. 85; Millet, 1916, fig. 554), two saints, placed at the side of the picture, look at the scene without taking part in it. Yet they do not perform any movement that would even vaguely remind us of the gesture discussed here. What, then, could have been Giotto's source of inspiration?

The metaphor of 'bound hands' made a profound impact on political and religious imagination; it was sometimes physically re-enacted in ritual and court

[3] See Weitzmann, 1961. For an example of such a bent figure, see the *Threnos* scene, in a Gospel Lectionary of the eleventh- or twelfth-century (Rome, Biblioteca Vaticana, MS gr. 1156, fol. 194v (Weitzmann, 1961, fig. 16)). Another typical example is a fourteenth-century icon, also in the Vatican, in which the movement of the bending figure is even more drastic. Cf. Millet, 1916, fig. 543.

ceremonies. It is a powerful formula of submission: of man to God, and of the
subject to the ruler. The details and specific gestures expressing awe before the
divine or the ruler often vary. They were apparently considered less important or
binding than the general configuration of the body, the act of symbolic self-
immobilization which makes one defenceless and thus at the mercy of higher powers.
This configuration is always preserved. Although this general image is not in detail
the immediate source of Giotto's figures it is worth looking at the tradition of those
configurations that have a broad resemblance to Giotto's images. This is the
background against which we should see Giotto's originality.

The stance we are discussing here was not unknown in classical art, but it never
became one of those 'Pathosformeln' which so deeply impressed themselves on
European imagery. It is sometimes vaguely suggested in Greek *stelae*, when the
figure of an older man – in a precarious, unstable attitude – inclines his head and
folds his limply hanging hands (see below, pp. 92ff.). This figure, completely
absorbed in himself, conveys a quiet melancholy and a contemplative mood. In a
fully articulate form we find the motif in a Hellenistic statue of Demosthenes, a
work that enjoyed great popularity in the ancient world and was frequently copied.
As far as we can judge, the posture of the *Demosthenes* (fig. 22)[4] was not conceived
as a mood formula, and it did not have a firmly established unchanging emotional
connotation. The inclined head may suggest introspection, but the posture as a
whole strikes us as representing the orator's energetic concentration and his will-
power.

The posture is also found in early Christian art, though – as in the art of pagan
antiquity – it is very rare. In the Christian context, however, its emotional connota-
tion differs from the one it conveyed in Hellenistic culture. In a work as important
as the Sarcophagus of Junius Bassus, St Peter, represented during his trial, is cast
in precisely the same position (fig. 23). Does the posture, especially the folded
hands, indicate that he is bound? St Paul, represented on the side corresponding to
that of St Peter, has his hands behind his back, quite clearly bound (Grabar, 1968,
fig. 70). As the two panels are symmetrically related to each other, one infers that
St Peter, too, is bound, even though no cord is visible. But whatever the narrative
meaning of St Peter's posture it conveys to the beholder the apostle's submission
to his fate and his devotion to his belief.

In the visual arts of the early Middle Ages the posture of immobilization,

[4] In antiquity the statue was often copied (see above, n. 3 to chapter 1). The same posture also appears in
the famous Sarcophagus of the Mourning Women in the Museum of Istanbul, the third figure from the
left on the central panel (see Bieber, 1961, p. 22). Somewhat different are the postures of the *matronae* on
a relief in Turin (Reinach, 1912, III, p. 424, fig. 4); the figures fold their hands, though the arms are not
fully extended downwards; the stance of the standing women is obviously expressive of dignity and expecta-
tion.

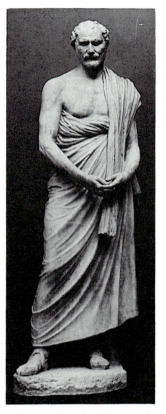

22 *Demosthenes*, Ny Carlsberg, Copenhagen

particularly with lowered or folded hands, did not become popular. Even in scenes where the gesture of humility and awe seems to be called for, this posture does not appear. Instructive examples can be found in representations of a king sitting on his throne surrounded by courtiers. Such representations are frequent in medieval art. It is therefore interesting to observe how the figures, all lower in rank than the seated king, behave in the presence of their ruler. To be sure, they are all standing, only the king being seated. Yet the gestures they perform are altogether different from those we have seen in Giotto. They often hail the king in the classical formulae of acclamation, they present offerings (real or allegorical), or they raise their hands in prayer and supplication. None of these figures, so far as I have been able to see, lowers his hands and folds them, or crosses them on his stomach; none makes the introvert, contemplative gesture which Giotto so forcefully presents.[5] This is also

[5] I will mention only the best-known examples. In the Vivian Bible (Paris, Bibl. Nat. Lat. 1, fol. 423v) frequently reproduced, the monks of the Abbey of St Martin at Tours present the Bible to Charles the

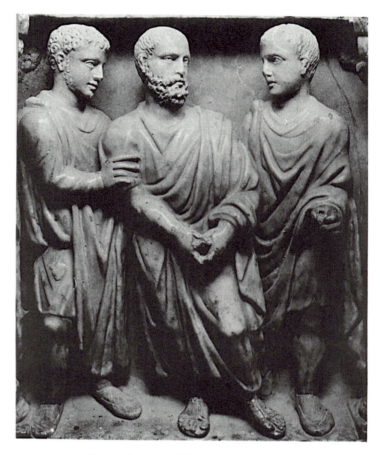

23 Sarcophagus of Junius Bassus (detail)

true for religious scenes carrying rulership connotations, such as the representation of Christ as the ultimate ruler and judge. Even scenes which do not depict rulers but present figures of various degrees of hierarchical status, show the same posture. Take the famous Carolingian rendering of Moses expounding the Law to the Israelites in the so-called Moutier-Grandval Bible (British Museum, Add. MS 10546, fol. 5v). Many figures in the crowd attentively listening to their leader perform gestures of concentration and thought (directed gaze, finger to mouth, hand clasping chin), but none folds his hands. It seems that the gesture of the folded hands was largely forgotten in the early Middle Ages.

Bald, a subject that would be proper for the representation of our gesture. Another example, equally famous and representative, is the representation of the Ottonian king (Otto II or Otto III) as he is receiving the homage of the four parts of the Empire (Munich, Staatsbibliothek, col. 4453, fol. 24r).

However, from the twelfth century on (perhaps even somewhat earlier) the motif of the immobilized hands became popular in Western imagery, and also acquired the meaning we have attributed to it in Giotto's work. Formulated in a diversity of shapes, it attained wide diffusion, appearing in various types of works of art, as well as in many iconographic contexts. Let us briefly mention some of the formulations which belong to the background of Giotto's depiction of the posture. Best known is the new funerary imagery which emerged in that period. The *gisants* hold their hands in several, well-defined positions, prominent among them being postures of 'bound hands', such as the modern prayer gesture. However, one of the attitudes one finds among the *gisants* consists of the hands crossed either on the breast, or stretched out and crossed on the stomach.[6] The latter posture seems to have been particularly popular in Italy (though it was of course not restricted to any single country), and we can see it in quite a few examples (see below, pp. 93ff.). In these monuments the hands are sometimes not even crossed, but one hand is clasping the other. See, for instance, the tomb of an anonymous layman in Wolchingen near Mossbach, in southern Germany, done in the early thirteenth century (Bauch, 1976, fig. 86). Let us imagine this figure standing up, and we have a posture very close to that of Nicodemus and his Companion in Giotto's *Lamentation*.

So common was this funerary image that it was represented, probably as a matter of course, in allegorical scenes where the dead or those buried in their coffins appear. The story of the Three Living and the Three Dead is a central theme (Rötzler, 1961; Künstle, 1908; Tenenti, 1957). In France the three dead are, in fact, usually depicted in an upright position. In a late thirteenth-century illuminated manuscript, the three dead are already shown as standing, one of them crossing his hands on his chest (British Museum, Arundel MS 83, fol. 128r; Rötzler, fig. 2). A well-known fresco in Subiaco, to mention a different example, also shows variations of the posture of crossed hands, though here, according to Italian tradition, the dead are lying in their coffins (Vigo, 1901, pp. 53ff.; Van Marle, 1932, fig. 424; Rötzler, 1961, pp. 153ff.).

The postures we have discussed were known not only to artists; they were also performed, and codified, in actual life. As a set of established rules and models they have come down to us mainly from Germany, but they were probably diffused all over Europe. From the thorough and detailed studies, mainly by Karl von Amira (1909), of the illustrations of *Sachsenspiegel* manuscripts (a frequently copied and illustrated legal text of the thirteenth century) we know about the gesticulations of

[6] See Panofsky, 1964, pp. 56ff. An early example is the tomb slab of the Dominican General Munoz de Zamora (died 1300) in Santa Sabina in Rome (Panofsky, 1964, fig. 195); the well-known tomb of Bernard von Breydenbach (died 1497) in the Cathedral of Mainz (Panofsky, 1964, fig. 223); and the equally well-known tomb slab of Ulrich Kastenmayer (died 1432) in St James in Straubing (Panofsky, 1964, fig. 223).

court procedures. These articulate and well-defined postures and gestures were considered a binding social code, a code intelligible to everybody. Deference, we learn from these manuscripts, is manifested by crossing one's lowered hands, a gesture still performed in Eastern Christian ritual (Amira, 1909, p. 233, n. 5). Clasping one hand with the other, symbolically indicating fetters, was another form of conveying respect.[7] In *Sachsenspiegel* illuminations subjects stand thus in front of Constantine or Charlemagne, the vassal in front of the bishop, and the servant in front of his master. Amira, the most careful student of these gestures and their legal meaning, stresses that the figures performing them did not actually have to bend their joints or bow their heads to convey their awe; a conventional gesture was sufficient. In late medieval German expressions such as 'sine hende fur sich twingen (legen, nemen, haben)' meant 'to manifest veneration' (Amira, 1909, p. 233).

The explicit meaning of these gestures in legal procedures sheds some light on what they were meant to convey in funeral imagery. Crossing or folding one's hands over the lower part of the body are gestures of awe and veneration, and this is how the deceased is made to express his awe in the presence of his divine judge, or the living to show their respect for their superior.

In Italian art of the twelfth century one occasionally – though rarely – also finds this posture. In Benedetto Antelami's *Deposition* of A.D. 1178 in Parma, one of the figures standing beneath the cross lowers his arms, and clasps his left hand with his right, his head is inclined and he does not look at the crucified, or at any other focal point of the event (fig. 24). This figure stands among the mourners; his tense posture and sad facial expression make him a mourner rather than a contemplative witness. Yet his posture may be a link between medieval traditions and Giotto's artistic language.

It seems unlikely that Giotto derived his Nicodemus group from classical art. The few ancient pieces in which these gestures are rendered were not known in thirteenth- and fourteenth-century Florence or Padua. On the other hand, we can be certain that Giotto was familiar with some of the major medieval figurations. As already mentioned, tombs with *gisants* crossing their hands were common in Italy. Examples were available in Tuscany,[8] and if Giotto was indeed in Rome he would

[7] In Amira's view (1909, p. 232), this gesture, as an expression of respect, is already found in the ancient Near East. The monuments referred to (though indirectly) do, however, show a different formal configuration, though the feature of immobilizing oneself is present in them.

[8] See the tomb of Pope Clemens IV in Viterbo (see Bauch, 1976, fig. 229), whose gesture of hand has been interpreted – wrongly, I think – as lifting the chasuble (Bauch, 1976, p. 142). See also the tomb of Pope Adrian V, also in Viterbo (Bauch, 1976, fig. 234), executed shortly after 1276; the tomb of Cardinal Enrico Annibaldi in the Lateran in Rome (Bauch, 1976, fig. 235); the tomb of the French Cardinal Guillaume de Bray in Orvieto, done by Arnolfo (di Cambio?) between 1285 and 1293 (Bauch, 1976, fig. 238); the tomb of Pope Benedict XI (died 1304) in Perugia (see Bauch, 1976, fig. 239). In the fourteenth-century women are also rendered in this posture. See e.g. the tomb of Bianca of Savoy, supposedly done

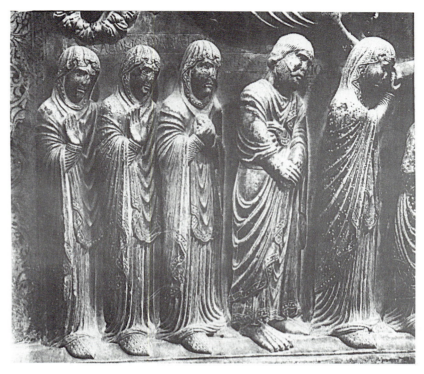

24 Benedetto Antelami, *Deposition*, Parma, Cathedral (detail)

have had occasion to see a mosaic slab for a Dominican general in Santa Sabina, where the dead man crosses his lowered hands, a work probably executed during the years Giotto was presumably there (Bauch, 1976, p. 142). He could also have been acquainted with the French novelty of making the three dead men stand up (one can perhaps imagine how such an innovation would have struck an artist of Giotto's nature). Several studies have shown a relationship of North Italian literature, thought, and art with the French culture of the period (Sapegno, 1967, I, pp. 33–44). I do not know how far legal procedures as practised in Germany were also known in Italy. Yet taking into account the great interest in legal studies that prevailed in central Italy (twelfth-century Bologna was already a centre of legal studies), it does not seem exaggerated to assume that even the *Sachsenspiegel* was known in some circles of late thirteenth-century Florence. Giotto could have known of customs in which, as an artist, he would have been profoundly interested. These are, of course, highly hypothetical suggestions, indicating only possibilities, but they should not be rejected without further study.

after 1387 (Bauch, 1976, fig. 245), and Jacopo della Quercia's freestanding tomb of Ilaria del Carretto in Lucca, done *c*. 1404 (Bauch, 1976, fig. 245).

25 Giotto, *God the Father Surrounded by Angels*, Padua, Arena Chapel

In exploring the connotations our gestures carry in Giotto's work, we are treading on more solid ground. In his paintings the gestures belonging to our types invariably convey the feeling of humility, awe, and the awareness of witnessing a sacred, mysterious event. In *God the Father Surrounded by Angels* (fig. 25) in the Scrovegni Chapel, Giotto followed a hieratic, strictly symmetrical model. Two angels, standing upright and seen in sharp three-quarter view, flank God the Father symmetrically; he is seated on his throne, which hovers in the middle above them. Into this venerable compositional type, known to us from countless medieval variations, Giotto introduces a new feature: he makes the angels fold their arms. The angel to our left bends his arms at a right angle, so that the forearms are placed horizontally on his stomach; the angel to our right folds his arms so that complete immobilization results. What these gestures are meant to convey is obvious: filled with awe in the presence of the divine, the angels wait for God's word. The angels do not have any narrative function, their gestures do not represent any action. Giotto here used a pure conceptual formula.

A similar, though perhaps less pure, sense is found in the gesture in a fresco in the Bardi Chapel. In *Innocent III Sanctions the Rules of the Order* in the Bardi Chapel, two profile figures with clasped hands stand in the aisle behind the large room where the Pope is receiving the saint. The two figures at the side of the fresco stand in a similar position, though the position of their hands is not exactly the same. Their posture also suggests the awe of people witnessing a unique event.

In the Upper Church of St Francis in Assisi the painter employed the same posture several times, and he did it in such a pure form that we are bound to recognize it as a formula. Again, the context clearly defines the meaning. In one fresco, *St Francis at the Christmas Crib at Greccio* (fig. 26), our motif reappears several times. St Francis – 'filled with pious love and shedding tears of joy' (*Life of St Francis*, chapter 1), as Bonaventura put it – is lifting the Chirst-child from the crib; around him are his followers, witnessing the event in awe. Two prominent figures, standing behind the saint and looking at the newly born Saviour in his arms, perform variations of our gesture. The friar to the left, clad in a black habit, clasps his right hand with his left; the man next to him, wearing an expensive, elaborate dress and cap, twines his fingers together. Both bow their heads slightly. Behind and above the saint another lay figure, deeply bowing his head, also seems to perform the same gesture. In another fresco, *The Clares Mourning St Francis in Front of the Church of St Damiano* (W 155; S 72), the artist who worked in the Upper Church also used the gesture. The nuns in the centre of the scene mourn passionately; and at the far left an erect figure (clearly resembling the man with the rich dress in the former fresco) quietly clasps his hands, expressing his awe at the scene he is witnessing.

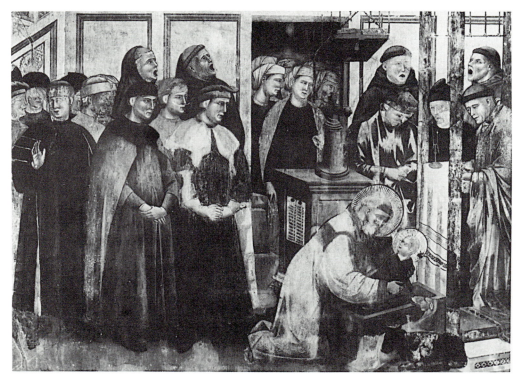

26 Giotto, *St Francis at the Christmas Crib at Greccio*, Assisi, Church of St Francis,
Upper Church

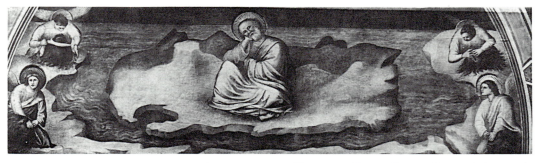

27 Giotto, *St John the Evangelist at Patmos*, Florence, Santa Croce, Peruzzi Chapel

An interesting variation of our motif appears in the Peruzzi Chapel in Santa
Croce. At two corners of the fresco depicting *St John the Evangelist at Patmos*
(fig. 27), Giotto represented two crouching angels (thus deviating from the regular
standing position of these personages) who clasp one hand with the other. What can
they be but holy witnesses, overawed by the Evangelist's vision?

28 Giotto, *The Dance of Salome*, Florence, Santa Croce, Peruzzi Chapel (detail)

In the same chapel Giotto used the gestural motif once more, presenting still another variation. In *The Dance of Salome* (fig. 28) a servant to the left of the central group folds her arms, while another servant clutches at her. Does her posture (an exact repetition of the posture of the angel to the right of God the Father) reveal how horror-stricken she is, or is it meant to convey her awe at seeing the severed head of the Baptist radiating with divine light? Or does her posture carry a social connotation, identifying her as a servant? Of course, in this servant figure we miss the quiet passivity characteristic of all the other figures that Giotto cast in this mould. Many gestures of horror were available to the artist, yet he did not use any of them. Nor can the social character of the gesture be the major meaning; the other figure gripping her is obviously also a servant, yet her attitude is altogether different. It seems, then, that the servant's posture, though tense in form, remains an expression of awe and veneration.

CHAPTER 3

PRAYER

Giotto was what we would call now a 'modernist', attentive to what was emerging in his time, and to original departures in his society. His 'modernity', his cutting himself off from closely following traditional lines and purposeful searching for new forms, is frequently stressed in matters of pictorial style. It is true, however, also in other fields, in themselves far removed from art. Nowhere, it seems to me, is this more clearly visible than in his representations of prayer gestures.

Giotto painted several praying figures. To indicate the action the figures perform, that is, praying, he always used the same gesture, the folded hands – a gesture which we today still associate with prayer. In *The Annunciation to St Anne* (fig. 3) in the Arena Chapel the angel appears in an opening of the wall, and the kneeling St Anne whom he is addressing raises her folded hands (roughly to about the level of her breast), palms placed inwards and fingers stretched out. It is true that one hardly sees the second hand, or the arm, behind the one exposed to the beholder, yet one will hardly go wrong in assuming that Giotto intended the beholder to see two folded hands. The very fact that St Anne is represented as praying is an addition of the visual tradition to the legend. The literary sources do not describe her prayer. What is repeatedly stressed is St Anne's lamenting her barrenness, and later mourning for Joachim, whom she fears dead.[1] One wonders what the praying gesture was meant to convey: her feeling of humility in the presence of the divine messenger? Or does it represent her entreaty that what the messenger promises may come true? No definitive answer can be given to these questions. There is, however, no doubt that Giotto intended to represent St Anne as praying.

In the fresco representing *The Sacrifice of Joachim* (fig. 4), next to the one just described, the gesture is again depicted. The old Joachim is falling to the ground,

[1] See the vivid description in the *Book of James, or Protoevangelium* I.3 (James, 1926, pp. 39–40) and the *Gospel of Pseudo-Matthew* II.3 (James, 1926, p. 73). In the *Golden Legend*, 1969, in the story of the birth of the Virgin, Anne is crying because she does not know where Joachim is.

while the angel in front of him performing the speaking gesture is addressing him. High above Joachim the hand of God emerges from the sky. God's hand is seen only by a shepherd at the lower left corner of the fresco. This shepherd, a marginal figure both in the narrative and in Giotto's composition, devoutly raises his head to the miraculous apparition in the sky, and also lifts his hands in an emotional attitude, clearly a gesture of prayer.

Codified prayer movements are found in every human society; they are among the most universal gestures we know (Ohm, 1948; Heiler, 1923, pp. 98ff.; Sittl, 1890, pp. 174–99). And yet folded hands are very rare among them. The two prayer gestures that dominated the European tradition, and which are found in many cultures outside Europe, are, first, the raising of the hands upwards, and, secondly, the spreading of the hands with open palms. Raising the hands seems to be the oldest, most universal prayer gesture; it is found in ancient cultures, and intuitively understood in modern times. Aristophanes describes the gesture as related to prayer.[2] And Paul, also as a matter of course, says: 'I will therefore that men pray everywhere, lifting up holy hands...' (1 Timothy 2:8). We cannot trace here the history of this movement. It is sufficient to mention that it was well known, as a prayer gesture, in Giotto's time and school. In *The Stigmatization of St Francis* (fig. 29), a work from this school by Guido da Siena (Meiss, 1951, pp. 115ff.), the saint lifts his hands dramatically; they are held parallel and do not meet. In the fresco *St Francis Delivering the Heretic from Prison* (W 158) in the Upper Church of St Francis in Assisi, to mention one additional example, the saint raises his hands in fervent supplication.[3] The hands, parallel, almost touch, but they are not folded. It is important for us to stress that Giotto, or his closest circle, was aware of the raised hands as a prayer gesture.

The other gesture, the spreading of the hands with open palms turned towards the beholder, is also known from ancient periods. 'And when ye spread forth your hands, I will hide mine eyes from you: when ye make many prayers, I will not hear...' These words of Isaiah (1:15) were often quoted, also in the Middle Ages. Like many other descriptive phrases, they made the spreading of the hands a time-honoured gesture of prayer. In early Christianity it was known from the *orans* figures, a favourite subject of Christian art that quickly developed the type. The Christian *orans*, as everybody knows, was developed from the pagan allegory of piety (*pietas*).[4] It soon became an image of the deceased, to indicate his or her piety.

[2] Aristophanes, *Birds*, 622–3:
　　With a present of barley and wheat
　　And piously lifting our heart and our hand
　　The birds for a boon we'll entreat.

[3] For raised hands as a prayer gesture in Graeco-Roman antiquity, see Sittl, 1890, pp. 187ff.

[4] The Christian *orans* has been discussed so frequently that no further comments are called for. See now

29 Guido da Siena (?), *The Stigmatization of St Francis*, Assisi, Church of St Francis, Lower Church

After the period usually called Early Christian the gesture remained an attitude of prayer. Medieval prayer gestures have not been systematically studied, and therefore we cannot be sure what the diffusion of each movement was. But it has been noticed that even in secular literature before the thirteenth century, such as the *Chansons*

Klauser, 1959–60, II, pp. 115ff.; III, pp. 112–33. For pagan models see Bieber, 1977, figs. 807ff. Among the older studies on the Christian figure, cf. Michel, 1902, and Weisbach, 1948, pp. 11ff. Interesting also is Ohm, 1948, pp. 258ff.

de geste, the prayer gesture usually consisted of an extending of the arms, only very rarely of a joining of hands (Ladner, 1961, pp. 260–1; Altona, 1883).

After the twelfth century, the folding of the hands, a new prayer gesture, rapidly spread in Christian liturgies. It was destined to replace all other forms and to become the prayer gesture *par excellence*. From the not over-abundant discussions of this gesture, particularly from the excellent article by Gerhart Ladner, we are certain of its origin. All students agree, though with some variations, that the new prayer gesture, the folding of the hands, derives from a medieval procedure whereby the vassal surrenders in a highly conventionalized manner to his feudal lord,[5] though other codified procedures, such as the consecration of bishops, may also have influenced the new prayer gesture (Ladner, 1961, pp. 261ff.).

Yet the origin of this gesture – as that of so many movements and postures – is found in antiquity. Captives, submitting to their conqueror, would stretch out their hands to be bound. Originally only barbarians were represented in this shameful posture,[6] yet the attitude soon entered the imagery of free, even noble, Greeks and Romans. Heliodorus, a Greek writer of the third century A.D., tells (*Aethiopica* IX.27) how a Greek ruler, Oroondates, manifests his reverence for the victorious Persian king. Oroondates 'stretches out his hands, places his right on top of his left, bows, and shows to the king his awe'. For Heliodorus and his readers the gesture obviously carried a clear meaning. Oroondates is not acting under the pressure of powerful emotions; he is merely using a convention that everybody understands.

Byzantine etiquette seems to have been unaware of this gesture. Folded hands, however, reached Western Europe, and are attested as early as the ninth century. Among the earliest medieval representations is probably the sarcophagus of Hincmar, Archbishop of Reims, who died in 882. The sarcophagus is lost, but we know it from what seems to be a careful drawing in Montfaucon's *Monuments de la monarchie française*, 1729–33 (fig. 30). At the left of the sarcophagus' central panel the Archbishop is depicted folding his hands in what is obviously prayer. Montfaucon interpreted the gesture as homage to the king who sits in the centre of the

5 See Amira, 1902, pl. 15. In the Heidelberg manuscript of the *Sachsenspiegel* (1976) there are different representations: standing (fig. 11), outside the church (fig. 13), or kneeling (fig. 129). One should remember that surrender, especially when highly formalized, traditionally implies an appeal to the victor's clemency. In that gesture we have a case of ambiguity which is typical of a wide range of expressive gestures firmly established in rigid conventions.

6 Sittl, 1890, pp. 149ff., n. 6, mentions examples as early as Assyrian reliefs. As the chief context, and therefore also the principal meaning of the joined hands, raised towards the victor – as if ready to be bound – is military, one is not surprised that the gesture is particularly frequent in Roman art, where it becomes one of the standard gestures of admitting the victor's superiority, and perhaps also of appealing to his magnanimity. See Brilliant, 1963, pp. 189ff. (the chapter on 'Submission'). How close this military gesture is to the gesture of prayer is indicated by Gombrich, 1965, p. 396, in an illuminating example: the figure of a barbarian throwing up his arms (in Paris, Bibliothèque Nationale) has been read as praying by Ohm, 1948, pp. 255, 340, and as surrendering by Brilliant, 1963, fig. 2.62, and pp. 74ff.

30 Drawing after lost sarcophagus. From Montfaucon, *Monuments de la monarchie française*

panel. Panofsky, in 1964 (p. 48), suggested that the Archbishop may be praying for Christ's intercession (see also Kingsley Porter, 1927; Hamann-McLean, 1951). Whatever the precise meaning, the gesture remained rare, its representation an exception. This changed in the heyday of feudalism. Folding one's hands became prescribed in the feudal ritual of Commendation, part of a feudal homage, which reached its climax with the vassal's putting his joined hands in those of his lord. It was a sign of surrender connoting dependence, but also trust and fidelity. Surrender, especially when highly formalized, traditionally implies an appeal to the victor's clemency. In that gesture we have a case of ambiguity which is typical of a wide range of expressive gestures firmly established in rigid conventions.

Illuminated legal manuscripts depict this gesture as a matter of course, as part of the feudal ceremony of Commendation. In a fourteenth-century manuscript of the *Sachsenspiegel* we see the liegeman kneeling, raising his folded hands; the crowned lord, placed on an elaborate seat in front of him, takes the liegeman's folded hands between his own (fig. 31). But sometimes the vassal is shown 'kneeling with joined hands before his overlord, at the moment immediately preceding Commendation itself, in the act of offering rather than performing homage to the lord' (Ladner, 1961, pp. 258ff.). In that case the vassal raises his folded hands without the lord taking them into his own. Such representations of the feudal court ceremony are particularly akin to the iconography of prayer.

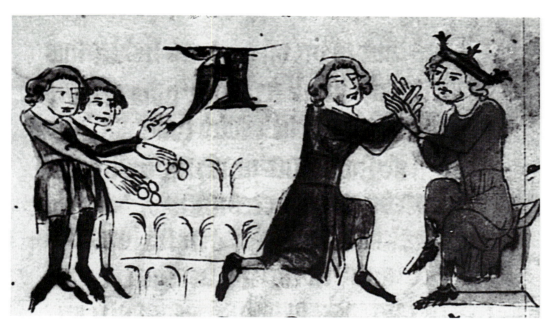

31 Dresden, *Sachsenspiegel* MS, fol. 8

In medieval representations of religious subject matter we occasionally find the new prayer gesture. We shall adduce an example from only one period and region, two striking reliefs from Chichester Cathedral, produced in the twelfth century (Saxl, 1954, pp. 32ff., pls. XVIII, XIX). We know little of how these gestures came to Chichester, but here they appear in powerful form. The artist who carved the two reliefs was profoundly aware of the expressive power of gestures, and he was obviously familiar with many classical motifs of gesticulation.[7] In one relief, representing *Christ and the Apostles Visiting the Sisters of Lazarus* (fig. 32), Mary and Martha, the two sisters, implore Christ to bring their brother back to life; they do so by folding their hands. Their gestures are of particular intensity. The two women raise their folded hands high above their heads, thereby creating an overall pattern which differs from what we are in the habit of associating with prayer. Though the two sisters perform the 'new' prayer gesture (folding their hands), their gestures preserve an essential feature of the older prayer gesture, the urgent raising of outstretched arms. But what does 'prayer' mean here? In a precise sense, the sisters do not pray in the Chichester relief. They do not perform any premeditated liturgical

[7] See, for instance, the classical lamentation gesture of tearing the cheek, performed by two women in the upper left-hand corner (Saxl, 1954, figs. XIX, XXIV). For tearing the cheek in classical art, see Barasch, 1976, pp. 10ff., 64ff. The masklike character of the two female faces has a definite classical quality.

32 Chichester Cathedral, *Christ and the Apostles Visiting the Sisters of Lazarus*, relief

function, ruled by an established convention. What they do is to implore Christ, and they do it spontaneously, in a manner which has little to do with formalized worship. In this Chichester relief, then, the new prayer gesture is an expressive gesture rather than the portrayal of a liturgical performance.

In the other relief, *The Raising of Lazarus* (Saxl, pl. XIX) the artist used the motif once more: the resuscitated Lazarus folds his raised hands before the blessing (or speaking) Christ. In expressive quality Lazarus' gesture strikes us as less intensive than his sisters' postures; his hands are raised only to about eye level, while they raise theirs high above their heads. Lazarus, too, cannot be considered as performing a liturgical prayer; he seems to express his thankfulness and admiration for the Lord, but again in a free, unconventional manner.

Medieval art prior to the thirteenth century does not abound in examples of folded hands. But a careful analysis of them shows what we can learn from the

Chichester reliefs: the gesture was known, its formal shape more or less established, but its precise function was not sharply defined. It strikes us as an expressive gesture, connoting a rather broad range of emotions.

The gesture penetrated ecclesiastical ritual, and it became the predominant prayer gesture. The process of penetration extended over several centuries but the thirteenth was surely the climax of the process. In this century, the one immediately preceding Giotto, the 'new praying gesture' vigorously displaced the older ones, though both raising the hands and spreading them still remained for a long time acknowledged postures of prayer.

How this gesture, which developed outside the church in what we are accustomed to call the 'secular sphere', penetrated into liturgy, is not easily explained. Liturgy is a domain known for sticking to traditional patterns, and for its reluctance to accept change. The rather rapid modification of prayer gestures in the period to which Giotto also belongs demands explanation. Gerhart Ladner, in the study already mentioned, suggests that the influence of the Franciscan movement was perhaps the major motivating force that brought about the change. Early Franciscan sources, such as the *Vita of St Francis* by Thomas Celano, do indeed suggest, though not unequivocally, the prayer with folded hands.[8] One origin of the folding of hands as a ritual gesture may be in the new significance granted to the raising of the host during Mass. The elevation of the host is informed by the desire to make visible the symbolic body of Christ. In addition to visualization, however, the act also carries elements of sacrificial offering, and in this respect it is close to the essence of the Mass as such (Browe, 1933, pp. 39ff.; Ladner, 1961, pp. 269ff.). The eucharistic devotion of the early Franciscan movement is attested; it needs no further discussion here. Now, the elevation of the host was performed with joined hands, *iunctis manibus* (Kennedy, 1940, p. 212); only the thumbs and index fingers were engaged in holding the host. If the elevation of the host is indeed a source for our gesture, it would seem that the folding of the hands carried some sacrificial connotations.

About the same time that the folded hands became popular as a prayer gesture, the gesture emerged also in another field, that of sepulchral sculpture (Bauch, 1976; Panofsky, 1964, pp. 48ff.). After the fourteenth century, *gisants* with folded hands, lost in eternal prayer, are household images in Europe, especially in the northern

8 '...[the saint] often spoke thus to his familiar friends: "When a servant of God at prayer is visited by the Lord with some new consolation, he ought, before coming forth from prayer, to raise his eyes to heaven and, with joined hands (*iunctis manibus*), to say to the Lord: 'This consolation and sweetness, O Lord, you have sent to me a sinner and unworthy, and I remit it to you, so that you may reserve it for me, because I am a robber of your treasure.'"' See Thomas of Celano, *Vita St Francis*, II.2, cap. 75.99 (*Annalecta Franciscana* 10 [Quaracchi 1926–41], p. 189). I quote the translation by Ladner, 1961, p. 270.

33 Brunswick Cathedral, Tomb of Matilda, Wife of Henry the Lion

countries. The gesture must have reached northern Europe in the 1230s. There seems to be no study of how this gesture spread, and we do not know what made funerary art so receptive to this motif. In any case, the reclining statues of the dead begin to be carved in this posture. Among the earliest examples is the tomb of Matilda, the wife of Henry the Lion, in the Cathedral of Brunswick (fig. 33) (Panofsky, 1924, pp. 60, 109–10). It is a statue produced *c.* 1240, derived from well-known French models, and opening a great tradition of *gisants* folding their hands on their tombs.

After this brief glance at a broad horizon, let us turn back to Giotto. Two questions immediately present themselves. First, we must ask what the folded hands

are meant to convey. Is this simply a descriptive gesture, intended to communicate to the spectator the fact that the figure cast in this stance is praying? Or is it an expressive gesture, trying to make visible various emotions, such as wonder, joy, entreaty, as well as different emotional intensities? If our gesture is only a descriptive one, a certain emotional restraint would seem to be characteristic of the folding of the hands. If we accept the second interpretation, however – if the gesture is meant as an expression of emotions – different emotional intensities should be revealed, and folded hands should also be capable of expressing great drama. Obviously, no watertight separation of the interpretations is possible, and every folding of the hands can be both descriptive and expressive. A careful observation of Giotto's frescoes will help us to better understand his use of the gesture, as well as his attitude to the language of gestures in general.

In *The Ascension of Christ* (fig. 34), in the Arena Chapel, Giotto juxtaposed old and new prayer gestures. Most conspicuous in the lower layer of the composition is the Virgin. She kneels close to the centre of the fresco, looks at her ascending son, and piously folds her hands in the new prayer gesture. (It should be noted that here, too, almost nothing is seen of the second hand, hidden behind the one that we see.) The Virgin's devout glance (raising the pupil so that a little of the white of the eye is perceived below it) and her half-open mouth – these features indicate a state of emotional agitation. Is the folding of the hands another result of that state? One notices that, though all the figures in the lower row are kneeling (with the exception of the two pointing angels, who stand upright), only the Virgin folds her hands. Is this prayer gesture, then, a sign of distinction, reserved only for the most distinguished of the kneeling figures? Or is it an indication of the emotional intensity which only the Virgin experiences? As is well-known, in Giotto's period the emotional experiences and character of the Virgin were emphasized in countless ways.[9]

The Ascension of Christ provides a rare occasion for the study of gesture in Giotto's art. In this fresco one can see both the juxtaposition of the old and the new prayer gestures, and the transformation of the old into the new. The Virgin in the lower part of the fresco performs the new prayer gesture, folding her hands; the angels and saints in the upper part, flanking Christ from both sides in two rows, exhibit several variations of the old prayer gesture, extending their raised arms and lifting

[9] The Virgin's emotional character is manifest also in the accounts of Christ's Ascension. For our purpose it will be sufficient to refer only to the *Meditations on the Life of Christ* by pseudo-Bonaventura. In the story of the Ascension (in the translation by Ragusa and Green, 1961) we read: 'What shall I say of the mother...who above everyone else loved Him so intensely? Do you not believe that at the idea of the departure of her Son, touched and moved sweetly by maternal love...' (p. 376). Later in the same chapter (pp. 379–80) it is said that 'the Lady humbly begged the angels to recommend her to her Son'. There are many similar expressions of emotions when the authors speak of the Virgin.

34 Giotto, *The Ascension of Christ*, Padua, Arena Chapel (detail)

up their open hands. The saints on both sides of Christ, bearded figures with long hair, stretch forth their hands. The hands are not folded, open space separates one hand from the other. The modern spectator intuitively reads these gestures as imploring and beseeching, though they may partly derive from ancient acclamations.[10] Most of the angels, next to, and interspersed with, the saints, fold their hands. The spectator perceives their postures as less emotional than those of the saints. Yet the division between angels and saints cannot be carried through consistently. One of the saints (left of upper row, third figure from left) also folds his hands. One of the angels (lower row left, second figure from right) has his hands almost meeting. The first angel in the right group (lower row, first to left) also raises his arms and hands in the old prayer gesture. It may well be that these intermediate gestures reflect stages in the emergence of the new prayer gesture.

The general character of the gestures in the upper and lower realm of *The Ascension of Christ* is different. In the upper, celestial realm the old prayer gesture, the outstretched arms and hands, dominates all movements, in the lower, terrestrial realm the new prayer gesture, the folding of hands, is most conspicuous. Here not a single figure raises his hands above his shoulders. The folding of hands, although occasionally performed also in heaven, seems a gesture clearly appropriate to the terrestrial sphere. Giotto, then, perceived of the time-honoured, archaic prayer gesture as befitting beings in paradise, the new prayer gesture as suited to human mortals. We cannot test this idea, but *The Ascension of Christ* in Padua suggests it.

Another way of juxtaposing the new with the old prayer gesture is to transform one of them – as a rule, one of the older gestures – from a conventionalized into an apparently natural movement. The submerging of former conventions in 'spontaneous' gestures occurs several times in Giotto's *œuvre*.

In the *Resuscitation of Drusiana* in the Peruzzi Chapel, Santa Croce (fig. 15), a figure behind St Paul raises his folded hands in the new prayer gesture as he witnesses the miracle that the apostle is performing. No literary source, we remember, suggests that anybody among the poeple present at the miracle was praying.[11] The depiction of the praying figure, then, is a comment that Giotto is making on the story. But what is this comment? The new prayer gesture in the *Resuscitation of Drusiana* is an expression of emotional turmoil, it is a spontaneous movement. Prayer is here conceived as the result of the welling-up of emotion, rather than as

10 That the Ascension of Christ is derived from, and often retains the character, of imperial acclamations is well known. See e.g. Gutberlet, 1934, p. 55, and Schrade, 1930, pp. 66ff., esp. pp. 113ff.
11 The *Golden Legend*, 1969, pp. 66ff., has many details about the miracle-working apostle being implored to help. Sentences such as 'Then the mother and the widow of the young man, and all his friends, threw themselves at the apostle's feet, and besought him to raise the dead man' are typical of the style of the narration. Yet no ritual prayer is ever mentioned in this connection.

a ritual action. It is interesting to notice that Giotto also infused one of the old prayer gestures with immediate life, so that it too looks like a spontaneous gesture. A bearded man behind Drusiana is raising his hands, palms open and turned towards the beholder. It is the traditional gesture of the *orans*, transformed into a vivid, direct expression of amazement and wonder. He used the same gesture, with the same meaning, in *The Ascension of St John the Evangelist* in Santa Croce. A figure in the agitated group behind the apostle performs the *orans* gesture, and the expressive tension characteristic of this figure immediately distinguishes him from the traditional early Christian figures in this pose.

Juxtaposition of old and new prayer gestures abounds in the frescoes of the church of St Francis in Assisi. The variations of these juxtapositions and fusions of the different gestures reveal both a master's hand and an intimate familiarity with the ritual gestures of many periods. Let us look at *The Resuscitation of the Boy Fallen from the Window* (fig. 35) in the Upper Church. Most of the figures in the fresco stand, or kneel, in prayer, and the prayer gesture they perform is the new one: they fold their hands, and hold them in front of their chests, only mildly raised. But some figures in this fresco raise their folded hands to a greater height, and thus endow their gestures with an intensity that the other figures lack. Two figures (a woman in the centre, last row, another woman at the left end of the central group, second row) raise their folded hands above their own eyes. These movements are not only emotionally tense, but here the gesture acquires an altogether new character: it is the old prayer gesture of lifting up the hands.

In the *Crucifixion* (fig. 36) in the Lower Church of St Francis in Assisi, gestures of two periods are also placed next to each other. The monk kneeling on the right of the cross raises his separated hands in the old prayer gesture. As so often, the posture strikes us here as an emotional expression, and this is how Giotto may have understood it. And yet we cannot doubt that he knew the origin and traditional meaning of this movement of the hands. The woman to the extreme left, spreading her hands and turning the palms towards the beholder, is a revived *orans* figure. The intensive emotional life infused into her makes her movement appear spontaneous, yet she, too, cannot obscure her historical origin. Next to these figures performing the old prayer gestures we see a classic formulation of the new prayer gesture. Behind the monk lifting up his hands, a young standing figure, raising her eyes to the cross, slowly folds her hands. Both in formal clarity and in emotional restraint we see here a perfect representation of the new, ritual prayer.

Another example of the fusion of different prayer gestures can be seen in *The Miracle of the Spring* (fig. 37). In the Upper Church of St Francis in Assisi, St Francis here folds his hands in the gesture the Franciscans favoured in everyday ritual, but he also raises them to a great height, thereby adding an emotional urgency

35 *Resuscitation of the Boy Fallen from the Window*, Assisi, Church of St Francis,
Upper Church

36 *Crucifixion*, Assisi, Church of St Francis, Lower Church

which is normally lacking in the prayer gesture with which we are now so familiar. It would probably not have been easy to find a model for this combination of old and new in the painter's own days. Yet the painter was following the literary tradition. *The Little Flowers of Saint Francis*, the late thirteenth-century collection of stories, tells us that St Francis, when he perceived of the thirst of his companion, 'Alights from his donkey and begins to pray. So long did he kneel with hands raised towards heaven' until he knew that God heard his voice (pp. 172–3). We don't know how the author of the *Fioretti* imagined prayer, but we know that for the painter of Assisi prayer meant folding the hands.

The praying monks moving in a procession in *The Resuscitation of the Boy Fallen from the Window* (fig. 35) fold their hands. It seems that the artist deliberately refrained from infusing emotional life into their gestures. Where he wants to show agitation, in the group in the centre, the gestures become more tense and dramatic, but the praying monks are restrained. They perform a ritual, they do not have an experience. The same restrained 'expressionless' quality of praying gesture occurs again in two frescoes in the Magdalen Chapel in the Lower Church, *The Communion and Reception of Mary Magdalen* (W 177) and *The Assumption of the Kneeling Mary Magdalen* (W 179). In the first fresco the gesture occurs three times: the humble, kneeling Magdalen quietly folds her hands; the prominent figure to the left folds his

37 Giotto, *The Miracle of the Spring*, Assisi, Church of St Francis,
Upper Church (detail)

hands in prayer; and in the upper part of the fresco, the Magdalen, who is being
carried to heaven, again folds her hands. It is not easy to distinguish different
emotional characteristics in these depictions of the folded hands in one fresco. It is
certain that all three figures are restrained in feeling. They fold their hands in the
ritual act of prayer, yet without any visible emotional impulse to do so. In *The
Assumption of the Kneeling Mary Magdalen* the folded hands are again a timeless
posture, a situation devoid of emotional drives.

CHAPTER 4

CROSSING THE HANDS
ON THE CHEST

Another gesture, closely related to the one discussed in the preceding chapter, is the crossing of the hands on the breast. Giotto painted it only three or four times, yet it is always of central significance both in form and in meaning. Let us start with the tribune wall of the Arena Chapel. Beneath God the Father, surrounded by angels, Giotto painted the Annunciation.[1] A wide arch divides the two figures of the Annunciation, yet the composition, and quite particularly the gaze and gestures, bridge the wide gap between them. Both the angel and the Virgin are on their knees. The angel, kneeling in an empty space, raises his right hand in a speaking gesture, holding a scroll in his left. The Virgin, kneeling next to her reading desk, crosses her hands on her breast, a small book in her right hand. The situation suggested by the mural is a traditional one: the virgin was reading when the angel's appearance interrupted her;[2] hearing this message she crossed her hands on her breast, even before putting the book aside (fig. 38). We are reminded of the *Meditations on the Life of Christ*, that important text by Pseudo-Bonaventura which preceded Giotto by only one generation, and was widely diffused in Italy. As the Virgin understood the angel's message and consented, 'she knelt with profound devotion and, folding her hands, said: "Behold the handmaid of God; let it be to me according to your word"' (p. 19). It is difficult to say what precisely 'folding her hands' means here:

[1] Art historians have often considered the compositional character of the tribune wall as a whole. For an analysis of the iconographic continuity of the wall, see the well-known article by Alpatoff, reprinted in Schneider, 1974, pp. 109–21, esp. p. 117. Iconographic continuities have also been noticed by other scholars. See, e.g., W, pp. xviiff. and Rintelen, 1923, pp. 29ff.

[2] In the pictorial types for the representation of the Annunciation, traditional in the East, the Virgin reading the book did not play a major role. Usually she is sitting or standing, often she also performs some specific action (such as weaving), but reading is not prominent among those represented. Even when she holds a book in her hands, or on her lap (usually a psalterium), she is not depicted as reading it, and the depictions hardly suggest that she was interrupted in the act of reading by the angel addressing her. Millet, 1916, pp. 67ff., suggests a typology of Annunciation depictions in Eastern art, and pays much attention to gestures and postures.

38 Giotto, *Annunciation*, Padua, Arena Chapel (detail: The Virgin)

folding them in the modern prayer gesture, or crossing them on the breast. Giotto gave a visual, concrete interpretation. But what does this gesture mean? Is this a spontaneous, immediate expression of the emotions welling up in the Virgin, or is she deliberately performing a ritual?

The crossing of the hands on the breast, often accompanied with a slight bowing of the head, strikes the beholder as particularly direct; he intuitively understands it. Yet a careful look at the contexts in which the gesture is represented, and in which it is actually enacted, makes it appear complex and ambiguous. It can be used in many contexts, and it can carry different connotations.

The crossing of the hands on the breast is one of the few gestures that have been studied to some degree. Georg Weise and Gertrud Otto, in their valuable study of

expressive religious movements in Baroque art, also discuss this motif (1938, pp. 28ff.). Though they naturally concentrate on the seventeenth century, what they have to say is of significance for our subject. The two authors define our gesture as *Inbrunstgestus*, 'gesture of ardour'. In their discussion it is implied (though never spelled out, one should add) that the gesture can be explained as resulting directly from the emotions; it is, if one may use the term, a 'natural' expression of awe. Whatever the natural, psychological basis of the gesture – and we do not intend to deny that such a basis may indeed be present – we shall argue that the motif also has an important historical dimension which cannot be overlooked if we wish to understand what the gesture means in Giotto.

The student of the crossed hands, as represented in Italian art around 1300, is faced with a paradoxical situation. On the one hand, as we shall see, the motif has a venerable history (though one of questionable continuity). On the other hand, in the late thirteenth century, it was considered as innovatory by many artists and workshops (though probably not by all); its novelty forms part of the appeal it obviously had at that time. How much of the traditional form and meaning of the hands crossed on the breast survived in the representations of the later *ducento*? And how far were the artists of that time aware of earlier renderings and interpretations of the motif?

Crossed hands in earlier periods

The earliest context in which our motif appears is funerary art. An Egyptian clay coffin for a child, made in the third century A.D., and discovered by the theologian Joachim Jeremias in the British Museum (Jeremias 1960, pp. 66ff.), portrays a little girl, her hair dressed in ringlets, the bird of Osiris showing under her chin, crossing her hands on her breast. In one hand she holds a lotus flower (the Egyptian symbol of rebirth), in the other a cross with serrated ends tied to a cord wound around her waist (fig. 39). The author was fascinated by the cross. If it is indeed a cross, the clay coffin would be the first instance in which the cross was represented as a religious Christian device. Recently Theodor Klauser has raised some doubts as to whether the object the girl holds in her hand really is a cross (Dölger, 1959, p. 29, n. 78). However, while scholarly attention remained concentrated on the cross, the posture of the girl's arms and hands was not analysed. Now, whatever the object the girl holds in her hand, the placing of her arms cannot be equivocal: they form the shape of the cross.

At about the same time that the clay coffin was produced, Tertullian, one of the central figures of Christian religion in North Africa, quite clearly suggested this position. A Christian girl, he tells his readers (*De anima*, chapter 51) had been laid

39 London, British Museum, Egyptian coffin

out after the Roman fashion, with her arms along her sides, but during the priest's prayer she miraculously raised them, performing the gesture of prayer (Jacob, 1954, p. 19). We do not know precisely what that gesture was, but it is probably not too bold to assume that the girl of the Egyptian clay coffin is doing what Tertullian describes. Forming the cross with one's arms on the breast was the posture of the Christian dead.

The custom does not seem to have survived for a long time. Gregory of Tours in the late sixth century speaks (*De gloria confessorum*, chapter 81) of a Byzantine author who reproached his Western colleague for not burying the dead with their hands in the shape of the cross. He probably meant the crossing of the hands on the lap, a position different from the one here discussed. Later it seems to have been completely forgotten.

In funerary art the crossing of the hands on the breast reappears only in the

40 St Génies-des-Fontaines, sepulchral relief

Romansque period. A whole group of tombs in the north-eastern corner of Spain, a region of great religious tension at that time, and one of great artistic creativity, shows the gesture of crossing the hands on the breast. Let us look at the group of monuments, all of them from the region of north-eastern Spain and Provence. In a sepulchral relief in St Génies-des-Fontaines (Kingsley Porter, 1923, fig. 621), the arms and hands, crossed on the breast, are huge, the figure itself almost becoming an appendix of the crossed arms (fig. 40). The crossed hands even overlap the frame of the relief, probably representing the ends of the coffin. Obviously the artist conceived of the crossed hands as the central feature of his work, and no less important is the fact that the patron accepted the design. Another work, the tomb of F. de Solerio in Elne (Kingsley Porter, 1923, fig. 623), done in 1203 by an artist called Ramon de Bianya, is primitive in the representation of the body and in the carving technique. However, the gesture of the crossed arms with hands extended so that they almost reach the shoulders, is clearly articulated and prominent. Similar

is the tomb of an unknown bishop, done by the same artist; the long, crossed arms forcefully suggest an X (Kingsley Porter, 1923, fig. 625; Bauch, 1976, fig. 85, p. 59, without discussion of gesture). On the tomb of Guillaume de Jordan, produced in 1186, the hands are smaller and more delicate, the ornamental decoration of the garment is pronounced. Yet, in spite of the rich decoration the arms crossed on the breast remain the central motif. In a tomb in Arles-sur-Tech, in the same region, executed a generation later (in 1211), the arms and hands are once more very large, and their crossing is the dominant feature in the whole relief (Kingsley Porter, 1923; fig. 627).

This group of tombstones is significant for us not only as an important instance of the revival of crossed hands in the twelfth and thirteenth centuries. In addition to this, the group is also of importance as a possible source for Tuscan art. That there were close connections between Provence and Tuscany we know primarily from the study of literature. The impact of Provençal poetry on Tuscan literature is well known, and a diffusion of visual motifs can be assumed.

But what do the crossed hands on tombstones mean? Are they spontaneous testimony to the deceased's humility, are they meant as a direct emotional expression? Or are they rather some kind of liturgical re-enactment of the cross, a deliberate, symbolic gesture? In some of the monuments we have mentioned a ritual connotation seems to be present. On Solerio's tomb two small angels are holding a cloth on which the deceased's head rests; in his other hand each of the angels holds a censer, as if performing Mass. And from behind Solerio's head a hand emerges carrying out the *benedictio latina*. On the tomb of the anonymous bishop carved by Ramon di Bianya there are also two angels (their action, however, is not easily established), and again a benedictory hand emerges from behind the head. In the tomb in Arles-sur-Tech two large praying angels frame the deceased's head; above it we see a large hand, in the posture of the *benedictio latina*, on the background of a cross.

Crossing the hands on the chest is also known outside the funerary context. The gesture was used as a ceremonial act in the Byzantine court. The emperor was greeted with it, and we know that Byzantine emperors required this posture from their subjects.[3] In Byzantium the crossing of the hands on the breast was understood as a symbolic expression of obvious submission and adoration.

The general configuration of this posture – though not any precise details of the

[3] In Byzantine society a special term was coined to describe that gesture (σταυροχεριάζεσθαι). For the custom, and the term, see Treitinger, 1938, p. 66, with an important collection of sources. Alföldi, 1934, esp. p. 64 and n. 9. It is a gesture typical of prisoners, usually barbarians, and therefore particularly humiliating. Alföldi describes it as 'diese Demütigung barbarischer Art'. See also Sittl, 1890, p. 151. Sittl also reminds his readers (p. 175) that a comparable position (hands bound on the back) is the typical posture of the captive in Egyptian art. He also quotes (p. 175) Tacitus, who relates (*Germania* 39) that the Germanic priests would enter the holy grove with fettered hands only.

gesticulation – struck early Christians as an expression of reverence and awe. Holding the arms close to the body and clasping one hand with the other is an appropriate position for receiving the Eucharist. St Cyril of Jerusalem instructs his flock: approaching the Eucharist, he says, 'come not with thy wrists extended, or thy fingers open; but make thy left hand as if a throne for the right, which is on the eve of receiving the king' (*Mystagogical Catechesis* v. 21). Even during the early Middle Ages we perceive the echo of interest in similar postures. At some time during the ninth century the Bulgarians wrote to Pope Nicolas I telling him that, according 'to the Greeks, whoever enters the church without his hands crossed on the breast, is committing a sin'. In 866 the Pope answered them, making explicit what the gesture suggested to him. In his reading the figure so holding his hands says: 'I have bound my hands and I submit to chastisement by God.' But, the Pope continues, the signs of humility differ from place to place. We shall probably not go wrong in assuming that it is the self-immobilization, in whatever precise posture it is embodied, that is read as a 'sign of humility'.[4]

Crossing the hands on the chest is a gesture which has a long history in Christian liturgy as well, even though this history is only intermittently known. In the earliest period, it seems, the gesture was clearly delineated by St John of Damascus, the influential seventh-century Greek Church Father. In his systematic work, *An Exact Exposition of the Orthodox Faith*, a text that left a profound imprint on Christian liturgy throughout the ages and in all countries, St John describes how the believer ought to behave when receiving the Eucharist. 'Let us come to him [the priest holding the Eucharist] with ardent desire, and let us receive the body of the crucified as our flat hands are placed in a cross pattern' (IV. 13, p. 359; and see Ohm, 1948, p. 279). Scholars assume that what St John of Damascus had in mind was the crossing of the hands on the chest.

There is an interesting ambiguity in the meaning of the gesture in St John's description. Does the believer cross his hands on his chest in order to show his veneration for the Eucharist? Or does he do so with the intention of re-enacting the central religious symbol in his own body? Does the believer manifest by his gesture that, by taking the Eucharist, he really becomes part of the crucified? If that be the case, the gesture would have little to do with the 'natural' movement of humility; it would, on the contrary, be the deliberate, premeditated manifestation of a belief. The slight ambivalence of St John's description cannot be resolved.

The further history of our gesture as a liturgical device does not help much in

[4] For the full text of the Letter (*Responsa Nicolai ad consulta Bulgarorum*) see Migne, *Patrologia Latina*, vol. CXIX, col. 1000. It is frequently mentioned. See e.g. Ohm, 1948, pp. 269ff., and Sittl, 1890, p. 175. The authors emphasize that the figure crossing the hands on the chest is also bowing. The bowing, they believe, is an oriental expression of humility, appropriate in prayer.

finding a clear interpretation of crossing the hands on the chest. From the twelfth or thirteenth century onward the gesture was performed by the priest celebrating Mass. Ever since the early Christian period the priest had begun the Mass by asking the community of believers to join him in prayer, and often he would describe himself as a sinner on this occasion. *Orate pro me peccatore* is a well-known formula in the Christian liturgy (Jungmann, 1951–5, II, p. 104). Since the late twelfth century, as we learn from a didactic poem, the priest, when pronouncing these words, would cross his hands on his chest, and bow slightly (Lietzmann, 1908, II, p. 54; Jungmann, 1951–5, II, p. 105). Here, then, the gesture again seems to be an expression of humility. But, as Jungmann has emphasized, these sentences commencing the Mass are immediately followed by the priest's request that God accept his sacrifices, which is also the sacrifice offered by the whole community. The crossing of the hands on the chest can be an expression of the priest's humility, acknowledging that he is a sinner, but it can also be seen as a formal liturgical gesture related to the offering of a sacrifice.

Crossed hands in the art of Giotto's time

In Giotto's time our gesture seems to have been a recent creation. The attitude of hands crossed on the breast was not known in early medieval art, and, as far as we know, it is not found among the gestural motifs in which art abounds. It was only in the late thirteenth century that this gestural motif entered European imagery. Its centre was originally Italy.

Byzantium seems to have been the immediate source for the Italian images. Though the gesture never achieved prominence in Byzantine art, one occasionally finds versions of it, yet not until close to Giotto's time does it attain a fully articulate form. In a tenth-century ivory in Berlin (originally a book cover) we have probably the earliest instance (Vöge, 1911, pl. 5; Weise and Otto, 1938, fig. 34). The ivory represents the forty martyrs, and one of them, bowing his head profoundly, places his hands on his chest in a manner reminiscent of our gesture. Note, however, that the hands do not form a cross. This ivory, it seems to me, shows that the articulate gesture of crossing the hands on the chest was not yet known in the tenth century, at least not in the workshop in which the book cover was carved. In Byzantine manuscripts of the early twelfth century, however, the gesture is already more or less clearly portrayed (Venturi, 1901–40, II, pp. 468, 482; Ebersolt, 1926, pl. 36). Weise and Otto, in the study we have mentioned, believe that the gesture may have come to Byzantium from the Islamic world (Weise and Otto, 1938, pp. 35ff.). We need not here go into this difficult problem. It remains obvious that even in Byzantium the gesture was comparatively late.

A first suggestion of the representation of the crossed hands in Italy can be detected in the Last Judgement panel of Nicolo Pisano's pulpit in Pisa. One of the just, in the lower left corner (Swarzenski, 1926, pl. 9), is performing the gesture a little awkwardly. The very fact that it is not fully articulate and clear – in the work of an artist who was always so clear in his compositions and movements – suggests that we are here faced with a new motif.

Giovanni Pisano, in his pulpit in St Andrea in Pistoia, a work completed in 1301, employs the motif twice. One of the sibyls, a corner figure, crosses her hands on her breast in a natural way (Ayrton, 1969, fig. 150). So light and rhythmic is the figure that one is tempted to doubt whether there was any particular intention in the gesture. It occurs again on the same pulpit, this time performed by the angel who announces his message to the Virgin (Ayrton, 1969, fig. 134). Again one is struck by the angel's natural ease. He is immersed in a lively dialogue with the Virgin, he bows his head, but he is smiling broadly. The expression of natural lightness makes it difficult to offer any definite interpretation of the gesture in this work. What one clearly perceives is that by the time Giovanni Pisano carved his figures the gesture was obviously generally known and accepted.

The motif must quickly have become popular north of the Alps as well. Let us look at only one example, an early fourteenth-century panel, produced in Germany, and now in Rome (fig. 41).[5] The panel is painted in two registers. In the upper register the Man of Sorrows stands in his sarcophagus, flanked by two angels; in the lower register a Nativity is represented. All three figures of the upper level, the Man of Sorrows, as well as the two angels symmetrically flanking him, cross their hands on their chests: in the lower register it is the Virgin, kneeling in adoration before the new-born Saviour, who crosses her hands on her breast. In depicting these crossed arms and hands the artist does not hesitate; obviously he is handling a pattern with which he is intimately familiar, and which is fully established. But what does the gesture mean? It may convey adoration, and perhaps even humility, on the part of the angels. The Virgin may express her adoration of the Christ-child by crossing her arms. But the Man of Sorrows, who so ostentatiously performs this gesture, is surely not meant to convey his humility. Is the gesture meant to express his request that his sacrifice be accepted? It is perhaps not possible to arrive at a definite answer. The ambiguity of the gesture, as depicted in late medieval art, becomes manifest.

In Florence and its surroundings, including Sienna, crossed hands appear in certain hightly visible works of art. It is sufficient to mention *The Crowning of the*

[5] Now in the Pinacoteca of the Vatican. See Van Marle, 1923–38, V, p. 180, and VII, p. 213. See also Weise and Otto, 1938, fig. 32. See also von der Osten, 1933, figs. 37ff. for additional depictions of the Man of Sorrows with hands crossed on the chest.

41 *Man of Sorrows; the Virgin Adoring Christ*, Rome, Vatican, Pinacoteca

Virgin (fig. 42), a later thirteenth-century mosaic in the Cathedral of Florence.[6] Here the Virgin, bowing her head, crosses her arms on her chest. The motif, however, is not yet completely established. Sometimes it seems that the artist is trying to give the ceremonial gesture a certain narrative meaning: the Virgin's right hand seems to grasp the left, her right hand is extended beyond the limit of her figure, as if she were reaching out for something. A little later, in a work from Duccio's school, an angel next to a Madonna holding the Christ child performs the same gesture.[7] Now the gesture is more established than in the Florentine mosaic,

6 See Weise and Otto, 1938, p. 30. For additional examples see Van Marle, 1923–38, I, p. 272; II, pp. 91, 280, 496; III, pp. 260, 319, 494, 507, 642.

7 In the Citta di Castello. Cf. Weise and Otto, 1938, fig. 31. For additional examples, see Van Marle, 1923–38, II, pp. 30, 80, 87, 532.

42 Florence, Opera del Duomo, *The Crowning of the Virgin*, mosaic

yet even here the hands do not form a clear cross, and the emotional quality, the animated movement, is more manifest than the liturgical.

Crossed hands in Giotto's work

One can safely assume that Giotto was familiar with these traditions. He may not have known learned texts explaining subtleties of liturgy, but he was surely acquainted with funerary art and with the depictions of our gesture in Tuscan art. He was also surely acquainted with the conventionalized gesture the priest performs when celebrating Mass. His education and cultural environment made him intuitively understand the gist of all these traditions. But what can we learn from these traditions to help us grasp what the hands crossed on the chest mean in Giotto's work?

Giotto painted several depictions of the hands crossed on the chest. Several figures

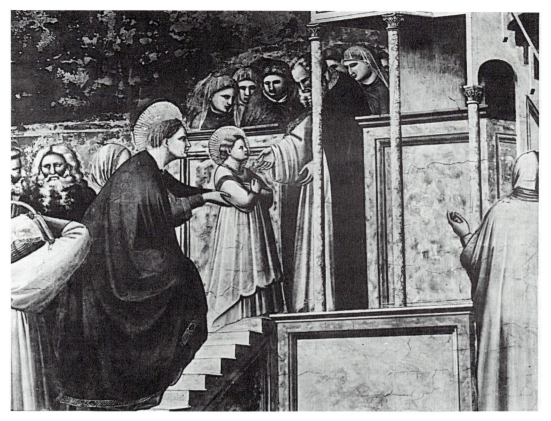

43 Giotto, *The Presentation of the Virgin in the Temple*, Padua, Arena Chapel (detail)

perform this movement, yet first and foremost it is the gesture of the Virgin. In three different scenes the Virgin crosses her hands on her chest and the common character of these scenes may tell us something about how the gesture should be understood in Giotto.

The gesture appears for the first time in *The Presentation of the Virgin in the Temple* (fig. 43) in the Arena Chapel. The young Virgin (according to the legend she was only three years old) is climbing the steps leading to the temple. Behind her, supporting the child, is St Anne; in front of her is the High Priest, ready to welcome the new devotee to the temple. Both figures extend their hands toward the young child, their arms forming a diagonal framework for the Virgin's figure. Looking carefully at this mural one notices to what extent Giotto used even indirect gesticulation to create an emphasis. The young Virgin herself is deliberately crossing her hands on her chest, raising her gaze in devotion to the High Priest. The crossed arms are raised, the movement has an angular quality. No narrative connotation is

carried by the attitude. The Virgin is doing nothing with her hands but crossing them on her chest. A specific interpretation of this gesture is difficult. One could, of course, read it as an expression of the Virgin's humility before the High Priest, or before the singular fate that the future holds for her. Yet nothing in the mural speaks for humility. The atmosphere of the scene as such is one of liturgical performance, and the emotional intensity is very restrained. To be sure, Giotto rarely indulges in very emotional movements, and emotional restraint is characteristic of him in general. But here the subject matter itself is a ritual ceremony, the dedication of a child to the temple. Looking at the Virgin's gesture, moreover, one must ask whether it perhaps has something to do with what was actually happening in the church: namely, the priest crossing his hands on his chest in asking God to accept his, and the community's, sacrifice. Does the Virgin here request that *her* sacrifice be accepted? It is an interesting hypothesis, but difficult to test.

Another scene in which Giotto employed the motif of the hands crossed on the breast is *The Annunciation* (fig. 10), already mentioned in chapter 1. How should we understand the Virgin's gesture in this mural? Let us start with the simple observation that in the figure of the Virgin we do not find any expression of humility. She does not bow her head, she does not bend her back – the conventional signs of humility are disregarded. Originally the kneeling position was the posture of submission, an act demonstrating the superiority of the figure before whom one kneels. By 1300, however, all these original connotations had long faded; genuflection was the conventional posture of prayer, a ritual act.

The Virgin is completely self-contained, she is detached from the world around her. While the angel speaks to her, raises his hand in a rhetorical gesture, and directs his gaze at her across the arch, the Virgin is altogether introvert, her eyes are half closed (compare her eyes with the open eyes of the angel), she is looking into herself.[8] The difference between the 'extrovert' angel, addressing her, and the 'introvert' Virgin, enclosed within herself, is even made visible in the outline of the figures: the Virgin's outline is completely 'closed', the angel's 'open' towards her. Looking at such a characterization of the Virgin one wonders whether Giotto wanted the spectator to believe that the Virgin is seeing what the future has in store for her. Can the general character of this work allow us to interpret the crossed hands as a manifestation of humility?

Throughout the Middle Ages the Annunciation was considered a *mysterium terribile*', its ultimate results – the crucifixion, the resurrection, and the salvation of mankind – somehow present in its image. It may well be that the implied connotation of Christ's death and resurrection made the Annunciation a popular theme on

[8] Rintelen, 1923, p. 29, believed that the Virgin (whom he compares with the Virgin in Van Eyck's *Annunciation* in the Ghent Altarpiece) is an active figure.

funerary monuments. The idea of sacrifice is always present in the story of the Annunciation: the Virgin accepts the will of God as a sacrifice that she is bringing. It seems that this interpretation was predominant in Italy, and that it was perhaps even related to our gesture. The representation of the scene in the theatre may give us a clue. The *Rappresentazione della Annunziazione*, attributed to Feo Belcari, was composed (and peformed) in the late fifteenth century, but it seems likely that it reflects habits, stories, and popular performances that go back for centuries. This play tells the story of the Virgin's doubts, and it ends with the Virgin speaking the liturgical formula. The author, acting also as director, gives us an interesting suggestion as to the gesture. 'The Virgin Mary', he says

kneels down, and making on her breast a cross with her arms, humbly says:

> Ecco l'Ancilla del Signore Dio:
> Sia fatto a me secondo il tuo dir pio.[9]

Again we have a certain ambiguity. While humility surely plays a part, it would seem that the gesture goes beyond humility. It may evoke many images: the bringing of an offering, the crucified.

For the third time we find the Virgin crossing her hands on her chest on a panel in the Capella Medici in Santa Croce. Scholars agree that the panel was not made by Giotto himself. Though it surely belongs to the artist's workshop, students are undecided as to who actually painted it (Siren, 1905, p. 153; Van Marle, 1923–38, III, p. 319). Whoever he may have been, he was a 'prominent member of the Giotto workshop'. We should add that in his rendering of gestures he faithfully followed his master. Therefore, I think, this work can be studied as an additional instance of Giotto's treatment of gestures.

In this panel the Virgin bows her head slightly; she wears a crown, and Christ imposes his hands on the crown (a gesture to which we shall return later). She crosses her hand in a particular way, not on the chest, but held quite low so that the forearms are almost horizontal (even slightly lowered). Only the palms of the hands cross. In spite of these differences, especially noticeable when compared with *The Presentation of the Virgin* (fig. 43), the gesture she performs must be included in what we have called the 'crossing of arms and hands'.

The great Mariological movement, which produced the theme of the 'Coronation of the Virgin', emerged in France, and from there spread throughout Europe. This

[9] Cf. d'Ancona, 1872, I, p. 189. The full text reads:
La Vergine Maria s'inginocchia, e facendo sopra il petto delle sue braccia croce, umilmente dice:
 Ecco l'Ancilla del Signore Dio:
 Sia fatto a me secondo il tuo dir pio.
Allora lo Spirito Santo discende sopra di le...

movement, as we know, conceived of the Virgin as a queen, a ruler of the world. Peter Damianus, one of the early speakers of the Mariological trend, may have exaggerated his contemporaries' views when he maintained that all the powers of heaven and earth are given to the Virgin and that she appears before God not as a handmaid but as a mistress, yet he expressed a trend of thought that came to be broadly accepted (Migne, *Patrologia Latina*, vol. CXLIV, col. 717 (sermo 40); Delius, 1963, pp. 156ff.). The Coronation of the Virgin is one of the visual manifestations of this attitude. When Italian artists took over this French theme they too imagined the Virgin not as a humble servant but as a queen fully aware of her powers. In Italian representations the Virgin is usually seated on the same throne as Christ. In Francesco Torriti's *Coronation of the Virgin* in Santa Maria Maggiore (*c.* 1295) (Wilpert, 1916, III, pls. 121–4; Van Marle, 1923–38, I, pp. 482ff.; Oertel, 1953, pp. 61ff.), probably the most famous Italian representation of this theme in the period here discussed, the Virgin does not cross her hands on her chest. But in the mosaic in the Cathedral of Florence, produced only a few years later (*c.* 1300), we see the beginning of this gesture (fig. 42), as we have already mentioned earlier. Though the precise position of arms and hands is slightly different from that in the panel from Giotto's workshop, we shall probably not go wrong in assuming that the Florentine mosaic was one of Giotto's points of departure.

The royal connotations of the Coronation of the Virgin support what we perceive in looking at the panel from Giotto's workshop: the crossing of the hands is not a spontaneous ardent gesture; it is rather a controlled ritual performance, restrained in emotional intensity. The Virgin's crossing of her hands is, in its essence, a liturgical gesture.

Giotto used this gesture once more, though this time he gave it a different character. In *The Resuscitation of Drusiana by St John the Evangelist* (fig. 15), in the Peruzzi Chapel in Santa Croce, the miracle-working Evangelist is surrounded by several groups of people. In front of him, falling at his feet, are the women imploring him to revive Drusiana; behind him are his followers, one of whom raises his hand in the accepted gesture of prayer; and next to him, belonging to no single group, is a kneeling figure, seen in profile, who raises his head and crosses his hands on his breast. Whom does this figure represent, and what does his gesture mean?

The story of Drusiana is first told in the apocryphal *Acts of St John* (James, 1926, p. 248). The version most important for us, however, is the one contained in the *Golden Legend*, the document closer in time to Giotto, and accessible to everybody in its popular narrative tone. 'And it so happened', the *Legenda aurea* tells us in the story of St John the Evangelist,

that John, who had wrongly been expelled to the island [of Patmos], was led into the city of Ephesus with great honours...But as he entered the city, they carried towards him the

dead Drusiana who, from the bottom of her heart, desired his return. And her parents and the widows and the orphans called: 'O St John...' And St John asked that the bier be put down, and they untie the corpse, and said: 'May my Lord Jesus Christ resuscitate you, Drusiana...'

One can see that Giotto, in his painting, followed mainly the version of the *Legenda aurea*. According to the *Acts of St John*, the Evangelist goes into Drusiana's tomb and resuscitates her by grasping her hand. Giotto clearly makes the city walls the background of the scene, and he makes St John revive her by speaking to her.

But who is the figure crossing his hands? He cannot belong, I believe, to those imploring the saint. Following an old tradition that goes back to Roman art, Giotto always places pleading figures in front of the personage addressed by them. Here the kneeling figure is beside, even a little behind, the saint. Nor does he belong to the crowd following the Evangelist. He is not walking, and he does not take an active part in the event depicted; indeed, his kneeling posture makes any movement impossible, he must therefore be understood as a separate part of the composition. I suggest that the kneeling figure crossing his hands is one who proclaims the true faith that has been manifested in the Evangelist's miracle. The *Acts of St John* do indeed tell of such a figure. Callimachus, we read, seeing the miracle 'with voice and tears glorified God'. Giotto never painted tears, even in lamentations. Yet one may imagine that he made this figure an expression of the faith. In order to do this he used the ritual gesture, performed by the priest who proclaims the true faith, of crossing the hands on the breast.

CHAPTER 5

THE GESTURE OF INCAPACITY

A gesture that occurs only once in the whole of Giotto's *œuvre* may illustrate, as in a nutshell, the intricate problem of the master's historical position, and of his attitude towards tradition. Such a gesture may be seen in *The Massacre of the Innocents* (fig. 11) in the Arena Chapel. In its general dramatic character, and particularly in its unrestrained depiction of the height of cruel action, this fresco differs from all others in the Arena Chapel, as well as from representations in the later stages of Giotto's work. Even such tragic scenes as the *Crucifixion* and *The Lamentation of Christ* (fig. 19) cannot compare with *The Massacre of the Innocents* in exhibiting cruel detail and expressing intensity of emotion. Yet even in this scene Giotto's inclinations – the leaning towards clear architectural composition and the tendency towards the drawing of pure types – prevail. The figures participating in the event are clustered in a few groups, each sharply differentiated from the others in both form and character. In the centre the wailing mothers, some still fighting for the lives of their children, are juxtaposed with the pitiless soldiers, submerged in the fury of action. Though only two of the soldiers are visible, they clearly represent an army, and fully counterbalance the more numerous group of the mothers. To the left of the soldiers executing Herod's order are three figures, joined together so as to form a compact group. In action and mood they are set apart from the other participants. They are not involved in any action, neither slaying, nor slain, nor struggling against violent death. As far as their expression – in face and posture – can be intuitively grasped, they seem to be recoiling from the fearful spectacle before them. One of the three, at the right of the group, turns his head away from the sight of the slaughter; the other two bow their heads in sorrow, their faces saddened. We cannot read them otherwise than as compassionate spectators, witnesses of the terrible scene.

In modern criticism this fresco has been judged very differently. John Ruskin (1900, pp. 113ff.), to cite an extreme expression of one attitude, finds that 'this composition is the one that exhibits most of Giotto's weaknesses'. In this instance,

Ruskin believes, Giotto is 'inferior not only to his successors, but to the feeblest of the miniature painters of the thirteenth century'. What is it that justifies such harsh comment? Interestingly enough, Ruskin here speaks of gestures.

It is, in fact, almost impossible to understand how any Italian, familiar with the eager gesticulations of the lower order of his countrywomen on the smallest points of dispute with each other, should have been incapable of giving more adequate expression of true action and passion to the group of the mothers...

It is, then, the restraint that Ruskin sees as Giotto's weakness. But, to another critic this weakness appears as a major virtue. Some admirers of Giotto's art, says Rintelen in his well-known monograph (1923, pp. 36ff.), do not want to think of *The Massacre of the Innocents*; it would have been better, they believe 'had the artist been saved this gruesome subject'. To him, however, the opposite seems to be true. Precisely 'in this harsh subject Giotto's creative power proves its embellishing force...He represents the murder in gripping symbolic abstraction.'[1]

Medieval imagination excelled in vividly picturing the details of the Massacre of the Innocents. Using examples drawn from both visual representation and literary description, modern scholarship has distinguished several types of depicting. Naturally the desperate mothers are the focus of all these renderings. Gestures are important: the mothers are described and represented as struggling with the cruel soldiers, attacking them with their bare hands. Symbolic and pathetic gestures also occur, such as the beating of the breasts.[2] Another focus, less conspicuous but also worthy of our attention, is Herod himself, whose face and commanding gesture are sometimes described. In the medieval renderings of the Massacre, witnesses of the scene do not appear as a separate, articulate group overcome with awe and sorrow. So far as we can see, such a feature slowly crystallized in the thirteenth and fourteenth centuries. These witnesses often appear as soldiers who are not involved in the massacre itself, mainly members of the king's bodyguard. A fine example is found in Duccio's representation (Brandi, 1951, pl. 45). Above the wailing, struggling mothers the king sits, surrounded by his councillors, and, next to him, two soldiers guarding the court. The soldiers form a separate group, they are not involved in the killing; they stand erect and motionless, their weapons, so prominently displayed,

[1] Certain difficulties in making *The Massacre of the Innocents* fit into the general schema of Giotto's work are also perceptible in Siren's study (1975, pp. 35–6). Siren devotes a much longer discussion to this picture than to most other works by the master. Dvořak, 1927, I, pp. 27–8, too, finds in *The Massacre of the Innocents* the expression of 'ruthless energy' which he juxtaposes with the sweet harmony of the angels next to this mural.

[2] Barasch, 1976, pp. 64ff., 71ff., 80ff. The literary sources are unequal in nature. While the *Meditations of the Life of Christ*, to mention only the major texts, hardly refers to the Massacre of the Innocents, the *Golden Legend* devotes a whole story to the event, prodigal in detail and suggesting the symbolic implications.

are not meant for use. Their facial expression is one of sorrow as they look on the scene. However, their sorrow does not in any way affect their gesticulation.

Giotto, then, did not invent the group of witnessing figures overcome with grief at the crime they are watching, yet he gave them a new form. First, he relieved them from any additional function in the event, especially from their connection with Herod. As opposed to the traditional models (clearly reflected in Duccio's panel), the marginal figures in Giotto's fresco do not hold any weapons. Are they soldiers at all? The only indication of this is their headgear, that can be read as some transformation of a helmet. We know how Giotto pictures Roman soldiers. They wear, as for instance in the Arena Chapel *Crucifixion*, a special dress (short tunic, sleeveless metal armour) (W 59),[3] which does not occur in *The Massacre of the Innocents*. Here the central figure of the group wears a wide cloak, reaching to his feet, a dress which does not carry any military connotation.[4] Given Giotto's consistency in the representation of a figure or a class, one doubts whether these figures are meant to represent soldiers at all. Yet even if we identify them as soldiers, they have lost any narrative function as such. They are detached from Herod, and though standing beside his palace they cannot be understood as his guard. As opposed to Duccio and all the models, they are not watching Herod's crime accidentally, as it were; their main, or only, function in the scene is to watch. They are nothing but compassionate witnesses.

Now what does this group, and particularly its central figure, broadly depicted, do? In posture the figure is prominent in his sweeping *contrapposto*. In a bold movement, dominating the whole personage, he recoils from the scene of horror, propelling his whole mighty frame to the left, away from the corpses and desperate mothers, and out of the picture field. Yet his head is turned back sharply, the face, almost seen in profile, clashing with the direction of his impulse. The meaning of this attitude is intuitively grasped: it is the conflict between a wish to avoid witnessing the scene of horror, and, possibly, a call to bear witness, to be present at this scene of sacrifice. Whenever Giotto employed the *contrapposto* stance he wished to express a conflict, either between a figure and some external force or

[3] I am not aware of any study examining in detail what models Giotto may have had in representing soldiers, especially as regards their uniforms. In the Arena Chapel he depicted soldiers only in the Passion scenes. The major ones are *The Scourging of Christ* (W 56), *Christ Bearing the Cross* (W 58; S 140), the *Crucifixion* (W 39; S 241) and *Noli me tangere* (W 5; S 147). The soldier on Christ's right in *The Scourging of Christ* shows a marked physiognomic similarity to the figure in *The Massacre of the Innocents* here discussed.

[4] What might be termed the social significance, or hierarchy, of dress patterns in Giotto's work has not been studied. As a general rule, we are inclined to believe, the length of the dress indicates the standing of the figure. The more dignified the figure, the longer and wider his dress, the less dignified, the shorter and closer to the body. 'Dignity' or otherwise can mean the intrinsic value of the figure (such as a saint) or his social standing (such as Herod, the High Priest, or, on the other hand, servants and soldiers).

obstacle, or – more frequently – a psychological conflict within the figure itself.[5] In this sense we may also interpret the stance of the witnessing figure in *The Massacre of the Innocents*.

We now come to the gesture of the hand. Of the three witnesses only one figure's hands are visible. If the gesture this figure performs has any meaning at all, it will be representative of the whole group. Now what we see is that the man who performs the *contrapposto* movement grasps his left hand with his right, clasping it slightly above the wrist, and thus in fact hiding the other hand. What does this strange gesture suggest? The answer is not readily available. The gesture is not intuitively understood, and the fresco itself contains no clue for its proper reading. Nor can we rely on the master's other works; he does not seem ever to have employed the gesture again. In spite of the difficulties of interpretation one hesitates to assume that the gesture is not meant to convey, however vaguely, some message. Giotto would hardly have depicted this gesture had it not had some function in the overall communicative economy of the composition. A careful look at the iconographic tradition of the High Middle Ages may help us to unriddle this movement of the hand. To be sure, the gesture we are here considering is not one of those common iconographic motifs which must have been known to almost everybody at the time, and handled as a kind of minted coin by artists. Yet though it is not one of the frequently represented, central symbolic gestures, it persisted in art for centuries, preserving its basic formal characteristics as well as its emotional nature.

Since about the twelfth century this gesture, as we see it in Giotto's fresco, seems to have been connected mainly with incapacity, with the inability to change fate or to bring about salvation or liberation. In the late Middle Ages it must have been fairly well established. Amira lists it as one of the articulate types of legal gesticulation represented in the illuminations of the *Sachsenspiegel* manuscripts (figs. 44, 45).

One hand, the right or left, clasps the other, the back of which is turned outwards, at the joint or at the forearm close to the joint. Both hands hang down heavily, or are raised to the breast, once even above the head. In its primary meaning this gesture seems to manifest an incapacity, for instance, not to be able to judge.[6]

[5] In general, *contrapposto* is rather rare in Giotto's work. A good example of *contrapposto* caused by external interference is the figure of the Virgin in *Christ Bearing the Cross* (W 58; S 140). She wants to follow Christ, but is prevented by the interference of a Roman soldier. The clash between the two forces is clearly mirrored in her posture. *The Sacrifice of Joachim* also forcibly shows such a conflict: the High Priest pushes Joachim out of the temple, but Joachim turns his head back. A fine example of *contrapposto* indicating an *internal* conflict is the *Noli me tangere* (W 65; S 147), discussed in some detail below, p. 169.

[6] Amira, 1909, pp. 321ff. As we have seen in another section (see above, pp. 49ff.), the same gesture occurs in the *Sachsenspiegel* several times, in some slight formal variations, without however losing its character.

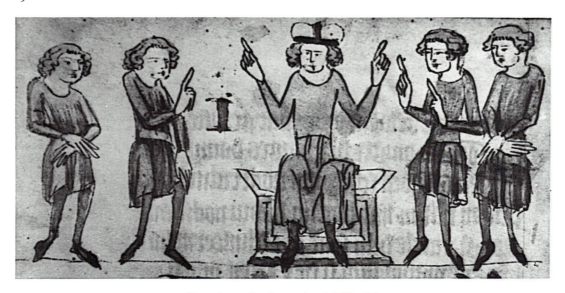

44 Dresden, *Sachsenspiegel* MS, fol. 37

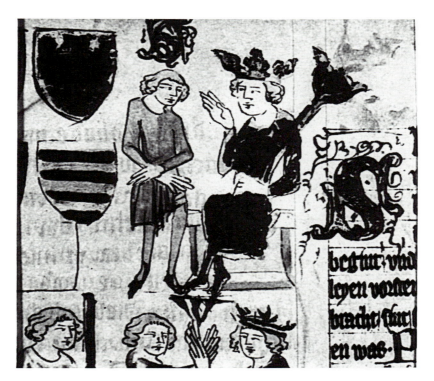

45 Dresden, *Sachsenspiegel* MS, fol. 11

46 Paris, Bibliothèque Sainte Gènevière, MS 777, fol. 424

The illuminators of the *Sachsenspiegel* did not invent the gesture. As we know from the art of earlier centuries, it existed before as an expression of suffering and of the inability to prevent the advent of doom. In a late twelfth-century lectionary (Paris, Bibliothèque Sainte-Gènevière, MS 127, fol. 40), for example, a figure in a state of perplexity and utter powerlessness is shown as he grasps his left hand with his right above the wrist (Garnier, 1982, p. 201, fig. J). It is a gesture very close to that performed by the witnessing in Giotto's *Massacre of the Innocents*, though the twelfth-century figure lacks the dramatic *contrapposto* represented in the Arena Chapel. In a fourteenth-century manuscript of Livy we see the kneeling Demetrius, the son of Philip V of Macedonia, who is calumniously accused by his brother, and sentenced to death, without being able to appeal against the verdict: he is kneeling down, raising his head (in request or supplication?) and clasping his left hand with his right above the wrist (fig. 46; Garnier, 1982, p. 201, fig. F). In a twelfth-century manuscript Job's wife cannot do more than substantiate the misery of her husband, and she does so by grasping one of her hands with the other (Garnier, 1982, p. 201, fig. A). In still another twelfth-century illuminated manuscript, one containing the Decretals of Gratian, a woman who remarried after she believed that her husband died learns that he is alive; she is torn between two commitments and loves; whatever the solution of her conflict, she will remain wounded for ever. (And *pleurants* on a thirteenth-century sarcophagus perform the same gesture (fig. 47).)[7] How does the artist depict her plight? He shows her as she grasps one hand

[7] For the Gratian Decretal, see Douai, Bibl. mun., MS 590, fol. 188. The sarcophagus, from the tomb of Gautier de Sully, is preserved in the Castle of Sully.

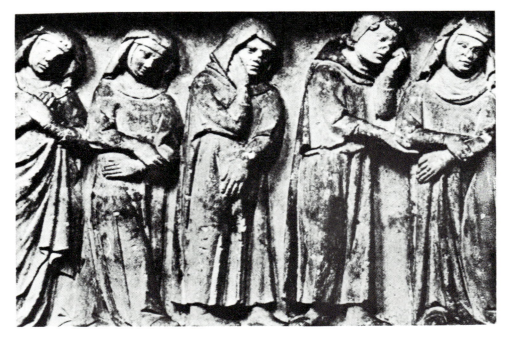

47 Chateau de Sully, sarcophagus from the tomb of Gautier de Sully (detail)

with the other, raising them to her breast. In Garnier's recent study (1982) of the 'language of the medieval image' some additional examples of this gesture have been collected. Among them are some as early as the eleventh century.

Giotto must have been acquainted with this gestural formula for powerlessness, for the inability to change a terrible fate, or to avert impending doom. One feels safe in assuming that when faced with the task of representing the witness to the Massacre of the Innocents, sorrow-stricken yet unable to help, he fell back on the well-known formula for precisely this situation. In using this formula Giotto made a statement: the witness is not guilty of the crime he is watching; he is unable to prevent it. This statement is not part of the original story, but this is not the only formula in the fresco which is not such a part. The hexagonal shape of the building in the background has been identified as the typical shape of the Baptistery (possibly carrying symbolic connotations – see Rintelen, 1923, pp. 36, 236), and this has been taken to mean that the Slaughter of the Innocents is a Baptism of Blood.[8] Both the

[8] The significance of blood in the religious imagery of the later Middle Ages is well known, and has been analysed in different contexts. See e.g. Mâle, 1949, pp. 108ff. It is also worth mentioning that in the Arena Chapel *The Scourging of Christ* is painted beneath *The Massacre of the Innocents*. Alpatoff has noticed this particular case of parallelism, but seems to explain it, at least in part, by reasons of expressive-

shape of the building and the witness showing his inability to change what he watches are implied statements by the artist, made by means of conventional formulae.

ness: 'It is not by chance', he says, 'that these two most turbulent and noisy scenes of the Paduan cycle are placed by Giotto one over the other' (Schneider, 1974, p. 113). But the Scourging of Christ is also a shedding of blood, and the parallelism should also be understood in this way.

CHAPTER 6

COVERED HANDS

Is the covering of the hands with a piece of cloth or a cloak to be counted among gestures? This question is not easily answered. Different aspects, in themselves not pertaining to gesticulation, are obviously essential components of the covering of hands. The criterion of classifying our motif is of course the simple fact that the hands are covered; only in the second place can we ask what the particular position of the hands is, or what action they perform or suggest. In fact, sometimes the covered hands are stretched out, sometimes they are held back, raised or lowered, serving to interact with other figures or stressing the figure's isolation. Can some order be introduced into this multitude of shapes and postures? Is the very fact that the hands are covered sufficient to form a category? Or should we distinguish between different types of covered hands? In this chapter we shall maintain that in Giotto's imagery the covering of the hands is a full-fledged, articulate gesture; in other words, it consists of a group of movements, performed with covered hands, and meant to convey – sometimes quite ostentatiously – specific connotations, or carrying certain 'meanings', as one is in the habit of saying. We shall also attempt to show that the covering of the hands is not uniform, neither in its typical shapes nor in the denotations carried. Actually, the particular form of the covered hands serves Giotto as a crystallized index of the scene's or figure's expressive character; it indicates the 'level' – if we may use such a metaphoric term – on which the scene or the figure is to be placed and interpreted.

Before turning to our subject proper we may be permitted to make a brief general observation on Giotto's attitude to the cloak. Art historians have often commented on his depiction of drapery; they have noted Giotto's use of drapery as a means to visualize a figure's mass and volume (Rintelen, 1923, pp. 58ff.; Dvorak, 1927, I, pp. 27ff.; Berenson, 1927, pp. 69ff.), to enhance the feeling of weight (Davis, 1974, p. 152), or to depict perspective space (White, 1957, pp. 57ff.).[1] One should also note,

[1] In Dvorak's view (1927, I, pp. 25ff.) garments are so represented that 'im Beschauer natürliche und räumliche Vorstellungen höchst zwingend ausgelöst wurden'. For the interaction of figure and space, cf. also Oertel, 1953, pp. 82ff.

we believe, how Giotto sometimes uses a figure's attitude to garments, mainly his or her cloak, as an expressive pattern, characterizing a situation or a figure. Tearing off somebody's coat, as we shall see in another chapter (below, pp. 142ff.), can be a formula for expressing burning offence and humiliation. We also know that rending one's own garment is an established and powerful formula of desperate lamentation (Weitzmann, 1961, pp. 476ff.; Barasch, 1976). But we also remember from the *Lamentation of Christ* in the Arena Chapel that a figure completely enveloped in its own cloak is a formula of deep, depressive mourning (Barasch, 1976, pp. 69ff.). To this list we should like to add still another variation of the relationship between figure and dress: the covered hands.

The covering of the hands – possibly because it does not belong to the central and recognized gestures – often poses serious problems in both reading and inter-pretation. To some of these we shall have to call attention in the following pages. In spite of such difficulties, however, we believe that in Giotto's imagery covering of the hands appears in two basic types, which can be distinguished from each other, schematically characterized, and catalogued. Each type also reflects a specific intention, clearly different from the intention attributed to the other type. Moreover, each also fits a specific mood or expressive level, and therefore serves to indicate this level to the beholder. The very fact that the hands are veiled, hidden behind a cloth or the cloak, is of course true for both types, yet this fact is clearly not sufficient for expressive communication; the types are never interchangeable. In a simplified, schematic way we can say that in one type the covering of the hands is conceived as a highly formal, ceremonial act, in which everything (such as a posture in which the hands are held, the way of covering them, the cloth by which they are covered) is carried out with a view to ostentation; the hands are covered in full awareness of performing a ritual act, and the spectator is expected to realize the intention behind the performance. The other type may be called 'a casual covering of hands'. The hands themselves remain covered, but this is not paraded, their being covered is not presented as the result of a premeditated action, an action the figure is aware of performing. But though performed casually, the fact of covering the hands here has perhaps no less meaning than in the other type.

Let us start with those themes where the covering of hands is of manifestly ceremonial character. There are not many scenes of this nature in Giotto's reper-toire, yet these few clearly show the typical tendencies of the motif, as well as the expressive problems it creates.

We begin with the most openly ceremonial, in our case liturgical, scene in the whole of Giotto's work, the Paduan fresco depicting *The Presentation of Christ in the Temple* (fig. 48). The centre of the composition, marked by the carved slim column of the Temple building, is occupied by an encounter – vividly suggested, though

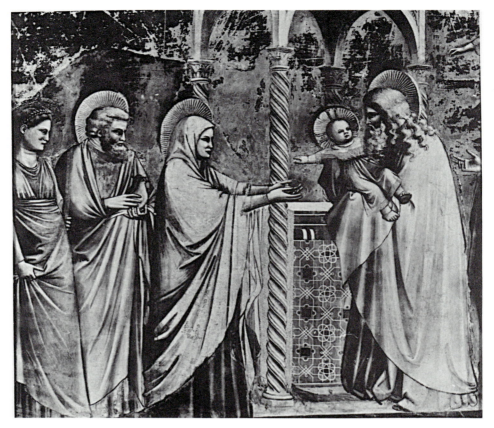

48 Giotto, *The Presentation of Christ in the Temple*, Padua, Arena Chapel (detail)

not actually represented – of the Virgin's hands, extended to receive the Christ-child, and the priest's, stretched forth to give the child back to his mother. The Virgin's hands are bare, the priest's, holding the newly born Redeemer, are covered by a fine cloth. The priest is the only figure whose hands are covered. In a panel in Boston, attributed to Giotto (fig. 49), the same scene is represented. The architectural frame is different from that in Padua, the general composition is also slightly changed, but the intricate pattern of the hands – their being covered or bare – is the same as in the fresco. The liturgical nature of the covering of the hands is possibly even more manifest in the panel than in the fresco.

There was of course nothing new in Giotto's depicting the Christ-child held with covered hands; in so doing, our master was following a firmly established tradition. In the pictorial tradition of rendering Christ being presented in the Temple, the priest's covered hands are so common a feature that it seems superfluous to mention

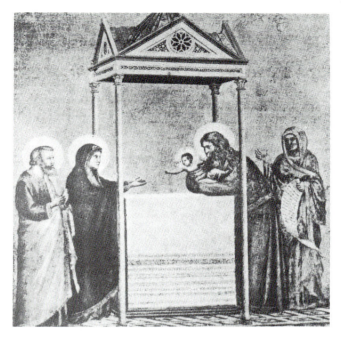

49 Giotto (attributed), *The Presentation of Christ in the Temple*, Boston, Mass.

any examples. Yet it should be noted that there is often another figure, in addition to the priest, whose hands are covered. This is particularly significant for the interpretation of the gesture, especially since it is not always clear why the additional figures cover their hands. Thus, in Duccio's *The Presentation of Christ in the Temple* (fig. 50) the priest holds Christ with covered hands, while Mary stretches forth her bare hands to receive the Redeemer. But behind her there is another figure with covered hands – an old man whose mantle hides his hands. What is he doing? Is he preparing himself to receive the child, possibly from Mary? (The original sources don't tell us anything about such a figure.) Or is he covering his hands as an expression of the awe that has overcome him in the presence of the divine? Or, finally, is this simply a ritual gesture, something one does when one is in the Temple? In another work, a mosaic in the Opera del Duomo in Florence which was probably produced a generation or two before Giotto, we see a more complicated pattern of our motif in the Diptych of the Twelve Feasts (fig. 51). Here Christ is in the hands of the Virgin, but she herself holds him with covered hands. The priest, bowing deeply in adoration, is just covering his hands in order to receive the holy child. A third figure – an old man behind the Virgin – is holding a book, obviously the holy book, with covered hands. These examples, which could of course easily be multi-

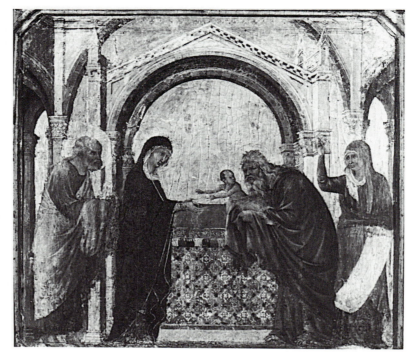

50 Duccio, *The Presentation of Christ in the Temple*, Sienna

plied, clearly show that even in these traditionally established scenes the covering of the hands is not just the priest's identification mark; it has a broader, necessarily more complex, meaning. This raises questions to which we shall immediately return.

The other scene with a prescribed iconography in which the hands are ceremonially covered is the Baptism of Christ. Giotto depicted *The Baptism of Christ* (fig. 61) only once, in the Arena Chapel, and here he was again following established traditions (see Millet, 1916, pp. 170–215). To either side of Christ and the Baptist is a group of figures: on the left of the fresco, behind Christ, the angels are holding his garments ready; on the right, behind the Baptist, stand two of his followers. To these followers we shall return in a moment; now let us look at the angels who, slightly bowing, present Christ's garments; the robes are in the colours of the Passion, red and blue, or shades of purple, the colour of kingship as well as of martyrdom.[2] The rich and adorned robes, falling in monumental folds, cover the

[2] In the Middle Ages the prescribed colour of the liturgical vestments worn by the clergy on martyrs' days was red (Braun, 1907, p. 745). In the thirteenth century black liturgical garments, worn on days of mourning, might be replaced in Rome by purple ones. See Braun, 1907, p. 741.

51 Florence, Opera del Duomo, *The Presentation of Christ in the Temple*, mosaic

angel's hands. One notes a characteristic ambiguity in their gesture. In holding forth
Christ's garments, they demonstrate their own covered hands. In performing their
action of having Christ's robes ready they also seem to perform a liturgical function,
to take part in a ceremony. That the angels can be read on two levels – as bringing
Christ's clothes, and as ritually adoring with covered hands – seems to be an
essential feature of their figures.

Again we need not search for any specific models from which Giotto might have
derived the particular combination of narrative and expressive components of the
motif. In a great pictorial tradition, long-lasting and widely diffused, the angels
present at the Baptism of Christ are often shown ceremoniously bowing, in some
cases ecstatically, while holding Christ's robes which covered their hands.[3] In these

[3] I shall mention a few characteristic examples, which are of course well known. In a Coptic manuscript
(Paris, Bibl. Nat. Coptic 13 – see Millet, 1916, fig. 123) the angels are hovering in mid-air. In a fresco in

52 Rome, Museum of the Capitol, Roman relief

depictions the angels are conceived as ceremonial, liturgical figures, precisely as is the priest in the Presentation of Christ in the Temple.

The ritual covering of hands has aroused scholarly interest, particularly (though not exclusively) among students of the ancient world. Almost a century ago Albrecht Dieterich (1911, pp. 440–8), an important scholar of ancient religion, studied this ritual, his starting-point being a work of art: he was struck by a Roman relief (fig. 52), obviously representing a religious procession, in which one of the figures, bearing a large vessel, has covered hands. More recently the subject has been taken up by such eminent scholars as Andreas Alföldi (1934, pp. 33ff.), who dealt with it as part of Roman court ceremonial and focused on its political significance, and Franz Cumont (1932–3, pp. 81–105), who was more concerned with the religious aspects of covering one's hands. In medieval, particularly in Byzantine, studies our subject has also been noted, though here it seems to have received a less detailed treatment than in studies of antiquity. But the observations of scholars like Grabar (1936, p. 87), Treitinger (1938, pp. 63ff.) and others (Cabrol and Leclerq, 1913–53, x, 1, s.v. 'mains voilées') have shed light on uses and meanings of the ceremonial act. As all these studies are easily available I need not attempt a detailed presentation of the history of covering the hands; it is enough briefly to outline some conclusions derived from the studies just mentioned that have a direct bearing on our proper subject – that is, Giotto's use of the motif.

The first conclusion concerns the meaning of the ritual. That a gesture as

Dionysiou, Mount Athos (Millet, 1916, fig. 147) they bow in expressive gestures. In a mosaic in San Marco in Venice the angels are bowing so profoundly that they seem to be performing perfect Byzantine *proskynesis*.

crystallized and ceremonial as the covering of hands is intended to convey a message has not been doubted by scholars. All the various forms and context of this ritual, Dieterich said, derive from a single thought – not to approach what is holy with bare, unclean hands. One covers one's hands, he believes, when one gets close to a saint, or when one is about to grasp a sacred object. The sacred should not be profaned by touching it with dirty hands. In the symbolic world of antiquity it is natural that what is valid for the sacred in general is also valid for the ruler. In fact, Graeco-Roman antiquity took over the custom of covering the hands from oriental courts, especially the court of Achaemenid Persia.[4] One of the earliest Greek sources mentioning our custom tells the reader that people approaching the Persian ruler with bare hands were immediately executed.[5] The custom became popular in the Roman Empire at the period when the style and manners of oriental courts became models for Western society and rulership. In the West it seems also to have been considered normal that subjects approach their ruler with covered hands. Ammianus Marcellinus, the fourth-century Roman historian, recounts the anger and indignation of the ruler aroused by his subjects' receiving his gifts with bare hands.[6] The ruler and his gifts are too worthy to be grasped with bare hands.

As in so many respects, so also in regard to our custom, the medieval Church inherited ancient patterns and continued their use. The covering of hands, as a symbolic, highly formalized act, is known in the liturgies during the millennium between Ammianus Marcellinus and Giotto. Thus in the Gallican Rite women are expressly forbidden to receive the host with their 'nude hands';[7] another source specifically mentions that they ought to carry a linen cloth (*linteamen*) for that purpose.[8] We also know of the priest covering his hands as he approaches the

[4] The Persian origin is accepted by all scholars, and was known in antiquity, during the period of the Empire. Dieterich, 1911, and other students refer to a passage in Plautus' *Amphitryo*, 255ff., which reads: 'The following day their foremost men came tearfully from the city to our camp, their hands veiled in suppliant wise, and entreated us to pardon their transgression' (transl. Nixon, 1966, I, p. 27). Dieterich, 1911, also mentions Ovid's *Metamorphoses*, XI.278–9, but here the author speaks only of a 'suppliant hand' holding an olive branch, not of a covering of the hand.

[5] Xenophon, *Hellenica*, II.1.8, relates: 'It was in this year that Cyrus put to death Autoboesaces and Mitraeus who were sons of Darius' sister – the daughter of Darius' father Xerxes – because upon meeting him they did not thrust their hands through the *kore* [long sleeve], an honour they showed the king alone.'

[6] Ammianus Marcellinus, XVI.5.11: 'When the agents had been summoned by his order on a festal day to his council chamber to receive their gold with the rest, one of the company took it, not (as the custom is) in a fold of his mantle, but in both his open hands. Whereupon the emperor said, "It is seizing, not accepting, that agents understand"' (transl. Rolfe, 1971, I, pp. 219ff.).

[7] The Synode of Auxerre, *c.* 578, decreed: 'Non licet mulieri nuda manu eucharistiam accipere.' As quoted by Duchesne, 1902, p. 224, n. 3.

[8] Men, as distinguished from women, may receive the host with their bare hands. 'Omnes viri, quando ad altare accessuri sunt, lavant manus suas; sed omnes mulieres nitida exhibent linteamina ubi corpus Christi accipiant.' See Duchesne, 1902, p. 224, n. 3 (original text in Migne, *Patrologia Latina*, vol. XXXIX, col. 2168).

host.[9] We need not follow in detail the ramifications of our custom and the history of its application to know that covering the hands was known in the Middle Ages, and that, as in the Roman Empire, it was a means of expressing awe and adoration. Giotto could have known it not only from art (to which we shall immediately return) but also from the church service.

The other area where we look for conclusions may be more limited in scope, but what can be learned here possibly has a more direct bearing on the painter's work. Here we ask, how, specifically, were the hands covered (or imagined to have been covered) on different occasions, and in different periods? Was the act performed by a special cloth? Did one take such a cloth with oneself when one went to the imperial court, or attended a particularly significant liturgical occasion? Or did one cover one's hands with one's mantle? There are no easy answers to these questions. Normally the texts do not deal with these details directly, though something can be learned from them, as we shall immediately see. Visual representations have to address the questions asked, but so far no attempt has been made to collect the material, sort out the types, and establish a development. We have to proceed on the basis of impressions only.

The literary sources, which seem to flow more abundantly for antiquity than for the Middle Ages, do not enable us to give definitive answers, yet they tend in one direction: they suggest a use of the mantle for the purpose of covering the hands. Ammianus Marcellinus (XVI.5.11) explicitly speaks of collecting the emperor's gifts with the spread-out chlamys as something everybody is familiar with. This was probably also how gifts were offered to the ruler. The same custom is attested for tenth-century Byzantium. At the court of Constantine Porphyrogenitus his courtiers used to receive the emperor's gifts in the spread-out chlamys (Treitinger, 1938, p. 65, n. 94). Newly promoted officials approached the emperor with their hands veiled, and this has been taken to mean that they folded their hands beneath their cloaks; they also received their written appointments with hands covered by the ends of the mantle (Treitinger, 1938, p. 65, n. 95). But we also know that, particularly in late antiquity, those who used to approach the emperor had a special piece of linen sewn into their outer garment, and this they used for receiving something from, or offering something to, the ruler. This piece of cloth was a highly formalized feature. It varied according to the wearer's rank, it was decorated with a purple border, and it was called by a special term, *segmentum*.[10] Were we to form our concepts only according to literary sources we would almost have to drop the hypothesis that people covered

[9] For an interesting discussion of the possible influence of this custom on the development of liturgical vestments, see Braun, 1907, pp. 554ff.

[10] See Wilpert, 1916, 1, pp. 87ff. As Alföldi, 1934, pp. 34ff., has shown, such a *segmentum* was already customary at the time of the Roman tetrarchy.

53 Ruthwell Cross, relief

their hands with detached pieces of cloth when they approached the emperor or carried holy objects. And yet we must assume that in many cases this was the way of covering the hands. One wonders, for instance, what, if not special pieces of linen, were the *linteamina*, which ladies used in order to receive the host.

The works of art suggest an altogether different answer. Many representations of figures with veiled hands, produced in late antiquity, have come down to us. Visual renderings from the later stages of the Middle Ages seem to be fewer, but are known in many copies and variations in the period as well. In the artistic renderings no single type of covering of the hands predominates. The figure holding a sacred object with the ends of his mantle or chlamys is a well-established motif, found in the whole medieval world. In the mosaics in Sant' Apollinare in Classe in Ravenna the archbishop holds the holy book with his cloak; similarly, on a fifth-century sarcophagus in Ravenna (Cabrol and Leclerq, 1913–53, fig. 7519), two old men carry crowns with covered hands. In the West, on the Ruthwell Cross (fig. 53),

54 *Moses Receiving the Laws*, marble relief, Berlin

Christ himself raises the end of his cloak to hold his book; in the Joshua Roll (Weitzmann, 1948, pl. 171) the Gibeonite messengers have turned their cloaks to hold the tributes they are offering;[11] and in Byzantine art Moses on Mount Sinai is shown receiving the Laws with his hand covered by his mantle (Dalton, 1911, p. 157; our fig. 54).

The other type is not less frequent, and it is possibly even more impressive; this involves covering the hands with a special piece of fabric, a cloth that does not form part of the figure's dress. On an ivory plaque from the throne of Maximian representing the Multiplication of the Loaves and Fishes an apostle holds a plate with his hands covered with a special cloth (fig. 55); on many renderings of the magi bringing their offerings to the Christ-child, all, or the first one, have their hands covered with special fabrics which hang down forming rich folds.[12] This type impressed itself deeply on medieval imagery; it became an accepted formula for ostentatious offering.

[11] Another example is the Byzantine ivory plaque in the Victoria and Albert Museum in London, representing Joshua and the Gibeonite Messengers.

[12] See Kehrer, 1908–9, II, figs. 19, 20, 34 (hands covered with mantle), 37 (with a special cloth), 77 (with the mantle), 106, 118 (with a special piece of cloth). These examples can of course easily be multiplied.

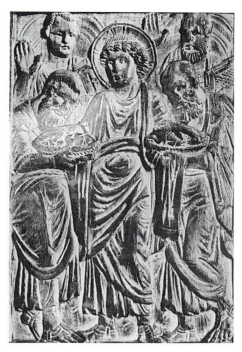

55 Throne of Maximian (detail: Multiplication of Loaves and Fishes),
Ravenna, Museum Arcivescovile

It is well known that examples for both types could easily be multiplied, for medieval Italy as well. One therefore feels safe in assuming that Giotto was familiar with models belonging to both patterns. It is worth noting that wherever he wished to depict a ceremonial, liturgical covering of hands he used the second type only – the covering of hands with a special cloth.

Ceremonial forms such as the covering of the hands, as every historian knows, are not among the shapes which easily undergo change. Even in an eventful history they remain, as a rule, close to the original configuration. Yet Giotto's work, particularly in the Arena frescoes, displays many variations on the theme of the covered hands. Our master's inventiveness can be appreciated when we see how he handles this traditional, firmly crystallized motif, constantly changing it without obscuring its essential form.

Let us begin our brief survey of how Giotto transformed the covering of the hands with his *The Lamentation of Christ* (fig. 19) in the Arena Chapel. In an earlier chapter (above, pp. 42ff.), we have already noted the two standing saints, who do not participate in the central event of the lamentation, the Wailing of Christ, but rather provide some testimony to what is taking place before our eyes. They may

be understood as indicating the presence of the terrestrial world at a sacred event. One of the saints, the one closer to Christ, raises his left hand to his breast (to his heart?); his right hand, held slightly lower than the left, is covered by an end of the white garment he is wearing over his cloak. Why is his hand covered? So perfect and so monumental is Giotto's creation that nobody – so far as I know – has ever asked what this unusual gesture may mean. Unusual it is – and for this reason, too, there must be some concept behind its depiction. Is the saint covering his hand in order to express the awe that is filling his soul in the presence of the divine? If the figure represents Nicodemus, as seems likely, one might speculate that he is covering his hand in anticipation of the task awaiting him, namely, bearing Christ to his grave. But we do not know of an established pictorial tradition depicting Nicodemus with covered hands. In many dramatic renderings of the *threnos* in the late Middle Ages the saints grasp Christ's figure, usually his feet, but they do so with bare hands.[13] Where they have their hands covered, they hold Christ's shrouds, as a kind of heavy, sagging load. In Giotto's rendering, however, the saints do not touch Christ, and the covering of the saint's hand does not seem to have any narrative function. On the other hand, a liturgical connotation almost inevitably arises: here, where Christ's sacrifice is completed, the ritual begins.

The nature of the garment covering the saint's hand is not easily established. It is not clothing serving an obvious practical purpose; worn over a long outer robe (which covers the whole figure), it suggests a liturgical, rather than an everyday purpose. Its general shape vaguely suggests a chasuble, the central liturgical vestment of the priest, though the form is not exactly similar.[14] Its white colour may be a hidden reference to the shrouds in which Christ will be wrapped.[15] The generally exalted, probably liturgical, quality of gesture and garment seem convincing.

Another version of the same motif may be seen in *The Visitation* (fig. 56), also in the Arena Chapel. The two central figures, the Virgin and Elisabeth, are flanked by accompanying figures. Such attendants are not required by the story itself (as we

[13] I give a few examples. The Tetraevangeliary of Parma (Palat. 5; see Millet, 1916, fig. 531) clearly shows the grasping of Christ's feet with bare hands; so does a fine panel in Bologna (see Millet, 1916, fig. 541). The same motif occurs in Duccio's *Lamentation* in Siena (see Brandi, 1951, pl. 84). The tendency towards direct physical contact with Christ's body by the mourner reaches a climax in the kissing of the Saviour's corpse.

[14] For the history of the chasuble, see Braun, 1907, pp. 149ff.; for our purpose particularly pp. 184ff. In the thirteenth century the chasuble became smaller and more modest than before. It should be emphasized, however, that the white garment of the saintly figure in Giotto's *Lamentation* is not a precise representation of a chasuble.

[15] In the *Meditations of the Life of Christ*, p. 343, we are informed that Nicodemus (together with John the Evangelist) prepares Christ's body for burial. They 'shroud the body and prepare it with linen cloth according to the Jewish custom'. As the shrouds could be transformed into Christ's swaddling cloths, they have also become Nicodemus' liturgical garment.

56 Giotto, *The Visitation*, Padua, Arena Chapel

know it from different texts), nor are they a regular feature in the depictions of the scene. Their depiction by Giotto may therefore indicate what he wished to emphasize in his fresco. Rintelen sensed that these attendants have an essentially ceremonial function, and lend a ceremonial character to the scene as a whole. 'As a duke gives visible appearance to his significance by the entourage he takes with himself',

Rintelen writes (p. 31) in his analysis of the *Visitation*, 'so [in Giotto's fresco] the maidens belong to the Virgin; they take part in her dignity...' One could even go further and claim that the attendants reflect the relative significance of each of the central figures. Thus, the Virgin, the more exalted of the two central actors, has two attendant women; behind Elisabeth, the lesser in rank, there is only one. The Virgin's attendants are large in size, they stand close to the beholder, their volume and heaviness are strongly emphasized; the attendant behind Elisabeth is smaller, more remote from the beholder, her bulk is less aggressive. One may perhaps also interpret our specific motif within this framework of general hierarchic signs. Only the Virgin's attendant has her hand covered; the woman accompanying Elisabeth reveals her bare hands. One is therefore tempted to read the covering of the hand as a formalized manifestation of adoration, appropriately offered to the highest-ranking figure present in the scene. On a more psychological level, one could also read the covering of the hand as an expression of awe filling the attendant as she witnesses the holy event.

Only once again did Giotto represent a figure covering its hand with a special cloth. In *The Meeting at the Golden Gate* (fig. 57) several women follow St Anne as she rushes forward to meet her husband, among them the figure wearing black (probably representing St Anne's nurse and counsellor) and, next to her, the woman clad in white. The latter has her hand covered with a special piece of material, possibly a piece of clothing. (That the cloth covering her hand is a garment can be inferred from its being lined – white upper surface, pinkish lining – and from its hem being decorated by an embroidered border.) But whether or not the cloth represents a garment, the covering of the hand is casual, it lacks the solemnity which the same gesture has in the *Lamentation* (fig. 19) or in *The Baptism of Christ*. And yet, one is reluctant to accept the figure with the white cloth on her hand as simply a genre fragment. In the Giotto literature the figure has not been identified, but several features of this woman – her being dressed in white only (an unusual feature in Giotto's work),[16] her upright festive posture, her being placed precisely in the middle of the gate – suggest a meaning going beyond what meets the eye; these are features which evoke a ritual mode. Seen in this context, the covering of the hand, however casual it looks, also acquires some ritual connotations.

To a different mood and emotional character belong the figures who cover their hands with their cloaks. Giotto represented such a movement several times. Here, perhaps even more than in the figures covering their hands with a special cloth,

[16] In the frescoes of the Arena Chapel many figures wear bright garments, but there seem to be only two prominent figures dressed in pure white; apart from the woman in *The Meeting at the Golden Gate*, only Christ in *Noli me tangere*. This is of course a tentative impression that should be carefully checked by a proper analysis of the colours. Giotto's colour symbolism is a field that seems to have received no attention at all.

57 Giotto, *The Meeting at the Golden Gate*, Padua, Arena Chapel (detail)

Giotto reveals himself as a master in evoking various moods, clearly distinct from each other. Small changes in formal configuration produce different expressive moods. A particularly solemn version of covering one's hand with one's mantle can be seen in *The Virgin's Wedding Feast* (fig. 20), in the Arena Chapel. In front of the Virgin seriously and festively paces a young man (of his companion only the head is seen); in spite of his facial similarity to the Christ type the figure probably represents Joseph, the Virgin's husband-to-be. Behind his mantle he raises his hand, but it remains covered by the rich and beautiful cloak. Ruskin (1900, pp. 89ff.) believes that this fresco is the 'most typical', if not of Giotto's individual

personality, then of his time and country. The scene, he says, is the perfect achievement of 'simplicity and repose'. Ruskin of course spoke of 'simplicity and repose' or 'a strange seriousness and dignity and slowness of motion' as qualities of pictorial style, but it is not difficult to see that the same qualities are also characteristic of the gestures that the figures in the fresco perform. These qualities are also characteristic of ritual in general, and of the gestures accompanying this ritual in particular. Ruskin's phrases also seem to describe rather well the specific gesture of covering the hand with the ample cloak.

But the meaning of this gesture is not clear. Is Joseph, by this suggested gesture, expressing his adoration of the Virgin, and awe for the son she will bear? Or is he only arranging his hand beneath his cloak for greater ease in walking? Giotto leaves us guessing. Should the spectator fall back on his acquired knowledge of conventional gesticulation, established in tradition and used in liturgy, or should he grasp what he sees as a direct appeal to bodily experience, a movement for which we have an immediate empathy? It is characteristic of Giotto's genius that he uses such organic disguises for gestures profoundly related to cultural traditions.

In *The Flight into Egypt* (fig. 16), also in the Arena Chapel, we again encounter the same questions. The group moves from left to right, in pure profile and fully parallel to the wall. Joseph, the first in the group, is a little behind the others, and turns back slightly to the central group. He holds a woven basket; but his hand is not seen, for his cloak falls over and altogether covers it. Again the covering of the hand seems altogether natural, a fine observation of an apparently insignificant event in nature. But is it so completely devoid of connotations beyond the natural? We cannot be sure, but one notices that Giotto emphasized the place of the covered hand more than would seem necessary. The rhythmic shapes of the folds lead the beholder's attention to the hand that is not seen; the spot where the hand is covered is illumined far beyond what the natural economy of light would warrant; it forms a bright, radiating area which attracts the spectator's attention. Though one cannot be sure, one feels that symbolic connotations are infused into a seemingly natural detail.

In *The Baptism of Christ* (fig. 61) Giotto has probably cast the liturgical connotations of our motif in still another pattern. As we have said earlier in this chapter, the angels present Christ's garments with covered hands, and they do so in a gesture of a pronouncedly ceremonial character. But they are not the only figures in the fresco who cover their hands: behind the Baptist, two men, probably representing some of John's followers in the desert, are witnessing the holy event. Their upright posture, their concentrated gaze, and their deliberate restraint in gesticulation express their awareness of the significance of the event that is taking place before their eyes. Their full mantles fall down to their feet, and both figures hide their

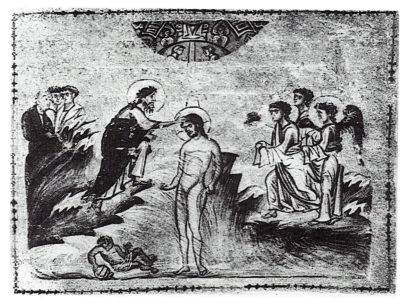

58 Paris, Bibliothèque Nationale, MS Gr. 75, 'Baptism of Christ'

hands behind their ample cloaks. One, an old man standing closer to the sacred group in the centre, has his hands completely covered; the other, a younger, beardless man who is a step removed from the centre, has his hand almost fully hidden; only a small part of the bare hand shows, depicting the fingers holding (or pulling) the garment. So small is this segment of bare hand that we can count this figure also among the figures with covered hands.

A group of followers standing behind the Baptist and witnessing the symbolic event of Christ's Baptism is not unknown in medieval renderings of the theme, although it remained a rather marginal compositional pattern. In some manuscript illuminations produced in Constantinople as early as A.D. 1128,[17] to give some particularly characteristic examples, we see groups of bearded followers in the representations of Christ's Baptism. They are not saints, their heads are not surrounded by haloes, and they watch the event from what is meant as a great distance. They are surely meant to express awe. They do not cover their hands; on the contrary, they seem to be gesticulating with bare hands (fig. 58). Giotto, in

[17] See Paris, Bibl. Nat., gr. 75 (Millet, 1916, fig. 138); Vatican, Urbin. 2 (Millet, 1916, fig. 139). And see also the fresco in Dionysiou, Mount Athos, representing the Baptism (Millet, 1916, fig. 147). Strzygowski's *Ikonographie der Taufe Christi*, Munich, 1885, was not available to me while writing this study. Millet, 1916, pp. 178ff., includes the increasing number of angels present at Christ's Baptism among the iconographic innovations of the twelfth century; he does not refer, however, to the bearded followers also increasingly present at the scene.

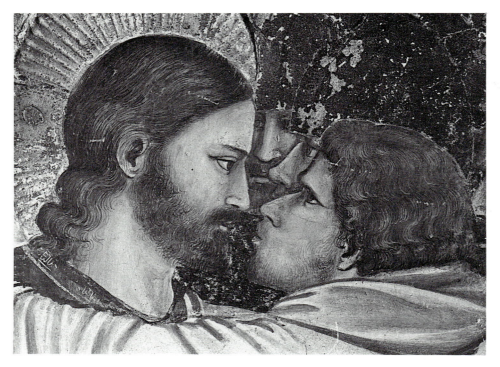

59 Giotto, *Judas Kissing the Lord*, Padua, Arena Chapel (detail)

depicting the two witnesses at the Baptism, has probably drawn from such broad
medieval traditions. Yet he was not content with the expressive language used in
these models. Therefore, one speculates, he employed one of the liturgical formulae
for awe in presence of the divine – the covering of hands – disguising an artificial
gesture as a natural movement.

Giotto's tendency to make gestures carry ambiguous meanings may have extended
the covering of hands into a surprising, almost paradoxical context. In the famous
fresco of *Judas Kissing the Lord* (fig. 59), to which we shall come back in greater
detail (below, pp. 159ff.), the treacherous apostle embraces Christ in a sweeping
movement of the arm which is one of the most prominent features in the composi-
tion. The apostle's yellow coat covers his arm and hand. To be sure, a careful
observer will detect a small segment of Judas' bare hand, but this segment is so
small, so devoid of any definite shape or colour, that one feels sure the artist did not
want the beholder to grasp it. For the spectator's visual experience Judas' gesture
is performed with a covered hand. The theme of the fresco is, of course, one of great
antagonism and tension; it is an encounter of supreme good and ultimate evil, of
redemption and betrayal. More specifically, however, it is the theme of disguise, the
hiding of treason behind the expression of love. One wonders, did Giotto extend the

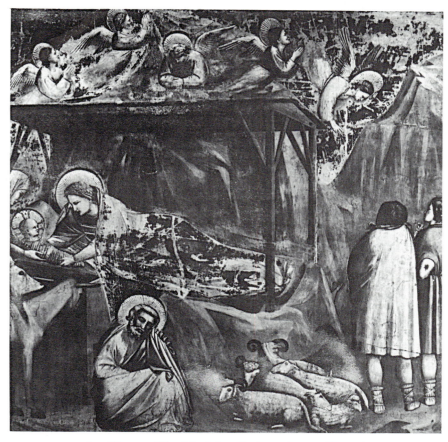

60 Giotto, *The Nativity*, Padua, Arena Chapel

reach of disguise? Is Judas approaching Christ with covered hand to indicate his presumed awe, while in fact he is about to betray the Lord? Should this be so, Judas' gesture in Giotto's fresco would constitute another use of the ritual formula, which the artist could have observed in the ecclesiastical liturgy of his day. The hypothesis is tempting, but it is difficult to test. The very fact that it suggests itself indicates much of Giotto's propensity to employ, and where necessary to transform, established conventional formulae.

Another form of covered hands which Giotto employed in the Arena Chapel should also be mentioned; it is a form where ritual connotations have altogether disappeared. Giotto employed this version only in depictions of sleeping men. The figure is completely wrapped in its mantle, and the folds also cover the sleeper's hands. One such figure is the sleeping Joseph in *The Nativity* (fig. 60), another is the sleeping Joachim addressed by the angel in *Joachim's Dream* (fig. 8). Joseph supports his head on his hand, but the hand is covered by the cloak. Joseph

crouching on the ground and supporting his head in the well-known position is, of course, a common feature in some medieval, especially Byzantine, renderings of the Nativity. Examples are so plentiful that they need not be mentioned here. Among them are also some of Giotto's time and region, showing that Italian artists around 1300 were well aware of this specific motif.[18] What should be carefully noted, however, is that in all these representations Joseph, crouching on the ground next to the Virgin, supports his head with his bare hand. Nobody will doubt that Giotto took over the Joseph-figure from the iconographic tradition, but precisely for this reason his covering of Joseph's hand is significant. Traditional features, like idioms, are usually taken over as overall patterns, in their comprehensive *Gestalt*. A change in a specific detail of a traditional model seems to indicate a definite intention.

One of Giotto's grandiose figures is the sleeping (and dreaming) Joachim. Completely wrapped in his large mantle, he is a magnificent expression of the sleeper cutting himself off from the world. The covering of the hands here further enhances the complete isolation of the sleeper, his encapsulation in his own introvert world. It is interesting that Giotto used this formula for sleepers only in the Arena Chapel. In his later work, and mainly in the frescoes of the Upper Church of St Francis in Assisi, sleeping figures reveal their hands.[19] It is not for us here to attempt to discuss the question.

The preceding observations lead us, I believe, to some conclusions. First, it seems obvious that the covering of the hands should be treated as a gesture. It has a core both in visual configuration and in basic meaning, and this core subsisted in a long history. Secondly, Giotto was familiar with this history, at least to some extent. In depicting figures covering their hands he was clearly borrowing from tradition, and in some cases he expected the spectator to be aware of this. Thirdly, he employed the formula of the covered hands in many contexts, and he created formal and expressive versions of the motif suitable to the context. These versions extend from the most solemn performance of ritual to a seemingly natural posture. In all the depictions, however, even where the covering of the hands looks most natural and casual, he retained something of the original character of the gesture.

[18] Cf. Millet, 1916, pp. 93ff., and figs. 35ff. An interesting case of making the iconographic formula appear more natural may be seen in Duccio's *Nativity*, now in the National Gallery in Washington: the general configuration of Joseph is maintained, yet the hand usually supporting the head is now made to hold the ends of the cloak.

[19] In Santa Croce, in the *Vision of Bishop Guido* (W 154) the sleeping figure reveals his hands. There are several sleeping figures, their hands never covered, in the frescoes of St Francis in Assisi. See the *Vision of the Palace* (W 144; S 30); *The Dream of Pope Innocent III* (W 146; S 35) shows the Pope conspicuously presenting his gloved hand; in the *Vision of Augustine and the Bishop Guido of Assisi* (W 154; S 68) the sleeper's hand is again clearly shown; this is also the case in another fresco in the church of St Francis in Assisi, *Gregory IX Sees in a Dream the Stigmata of St Francis* (W 157; S 76). None of these figures, however, depict Joseph.

CHAPTER 7

IMPOSITION OF HANDS

The imposition of hands is a symbolic ceremony intended to communicate some favour, quality or excellence, mainly of a spiritual kind. It is a ceremony also performed when endowing somebody with a clerical function. This ceremony is apparently widespread and one finds it in many cultures (Ohm, 1948, pp. 290ff.; Heiler, 1923, p. 572). It is frequently described in the Bible, always endowed with great dignity. Jacob bequeathed a blessing and inheritance to his two grandsons, Ephraim and Manasseh, by placing his hands upon them (Genesis 48:14). When the old Moses was looking for a younger leader who would replace him, the Lord said to him: 'Take thee Joshua the son of Nun, a man in whom is the spirit, and lay thine hand upon him.' This is what Moses did. 'And he laid his hands upon him, and gave him a charge, as the Lord commanded...' (Numbers 27:18, 23). The imposition of hands is particularly the gesture of investing somebody with clerical office. From the Acts of the Apostles we learn that in the ordaining of the first deacons 'they were set before the apostles; and when they had prayed, they laid their hands on them' (Acts 6:6). When Saul and Barnabas are selected by the Holy Ghost for missionary work, the prophets and doctors among whom they were set them aside. 'And when they had fasted and prayed, and laid their hands on them, they sent them away' (Acts 13:3). Moreover, the imposition of hands also played a part in the ceremonies of offering ritual sacrifice. The biblical priests, before immolating animals in sacrifice, laid their hands upon the head of the victim (Exodus 29; Leviticus 8:9). In the expressive dismissal of the scapegoat, the officiant laid his hands on the animal's head and prayed that the sins of the people might descend thereon, and be expiated in the wilderness (Leviticus 16:21). As can be seen even from the few examples we have mentioned, there is a wide range of meanings which the imposition of hands could express.

Since this gestural motif was so central in liturgic imagery one is not surprised to find it in the art of medieval Europe. The artistic renderings of the imposition

of hands in some periods (especially in early Christian art) have been carefully studied,[1] but for other periods no studies seem to have been undertaken. From the material available we have learned that in art the gesture had as many different meanings as it has in religion. For the period that most interests us here, around 1300, we have no study of the gesture.

The imposition of hands is not one of the central motifs in Giotto's art, yet it appears several times. The distribution, and the dates of the works in which the gesture is rendered, are interesting. Only once does the gesture appear in a work executed by Giotto himself. It is more often seen in paintings related to his workshop, or traditionally ascribed to him on rather dubious grounds. These works are usually later, even if only by a few years, than the murals done by Giotto himself. We shall start with the work that is clearly by his hand.

The mural of *The Baptism of Christ* in the Arena Chapel (fig. 61) combines several traditionally established motifs with some that are less usual.[2] In the centre of the painting is the nude Christ, immersed up to his breast in the water; to the left, angels covering their hands with cloth; to the right, two dignified figures, probably apostles. St John, wearing the hermit's hairy garment (and over it a Roman pallium), extends his right arm and places his hand on the halo surrounding Christ's head. The sky opens and in the glaring light that becomes visible one discerns the figure of God, holding a book in his left hand and stretching out his right hand towards Christ – it is hard to say whether he is pointing at Christ or whether he is trying to reach Christ's head. The introduction of God the Father instead of the dove representing the Holy Spirit is not common. Here we shall deal only with St John's gesture. What he does is to impose his hand on Christ's head.

All four gospels record the Baptism of Christ, but they do not tell us exactly how this mysterious event took place.[3] Did John the Baptist pour water on Christ's head (as was often imagined in the Middle Ages), or did he impose his hands on Christ? We do not know. Modern scholarship maintains that the story of the Baptism, as it crystallized in the Middle Ages, includes two different rites: baptism proper, which is a ritual of symbolic cleansing from sin, and imposition of the hand, which is a post-baptismal ritual calling down the spirit, or the divine grace, on the baptized person and was therefore used in ordination rituals.[4] We do not know how, or if,

[1] Behm, 1911; Coopens, 1925; Cabrol, 'Imposition des mains' in Cabrol and Leclerq, VII, p. 1, cols. 399ff.; Eisenhofer, 1932, I, pp. 268–72; de Bruyne, 1943, pp. 113–266.

[2] Art historians who carefully described and analysed the compositions of Giotto's *Baptism* usually did not consider gestures, either in their meaning or in their formal features.

[3] Matthew 3:13–16; Mark 1:9; Luke 3:21–2. John does not give any description. In none of these texts is the reader told which gestures were performed during the act. Nor do the apocryphal texts relating to the New Testament, texts which usually abound in narrative detail, suggest any gestures.

[4] The literature is of course vast, and not easily grasped. For a clear summary with particular emphasis on liturgy and ritual, see the entry 'Baptême' (by de Puniet) in Cabrol and Leclerq, II, p. 2, cols. 251–346. See also Stenzel, 1958, I. For a discussion of the imposition of hands in the early Christian baptismal ritual, see Behm, 1911, pp. 19ff., 79ff., 142ff.

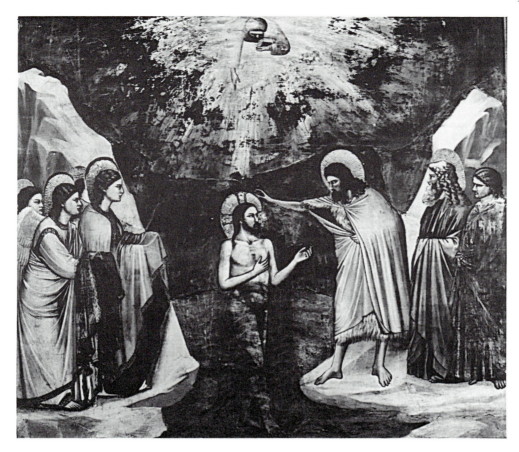

61 Giotto, *The Baptism of Christ*, Padua, Arena Chapel

the two rituals were originally related to each other. Medieval artists, however, gave an answer, though had they been asked to defend their suggestion on theological grounds, they would probably have been in trouble.

In Byzantine representations of the Baptism in illuminated manuscripts and mural painting the imposition of hands is a preferred, almost regular pattern (fig. 62; Millet, 1916, pp. 170ff., figs. 122ff.). The Baptist's hand usually penetrates Christ's halo and rests directly on his head; at least in one school the Baptist's hand rests on Christ's forehead.[5] But there are also examples – though they seem to be rare – of the Baptist's hand resting on Christ's halo as if that halo was some solid

[5] For the Baptist placing his hand on Christ's head (the skull), see e.g. Paris, Bibl. Nat., Copt. 13, fol. 8v (Millet, 1916, fig. 123) or the mosaic representing the Baptism of Christ in San Marco in Venice (Millet, 1916, fig. 130). For an example of the Baptist placing his hand on Christ's forehead, see the so called Evangile d'Iviron no. 1 (Millet, 1916, fig. 130). So far as I know, the gestures of the Baptist have not been classified.

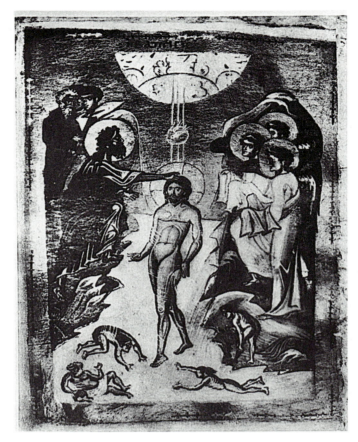

62 Rome, Vatican Library, Vat. Urbin. 2, 'Baptism of Christ'

part of the Saviour's body (e.g. British Museum, Add. MS 19352, fol. 154; Millet, 1916, fig. 143).

Western art of the Middle Ages displays a much greater variety in the posture of the Baptist's hand. There was no dominating model, as a few examples will show. In a twelfth-century ambo in Cagliari, for example, the Baptist holds a dove above Christ's head (Kingsley Porter, 1923, fig. 187); in a contemporary capital in Spain he holds a vessel (Kingsley Porter, fig. 608). There are, of course, also examples of John the Baptist imposing his hand on Christ's head (Kingsley Porter, fig. 1485).[6] In the posture of the Baptist's hand, it seems, Giotto was much closer to Byzantine than to Western artistic traditions.

[6] In the fourteenth century Christ's blessing often turns into an imposition of his hand. Cf. Kehrer, 1908–9, II, p. 195.

If Giotto did indeed follow a Byzantine model, he did not copy it faithfully in all its details. Giotto was independent of his models not only in the general character of his style, but also in the specific shape of a gesture. This is of particular significance in our case, as a change in posture, even if only slight, may indicate a different concept of the theme. In Giotto's *Baptism* (fig. 61), John the Baptist's hand, seen in profile, is half open; thumb and index fingers are fully visible, and sharply illumined; the other fingers, covered by a deep shadow, are only vaguely suggested. In Byzantine representations of the Baptism – and particularly in those where John extends his arm in a similar attitude – I could not find this particular position of the open hand. Byzantine painters depicted the Baptist placing his hand, firmly and solidly, on Christ's head. Usually the back of the hand is shown; as a rule one sees all four fingers, while the thumb never seems to be visible. It seems that Giotto did not take this specific image of the open hand from Byzantine sources.

But he used this motif several times. The contexts in which it appears tell us that this is a speaking gesture, possibly also uttering a benediction. In *The Sacrifice of Joachim* (fig. 4) in the Arena Chapel, the angel announcing the birth of a daughter to the old Joachim performs a very similar movement. Enrico Scrovegni in *The Last Judgment* (W 124) in Padua, raises his hand in a similar posture in offering a small model of the Arena Chapel. Though this gesture can here be read a little differently (Scrovegni is about to be lifted up by the angel, who extends his hand towards him), I believe that it should be understood as an expression of the donor's explaining his offering and making his request. The old Giotto used the motif on a third occasion in *Zacharias in the Temple* (fig. 6) in the Peruzzi Chapel in Florence (see above, pp. 24ff.), where the angel speaking to Zacharias performs exactly the same gesture. In all three murals this is, then, a speaking gesture. One should notice that in all three paintings the hand is held more upright than in the *Baptism*. One remembers that in Roman art, the gesture of speaking is always represented with the hand in a vertical position.[7] In the *Baptism* Giotto had to deviate from this angle. For the Baptist to place his hand on Christ's head he has to hold it horizontally. Apart from the change in general posture, Giotto kept faithfully to the shape of the speaking hand. We do not know why he did so, but we must assume that he did it on purpose. In his repertoire of gestures there are many hands which are firmly placed on an object or a figure, and some even have the general direction (from above downwards) which would suit the hand of John the Baptist in the *Baptism*.[8] What did Giotto

[7] In most cases the speaking hand shows the back of the hand, but see the pointing Jew in *Judas Kissing the Lord* (W 50; S 134). The Jew's hand is less noble and elegant than John's. The angel in *Joachim's Sacrifice* (W 9; S 92) is in character similar to John's but the axis of its position is a little steeper. See also the extended hand of the sitting angel to the extreme left in *The Angels on the Sepulchre* and *Noli me tangere*.

[8] The priest firmly grasps Joachim's mantle in *Joachim's Sacrifice Refused* (W 6); in *The Marriage of the Virgin* (W 18) the priest grasping the bride's and bridegroom's hands is made the focus of attention; in

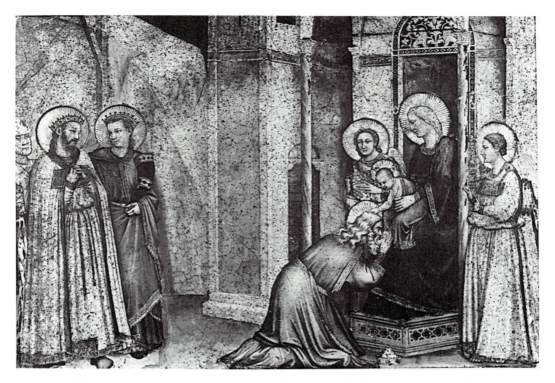

63 *The Adoration of the Magi*, Assisi, Church of St Francis, Lower Church

wish to express by this gesture? Was it the spiritual meaning of Baptism he intended to visualize by evoking the memory of speech, and making this image the centre of the whole scene?

Adoration of the Magi

The other paintings which belong to the material of the present section are not by Giotto himself; they originated in his workshop or his school. In other words, they are not only removed – more or less – from the master's personality, they are also a little later. The short span of time involved here (between Giotto himself and his close disciples) seems to have been sufficient to make the imposition of hands an accepted gesture, and to reveal its various functions and its affinity to many themes.

The Visitation (W 24) the Virgin's hand firmly holds her visitor's arm; in *The Hiring of Judas* (W 44) grasping and clutching play a particularly important part: the devil grasps Judas' shoulder, while Judas himself holds the moneybag with curved fingers.

One mural in the Lower Church of St Francis in Assisi represents *The Adoration of the Magi* (fig. 63). Scholars are agreed that this mural is not by Giotto himself, though their opinions are divided as to who may have been the painter who produced it (for older literature, cf. Thode, 1934, pp. 280ff.; Siren, 1917, pp. 113ff.). The vivid colours of the fresco and the elongated proportions of the figures depicted have reminded some students of Siennese painting. The representation of space, a little more advanced than in the Arena Chapel, suggests a date slightly later than the Paduan cycle. Yet in spite of these differences no doubt has been raised as to the fact that this mural reflects developments in Giotto's school, close enough in time to indicate something of the master's spirit.

The composition is divided into two halves. To the left two kings, surrounded by their servants and animals, are waiting to be admitted to Christ's presence. To the right (the only part that interests us here) the Virgin and child are flanked by two angels, and one of the kings, Balthasar, is kneeling and kissing Christ's foot, a traditional ritual motif.[9] The Christ-child leans towards the king and puts its little hand on Balthasar's head, penetrating the halo that surrounds his white hair. How should we read Christ's gesture? Is it a blessing? Or does it have an additional meaning?

The story of the three magi was particularly popular in the century preceding Giotto. The *Golden Legend* tells it twice, in the story of 'The Epiphany of the Lord' and in the story of 'The Innocent Children'. Pseudo-Bonaventura's *Meditations on the Life of Christ* (1961, pp. 45ff.) describes it in such vivid detail that, as a modern scholar put it, it reads almost like 'a description of a painting' (Kehrer, 1908–9, I, p. 42). At that period, mainly in the thirteenth century, the story of the three magi formed the subject matter of religious plays, performed in the church and in the open air, first in France, and then in the other countries of Western Europe (Kehrer, 1908–9, I, pp. 55ff., II, pp. 129ff.). The story was also frequently represented in the visual arts. The prevailing posture of Christ – when it is not one of hierarchic, symbolic frontality that excludes any reference to narrative events[10] – is that of accepting the gifts of the magi, or of benediction. In the latter case, the child's forearm is raised, the fingers are rendered in the position of the *benedictio latina*. A

[9] 'Kissing the feet' (*bacio di pede*) is of course a well-known liturgical gesture highly formalized both in meaning and in shape. Ohm, 1948, pp. 215ff., correctly points out that, in a precise sense, kissing the feet is not a liturgical gesture, but a demonstration of adoration and submission. The biblical origins of the ceremony are well known (Acts 10:25; Luke 7:38) and from those biblical sources they have been derived as gestures demonstrating the acceptance of the Pope's superiority, and the bishop's authority. So far as I am aware, there is no study of the *bacio di pede* as a gesture.

[10] See, for instance, a French Romanesque relief now in the University of Montpellier (Kingsley Porter, 1923, fig. 1301) and a relief in the church of St Gilles (Kingsley Porter, 1923, fig. 1386). A fine example may be seen in the tympanum of the Liebfrauenkirche in Trier, produced *c.* 1260. See Kehrer, 1908–9, II, fig. 175.

fine Italian example of around 1250, a pulpit relief by Guido Bigarelli da Como
(Kingley Porter, 1923, fig. 234), can be seen in the Cathedral of Pistoja. In the
representation of the Annunciation in the upper panel of this pulpit the announcing
angel speaking to the Virgin employs precisely the same gesture. In the first decades
of the trecento Christ's gesture sometimes changed and he is now often seen
imposing his hand on the head of the kneeling king. What intention is indicated by
this new gesture? And can we try to understand the motives for this shift in Christ's
gesticulation?

To attempt an answer to these questions it will be useful to remember that the
magi came to be regarded as saints only in the twelfth and thirteenth centuries.
Moreover, it seems to have been the people, rather than the establishment of the
official Church, who canonized the three magi–kings. One of the early expressions
of this view was the belief (apparently widespread) that the three magi had miracu-
lous healing power (Kehrer, 1908–9, I, pp. 75ff.). In the East, the adjective 'saint' is
first appended to the names of the magi in a hymn by Sophronius (Daniel, 1841–
56, III, p. 26), composed at the end of the sixth or the beginning of the seventh
century. But even in the East the belief in the magi–saints developed only slowly
(Kehrer, 1908–9, I, p. 75, n. 2). It took the West much longer to reach this stage.
The Latin formula *sancti magi* was used for the first time, so it seems, by Hildebert
of Tours, in 1139. In Germany it does not occur before the thirteenth century. In
Italy in general, and in Milan in particular, the belief in the holiness of the magi
was widespread. For centuries it was generally believed that the remains of the three
magi were buried in Milan, before they were transferred to Cologne. In 1336,
roughly at the time when the mural in the Lower Church in Assisi was painted, a
great pageant took place in Milan in which large crowds participated. The pageant
was devoted to the three magi and re-enacted their story.[11] It is also worth noticing
that only at that period, and mainly in Italy, were the magi endowed with haloes.
An eleventh-century mosaic originally from the Baptistery in Florence, the Diptych
of the Twelve Feasts, depicts the scene in a Byzantine manner (Zarnecki, 1975, fig.
342); the magi, we notice, have no haloes. We can say, then, that in the visual arts
the magi were identified as saints even later than in literature.

Some of the gestures performed by the figures in the story were fixed both by the
literary tradition and by the plays performed in most European cities. These were
mainly the kneeling posture of King Balthasar, and King Melchior's hand pointing
at the shining star.[12] Christ's posture and gestures, except for his sitting on the

[11] For the pageant, see the brief remarks by Kehrer, 1908–9, I, p. 62, n. 1. The report about the pageant is
found in Muratori, 1728, XII, p. 1018. The significance of pageants for the visual arts, particularly with
regard to gestures, is still an open problem. A careful analysis, which is made difficult by the nature of
the literary sources, could shed new light on medieval and Renaissance art.

[12] The literary sources are vague with respect to gestures. Walafried Strabo tells the reader that the magi

Virgin's lap, were not established in advance. We should like to suggest that Christ's imposition of his hands on Balthasar's head, as we see it in the mural of the Lower Church of St Francis in Assisi, may indicate the act of beatification. The general historical process of seeing the magi as saints reached its climax in that period. But how can one express visually that the magi, heathens before, become saints when they kneel down before Christ, adore him, and offer him gifts? By way of analogy to what is common knowledge. Everybody knew that a layman became a priest by the bishop's imposing his hands on him as he knelt.[13] The ceremony of ordination, the act by which the Christian is invested with the clerical function, became the model of turning the kneeling king into a saint. How else, one wonders, could a fourteenth-century artist communicate to his public the sanctification of a legendary figure?

In Western art of the mid-fourteenth century the motif of Christ imposing his hands on the kneeling magus became widespread. In Orcagna's retable of 1359 (?) in Or San Michele in Florence the kneeling magus kisses Christ's foot; at the same time Christ places his hand on the magus' head (Venturi, 1901–40, IV, p. 657, fig. 541). In a late fourteenth-century triptych in Vienna the same combination of motifs is found (Kehrer, 1908–9, II, fig. 185). The triptych is rather primitive in composition and carving; it surely did not originate in one of the artistically and intellectually advanced workshops. At this time the motif of Christ imposing his hand on the magus' head must clearly have been common knowledge, and generally accepted, to have found its way into the work of a rather backward workshop.

Coronation of the Virgin

Let us now turn to the third painting in which the imposition of the hands is represented, a panel in the Medici Chapel in Santa Croce depicting *The Coronation of the Virgin* (fig. 64).[14] While this painting is not by Giotto himself, it originates, as we have already mentioned in an earlier chapter, from the master's workshop, and was done by a prominent follower of the early Giotto tradition in Florence.

'greeted' the star with excitement (see Rambach, 1817, pp. 202), but does not specify the gesture. Neither the *Golden Legend* nor the *Meditations on the Life of Christ* suggest that the magi pointed at the star; they only tell us that the magi followed the star. In the visual arts, however, expecially after the eleventh century, the rendering of one of the magi pointing at the star becomes frequent. See Kehrer, 1908–9, II, figs. 32, 34, 35, 75, 127, 142, 162, 163, 167, 186, 187, etc.

13 The origins of this ceremony go back to the Old Testament (Num. 27:18; Deut. 34:9) and to Roman customs (see Kleinheyer, 1962). For a concise summary of the medieval discussions of ordination by imposition of hands, see Suntrup, 1978, pp. 303–7.

14 There is no need here to go into the complex problems of authorship, on which scholarly opinion does not always agree. Whoever was the artist who executed this altarpiece, he must have been intimately familiar with Giotto's art, and in gestures he may be said to reflect the motifs common or accepted in the master's workshop.

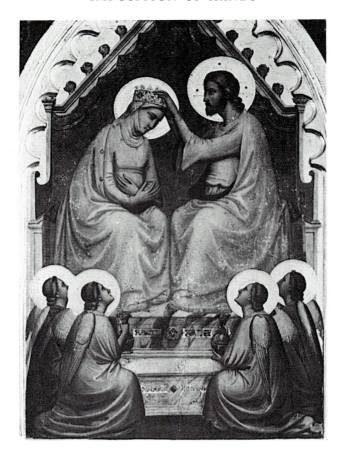

64 *The Coronation of the Virgin*, Florence, Santa Croce, Medici Chapel

In this painting Christ and the Virgin sit on the same throne, though he is somewhat taller. The Virgin bows her crowned head slightly, and Christ, turning towards her, places both hands on her crown. Christ's gesture is not easily read. Does the posture of his hands suggest that he has just placed the crown on the Virgin's head? Or does the gesture evoke the symbolic ritual of the 'imposition of hands', without being tied to a specific action?

Comparison with other representations of the Coronation of the Virgin does not help us very much in reading Christ's gesture or establishing its meaning. In the great thirteenth-century renderings of the scene, specifically in France, there is no physical contact between the two figures. In Jacopo Torriti's great mosaic in Santa Maria Maggiore, Christ places the crown on Mary's head with one hand, while in

the other he holds open a book.[15] As far as I could determine, renderings of the scene in which Christ, in a ritual gesture, places both hands on the Virgin's crowned head are unknown around 1300. Jacopo Torriti's mosaic may even serve to show that the placing of Christ's two hands on the Virgin's head was unknown, or not accepted. Had it been known, one argues, Torriti would have used it.

Now, can it be that we are misreading the gesture, and that the painter's intention was to depict Christ placing the crown on the Virgin's head? In the work of Giotto himself we find no precise parallel to Christ's gesture in *The Coronation of the Virgin*. However, Giotto depicted many gestures of holding and grasping, and from them we can infer something for the correct reading of the gesture in *The Coronation of the Virgin*, though this work was produced in his workshop. In Giotto, hands holding an object are never simply placed on something, as with Christ in our *Coronation of the Virgin*. The painter of this panel was surely familiar with Giotto's work. If he in fact employed the master's 'idiom' for holding, he probably wished to portray Christ not as holding the crown, but as imposing his hands on the Virgin.

Such an imposition of hands can be an expression of blessing. As is well known, benediction is often performed by placing the hands on the blessed. The Gospels lend authority to this act. Little children were presented to Christ 'that he should put his hands on them and pray...' (Matthew 19:13ff.). In the Gospel of Mark the intention is made even clearer: 'And he took them up in his arms, put his hands upon them, and blessed them' (10:16). Judging by these and countless other examples, one may infer that in *The Coronation of the Virgin* Christ is depicted blessing the Virgin after he has placed the crown on her head.

Still another connotation is evoked by Christ's gesture. It belongs to the realm of coronation ceremonies. One of the interesting features of the political and religious ritual of the coronation was its division into two acts, the placing of the crown, and the anointing of the new king's head. In the imagination of the Middle Ages the two acts merged into one process, richly endowed with symbolic connotations. Is it possible that *The Coronation of the Virgin* from Giotto's workshop was meant to evoke the memory of crowning and anointing the queen of heaven? Though we cannot be sure, it may well be that this was what instantly emerged in the mind of a fourteenth-century spectator.

[15] Cf. Oertel, 1953, p. 61 and n. 109. Oertel considers the possibility that what Torriti actually represented is the 'Enthronement' rather than the 'Coronation' of the Virgin.

CHAPTER 8

GRASPING THE WRIST

In the first chapters of this study I dealt mainly with gestures made by single figures. Now I shall turn to gestures which join figures together and turn them into groups. One of the oldest gestural formulae for the interaction between individuals is the grasping of hands, one figure taking the other's hand – the handshake. Only one other motif equals the handshake in frequency of representation and in its venerable history: the joining of two figures by means of gaze. The grasping of hands, though usually clear and simple, is a gestural situation capable of many nuances: a slight change in form, as we shall see, can bring about a change in meaning. Few gestures, we are not surprised to note, are more ambiguous than the grasping of hands.

Among the many meanings of our motif the one most important for the present study may be termed the 'magic' one. It originates in spheres of thought and imagery far removed from the merely conventional connotation that the gesture now carries. Physical touch is the carrier of the life force. Something of a figure's power and vitality is transferred to the person who holds that figure's hand. This is probably why the handshake could become, as early as the first century B.C., a way of visibly proclaiming the ruler's legitimation. The god, shaking the ruler's hand, transfers something of his own divine nature into the king's person. Thus the king becomes the 'Epiphanes', the man who makes the invisible god manifest in his own person.[1]

I do not propose to retrace the history of the handshake in European imagery, a subject not yet sufficiently explored; nor can I present all the meanings this gestural situation served to manifest. I turn to Giotto's depiction of this complex motif, and of the role it plays in his art.

Giotto presents the handshake in several, clearly distinct types, differing from

[1] To give but one example, we shall mention the *dextrarum iunctio* on the colossal tomb which Antioch I of Commagene erected for himself on Namrud-dagh (Cumont, 1896, II, pp. 187ff.). Different contexts and variations of the *dextrarum iunctio* are discussed by Schrade, 1930, pp. 109ff.

each other in form, content, and the message they are meant to convey. The first type can be seen in what, for centuries, remained his most famous work, the *Navicella* in St Peter's (fig. 65). The history and consecutive restorations of this work have been carefully studied. Without going into the problems posed by these studies we can say that the group of Christ grasping the hand of the sinking St Peter goes back to Giotto himself (Paeseler, 1941).

Before discussing Giotto's depiction of the gesture it is worth reminding ourselves that in the fourteenth and fifteenth centuries this work struck spectators specifically by its convincing representation of psychological states, and by the liveliness and natural appearance of the gesticulation. Filippo Villani mentions (1402) specifically 'the apostles in danger on the boat',[2] and Alberti (transl. Spencer, 1956, p. 78), a generation later (1435), adduces this work as the only modern one.

They praise the ship painted in Rome by our Tuscan painter Giotto. Eleven disciples, all moved by fear at seeing one of their companions passing over the water. Each one expresses with his face and gesture a clear indication of a disturbed soul in such a way that there are different movements and positions in each one.

The gestures of the apostles in the boat, all based on traditional models for depicting fear, horror, and desperate prayer, are indeed the most dramatic Giotto has at his disposal. They are particularly convincing when we understand them in terms of the language of gestures current in thirteenth- and fourteenth-century art. When Alberti stresses that each apostle shows in his 'face and gesture a clear indication of a disturbed soul', he also gives us a clear indication of how these gestures were read in his time. Clarity of expression and dramatic intensity are the central values in this view.

It is interesting that Alberti mentions only the apostles in the boat, completely disregarding the actual focus of the story and the central group in terms of religious significance: the sinking Peter saved by Christ. Now let us look at that group, and particularly at the two hands, Peter's grasped by Christ's.

At first sight there seems to be nothing peculiar about this gesture. St Peter extends his hand in a plea for rescue. It is a fine, flat, delicate hand – the forerunner of Adam's hand in Michelangelo's *Creation of Adam* – and it is in obvious contrast to the large, bulky, dramatic figure of the sinking apostle. Christ, seen in full frontal view, does not even look at his disciple; with deliberate response he touches the apostle's hand – in fact, only his fingers.

The modern spectator is struck by the discrepancy between the character of the

[2] Filippo Villani, *De origine civitatis Florentiae et eiusdem famosis civibus*, as reprinted in Schlosser, 1896, pp. 370ff. An English translation in Schneider, 1974, pp. 37ff. For the significance of Filippo Villani's chapter on Giotto, see Schlosser, 1927, pp. 261–70.

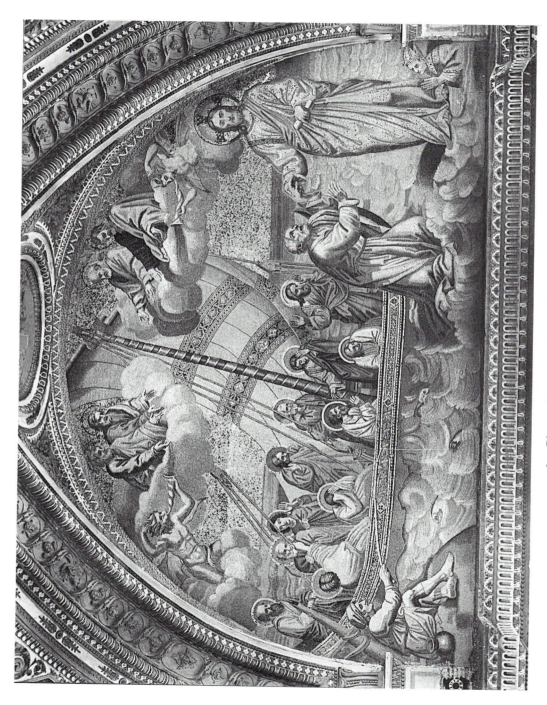

65 Giotto, *Navicella*, Rome, St Peter's

gestures performed by the apostles in the boat, and those of Christ and St Peter. The apostles, as we have already noted, perform their movements abruptly, with great energy and tension. One hides his face in horror, another abruptly raises his hands, a third covers his mouth, a fourth forcefully pulls at the sails; the artist is obviously attempting to convince the beholder of their panic. Seen against this group, the symbolic nature of Peter's and Christ's gestures is manifest. Note that neither Peter nor Christ really stretches out his arms. Peter's hand does not try to grasp and clutch, which we would expect of a 'naturalistic' rendering of a drowning man trying to save his life. Christ does not pull at the apostle to save him from death in the water; the Saviour's arms remain flexed. He does not tug at the man in mortal danger. Yet what this group lacks in emotional immediacy, it possesses in conventional clarity. Giotto here applies the clear, unmistakable formula for help and salvation, the grasping of the hand. For the Saviour to extend help means delicately to encompass with his own hand the outstretched hand of him who requests succour.

The particular gesture of Giotto's *Navicella* seems to be very rare in earlier depictions of the scene. In most medieval representations, especially in the East, Christ touches the apostle differently: he grasps Peter's arm, above the wrist. Such representations occur, for instance, in a mural of San Saba in Rome (Wilpert, 1916, p. 807, pl. 188.1; Paeseler, pp. 148ff.), and in a great mosaic in Palermo (Paeseler, 1941, fig. 131). In Byzantine manuscripts, too, the same gesture is represented.[3] Yet this gesture, as we shall shortly see, has a different, even though related, meaning.

In form and composition Giotto's group of Christ saving St Peter by grasping his hand goes back to a well-known theme of Roman political iconography, what is known as the *restitutio* motif.[4] (In literal translation *restitutio* means 'restoring to an upright position'.) Roman emperors were glorified for the restitution of *libertas* to the Roman people, for the restitution to Rome of her old fame and grandeur, for the restitution of its former dignity to a province which the emperor had conquered. In its visual formulation the *restitutio* usually consists of the figure of the emperor portrayed in the act of lifting up a – usually small – figure, the personification of Libertas, Rome, or the province, that kneels before him. We know many representations of *restitutio* from coins. The constraints of this official and concise medium forced the artist to make do with bare essentials, thus further stressing the significance of symbolic posture and gesture. In most coins the two figures face each other, the emperor thus being represented in profile or in a sharp-angled three-quarter

[3] As a single example we mention here the ninth-century manuscript containing the homilies of St Gregory Naziancence, now in Paris (Bibl. Nat., MS grec 510, fol. 170). See Omont, 1929, p. 22.

[4] The emperor's restorative benevolence was of course a motif often employed in imperial propaganda. See Sittl, 1890, p. 347, for a collection of literary passages attesting to the Roman emperors' pride in *restitutio*. For the use of the motif in Roman art, cf. Brilliant, 1963, *passim*, esp. p. 189ff.

66 Gallienus Restorer of the World, Roman coin

view.[5] In some coins, however, the emperor is shown almost full face, extending his
arm – without fully stretching it out, so that the angle between upper and lower
arms remains – to raise the kneeling figure (fig. 66).[6]

We do not know whether Giotto was acquainted with Roman *restitutio*, but to
understand the group of Christ and St Peter in the *Navicella* we do not need to
assume such acquaintance. Giotto does not follow the Roman model in the respective
proportions of the figures. Christ and Peter are drawn roughly on the same scale
while in most Roman coins the principle of hierarchic scaling makes the emperor
much bigger than the figure he lifts up. Yet in the particular gesture of the
hands – one figure's hand clasping the hand of the other figure – he is much closer
to the Roman model than to the Byzantine representations of the scene that he is
depicting.

Another work, representing a potential rather than an actual extending of help,
should also be related to the same type. It is a fresco in the Lower Church of St
Francis in Assisi, representing *Mary Magdalen and the Founder of the Chapel,
Teobaldo Pontano da Todi* (W 182). In composition this work is closer to the Roman
restitutio motif than are Christ and St Peter in the *Navicella*. The kneeling founder
of the chapel, seen in pure profile, is tiny as compared with the standing Mary
Magdalen, who is drawn on an altogether different scale. Though she looks at the
founder, and even slightly inclines her head towards him, she is rendered frontally.
In the particular gesture with which we are here concerned, Giotto deviates both
from Roman models and from traditional medieval formulations. The saint is

[5] See, for instance, the coin of the emperor Galba lifting up the kneeling figure of Roma (Bernhart, 1926,
pl. 83.13); the coin of the emperor Vespasian lifting up a kneeling figure, variously interpreted (see Toyn-
bee, 1934, pl. XVIII.16). For a review of the different interpretations see Brilliant, 1963, p. 91.
[6] See, for instance, the coin of Gallienus, A.D. 257–9 (see Grant, 1968, pl. 20, n. 6).

extending her protective right hand to the mortal founder, but he is not offering his own right hand, as is the case on all Roman coins. He grasps her right hand with his left, raising his own right hand in prayer. It is a Christian version of the Roman motif, taking into consideration the significance of prayer.

I have already mentioned a particular variation of the manual gesture demonstrating the offering of help in Byzantine representations of Christ saving Peter: let us now come back to this theme. Let us first consider a panel painting by Giotto, now in Munich, *The Descent into Limbo* (W 210).[7] Not surprisingly, Giotto's representation of this traditional theme is centred on the movement of Christ grasping Adam's hand in order to draw him, and his descendants, out of Limbo, and to lead them to eternal salvation. Giotto's composition reminds us of some Renaissance depictions of the Annunciation which Panofsky has made us see in a new light. As we remember, there is sometimes a clear difference in the quality (and probably the meaning) of the space in which the angel stands or kneels, and the space containing the Virgin (Panofsky, 1953, pp. 134ff.). Giotto divides the internal space of Limbo into two halves: one half, in which Christ stands, is illumined, has a high ceiling, and leaves ample room for the Saviour and his companions to move; the other half, containing Adam and his progeny, is low, narrow, and completely dark. A pillar divides the two spaces, which are obviously different not only in visual character, but also in symbolic meaning. Unfortunately, the pillar obstructs our view of the focus of the action: we cannot see precisely how Christ grasps Adam's hand, where specifically he touches him. We must reconstruct. Yet if we try to re-enact in our own minds the action Giotto represented, we are immediately certain that this is not an ordinary handshake; Christ grasps the first father at his wrist, or slightly above it.

In making Christ grasp Adam's wrist Giotto was not deviating from tradition, and was not particularly inventive even within that tradition. This is the gesture artists of his time employed in depicting the Descent into Limbo. The particular gesture of the Christ grasping Adam's arm we find not only in Florentine painting, but also in other schools. Duccio's *Descent into Limbo* (Brandi, 1951, pl. 87), to mention just one famous example outside Florence, differs from Giotto's in many respects. In the formation of space the Siennese artist is not as bold and original as the Florentine master; Duccio's Limbo looks like a conventional cave, frequently encountered in contemporary landscape paintings. There are also differences in significant iconographic features, such as the devil. Duccio's devil, on whom Christ treads, is an old, hairy, winged Silenus-like figure, a kind of 'wild man' of late

[7] Again we abstain from a discussion of precisely who painted the panel (and those belonging to it), Giotto himself or one of his followers. The painter, whoever he may have been, was thoroughly familiar with the types and gestures of Giotto's art.

medieval fantasy (Bernheimer, 1952). Giotto's devil is an instance of classical imagery demonically interpreted, an image that deserves closer study (but see Erich, 1931; Russell, 1977). The devil is placed at the far right of the painting, outside the cave; in body (also covered by hair) and posture he reminds us of the familiar motif of the putto with inverted torch. In front of him sits, face in hands, another hairy little putto. In their dark colouring these two putti–devils are almost absorbed into the shadow of the mountain surrounding Limbo. Yet in spite of such wide differences in composition and meaning, the focus of action – the salvation of Adam and his descendants – is identical both in Duccio and in Giotto: both artists represent Christ grasping Adam's wrist. What does this unusual gesture mean? What are its origins?

Antiquity was aware of this particular gesture, though the reflections of it that have come down to us are fragmentary. In Greek and Roman legal practice grasping, and leading, somebody by the hand, and sometimes even specifically by the wrist, had a well-defined symbolic meaning: it was an indication of taking possession of him or her.[8] Normally it is a female figure that is so grasped. The wife is *in manu mancipioque* of her husband.[9] The father, in whose 'hand' the bride was until the day of her wedding, puts his daughter's hand into that of her husband. In Greece it was often the mother who performed this action. In Nonnus' *Dionysiaca* (IV.207ff.), we have an interesting description of such a performance, composed of rhetorical formulae current among the educated classes of late antiquity.[10]

Grasping the hand, and sometimes even specifically the wrist, was also an accepted manner of politely guiding somebody. This is how a woman was led by every man, not excluding her lover. When a newly arrived guest did not know his way, the polite host would lightly grasp his hand or wrist, and lead him to the proper place, either in the house or at the table.[11]

[8] Only after completing this chapter did I come across Walter Loeschke's article on this motif.

[9] See, for instance, Aulus Gellius, *The Attic Nights*, transl. Rolfe, I, pp. 324ff.: '[A woman is called a concubine]...if she lived on terms of intimacy with a man who had another woman under his legal control in a state of matrimony', which reads in Latin: *in cuius manu mancipioque alia matrimoni causa foret*. See Sittl, 1890, p. 131.

[10] 'And then Electra took Harmonia by the hand, under the witnessing escort of the gods, and took her undowered to Cadmos as his due, wiping the streaming shower from her face.'

[11] Only a few select examples should be mentioned. Ovid, *Metamorphoses* II.691, reads 'blandaque manu seduxit' which is translated as 'drawing him aside with cajoling hand' (transl. Miller, 1946–68). Polybius, *Histories* xv.30.6 (transl. Paton, 1922–4): 'After lamenting his ill-fortune to the boy in a few words he took him by the hand and went up to the gallery.' Often in classical literature the guiding by the hand has a strong connotation of salvation from danger or misfortune. Thus, Pindar in the Ninth Pythian Ode, 122ff. (transl. Sandys, 1968, pp. 284ff.) says 'Alexidamus, when he had outstripped the rest, took the noble maiden's hand in his own, and led her through the host of nomad horsemen.' In the *Argonautica* by Apollonius Rhodius (transl. Seaton, 1912) IV.750ff. (pp. 344ff.) we read: 'Thus she spake, and measureless anguish seized the maid; and over her eyes she cast her robe and poured forth a lamentation, until the hero took her by the hand and led her forth from the hall quivering with fear.' And later on

For the specific detail of grasping the wrist we cannot rely on literature; the texts tell us no more than I have mentioned. The visual, artistic evidence, however, is more detailed. A painted vase from Ruvo (line drawing in Sittl, 1890, p. 131) provides ample testimony for the mother guiding her daughter. Both figures are standing: the bride, clad in an ornate, embroidered dress, extends her hand, and her mother grasps this hand slightly above the wrist. Both figures give the impression of walking in one direction, probably towards the bridegroom.

In the theme of Perseus saving Andromeda, frequently represented in classical art, the grasping of the wrist became an established formula for leading, yet at the same time carrying the connotation of taking possession. Many ancient representations concentrate not on the climax of the story – the killing of the monster – but on the later stages. As we know, Perseus was promised Andromeda as his wife if he saved her from the cruel monster. In a relief in the museum of the Capitol in Rome (Reinach, 1912, III, p. 198.2; Helbig and Amelung, 1912, I, p. 450, n. 806), Andromeda descends with a light, almost dancing, step from the rock to which she had been chained, the dead monster lying at her feet; Perseus delicately helps her by holding her lower arm, both leading her and taking possession of her, while at the same time she grasps his wrist. A relief in Naples represents the same scene in a more static manner (Reinach, 1912, III, p. 81.5). Again we see the double gesture: Perseus holds Andromeda's arm near her wrist, Andromeda grasps Perseus' wrist.

The same gestural motif is also employed in the depiction of other themes. On a Dionysiac relief on a vase in the Camposanto in Pisa an ecstatic maenad leads her companion into Dionysiac dance by holding her at her wrist (Reinach, 1912, III, p. 108.3).[12] Incidentally, this particular relief was well known in thirteenth-century Tuscany: it is from it that Nicolo Pisano borrowed the figure of Dionysius, transforming him into the old Simeon watching the presentation of Christ in the temple (Swarzenski, 1926, pl. 24; Panofsky, 1960, p. 68). Other features of this same relief would also have been known in Florence.

One of the most famous works of antiquity represents the grasping of the wrist twice; it is the relief, in the Villa Albani in Rome, depicting *Hermes, Orpheus, and Eurydice* (fig. 67). (How popular this work was is evidenced by the fact that two other replicas have come down to us, now in the Louvre and in Naples.) Orpheus turns towards Eurydice, she places her hand gently on his shoulder, and he grasps it at the wrist. Does Orpheus' gesture express his desire to lead her away, and to take possession of her? Yet Hermes, at the other end of the composition, now entitled

(IV.1659ff., transl. Seaton, pp. 406ff.): 'and Aeson's son took her hand in his and guided her way along the thwarts'. In none of these passages is it indicated precisely where the hand is grasped. The visual representations may be seen as a commentary regarding this point.

[12] In the same group of dancing maenads we also find the regular clasping of hands, but grasping the wrist is made particularly prominent: the maenad leading the group grasps the next figure by the wrist.

67 Rome, Villa Albani, *Hermes, Orpheus, and Eurydice,* relief
(line drawing after Reinach, 1912)

to carry her back to Hades, grasps her other wrist, again expressing, though in a
different emotional context, his resolve to take possession of Eurydice and to lead
her back to the underworld.

The few examples here adduced show, I believe, that the gesture was consistently
employed in ancient art, and that it usually carried the meaning of leading and of
taking possession.

We know very little of how this gesture survived in post-antique imagination.
Medieval literature, so far as I have been able to see, tells us very little about it
(though a final statement should of course be suspended until the great treasures of
medieval literature have been systematically sifted with the concept of gesture in
mind).

From medieval literary descriptions of the Harrowing of Hell, Florentine artists
of around 1300, even had they been familiar with them, could have learned very
little as far as Christ's specific gesture is concerned. The apocryphal *Acts of Pilate,*
as is well known, contain the first detailed report of this mythical event. Nothing is
said about grasping the wrist. We are only told about 'Christ stretching forth his
hand' to Adam (James, 1926, p. 137).[13] When the author mentions a gesture it is
an altogether symbolic one that has nothing to do with touch: Christ makes the sign

[13] The Latin version reads: 'And the Lord stretching forth his hand, said: Come unto me, all ye my saints
which bear my image and my likeness' (chapter VIII [XXIV]). The Greek version reads: 'And as Hades
talked thus with Satan, the King of Glory spread forth his right hand and took hold on our forefather
Adam and raised him up.'

of the cross over Adam (James, 1926, p. 139). Another text, composed not long before Giotto's time and enjoying an immense popularity, is the *Golden Legend*. The account of the descent into Limbo contained in the *Golden Legend* ('Resurrection of Our Lord', chapter LIII), is rich in concrete images, but it does not indicate in any way the grasping of the wrist. Christ illuminates by his presence the eternal darkness of Limbo, but what precisely were his movements? 'And he stretched out his hand, and took Adam by his right hand, and said "Be peace unto thee"..And he led Adam by his hand and delivered him to Michael, the archangel, and he [Michael] led them all to paradise.' The texts, then, cannot be considered as a channel by which the ancient gesture of grasping the wrist was transmitted. If the motif nevertheless survived, retaining much of its original form and its original connotations, this can be explained only by assuming some continuity of visual tradition.

In medieval art the grasping of the wrist was prominent in two themes, the Descent into Limbo and the Ascension of Christ. For the former motif we have no monographic study. Yet even a cursory glance at the major monuments representing this theme indicates how medieval art preserved the gestural motif. The first link in that chain was Rome, not Greece. In some Roman *restitutio* coins the emperor grasps the wrist of the figure personifying the province (there is a particularly good example in Brilliant, 1963, fig. 4.72). These coins may have served as the original models for the early renderings of the Harrowing of Hell, an event with military and imperial overtones since it was interpreted as the victory of Christ over Hades. The oldest example is probably a fresco in Santa Maria Antiqua in Rome, of the seventh or eighth century.[14] A slightly later depiction, an illumination in the Chludov Psalter in Moscow (Grabar, 1968, fig. 302) is clearer. The composition differs from what we know in later representations; all the figures are standing upright (the motif of crouching, so prominent in Giotto and Duccio, is altogether absent), and Limbo itself is not depicted. Yet Christ grasps Adam at the wrist – an unmistakable, though somewhat coarse, version of the ancient gesture. The image survived potently in the Christian East. An imposing eleventh-century mosaic in Torcello represents the same scene. Composed in a hieratic manner, it is altogether different from the earlier renderings just mentioned, yet the saving gesture is the same: Christ clearly and firmly grasps Adam's wrist, leaving his weak hand motionless (fig. 68). The West, too, knew the gesture (to give but one example): in a twelfth-century stained glass window of the cathedral of Le Mans (Mâle, 1953, fig. 94), representing *The Descent into Limbo*, the whole scene is again different from what we know in

[14] For a recent survey of this theme in art, see Lucchesi Palli, 1963. For the imperial connotations of the Harrowing of Hell, especially as perceived in Byzantium, cf. Grabar, 1936, pp. 245ff. And see also Mâle, 1953, pp. 104ff.

68 Torcello, *The Descent into Limbo*, mosaic (detail)

eastern depictions, but Christ is still grasping Adam's wrist. The position of the
hand is somewhat different from the Byzantine models, but the motif of grasping
the wrist is unchanged, and clearly displayed.

Medieval representations of the Ascension of Christ have been studied several
times, and in some of these studies attention has been paid to the gestures (Gutberlet,
1934; De Wald, 1915; Schapiro, 1979, pp. 267–87; Schrade, 1930). Strangely
enough, the specific gesture of grasping the wrist, which often appears in artistic
renderings, has never been discussed and seems never to have been noticed.

Probably the earliest representation of Christ's Ascension, an ivory now in
Munich, is a work of the fifth century, most likely of Gallic origin (fig. 69; Morey,
1942, fig. 144). We find our motif in that ivory, but in a rather vague form that
allows for varying readings. Christ is climbing to heaven (a well-established mode
of representing the Ascension), and from above a hand is extended, God's hand,

69 Munich, National Museum, *Three Marys at the Sepulchre; Christ Ascending*, ivory

which clasps the outstretched hand of Christ. The very appearance of this hand is problematic; the literary tradition – both the sacred texts of the New Testament and the less sacred ones of the Apocrypha – does not mention a hand. If it is indeed God's hand (that is, the hand of God the Father), it raises serious theological difficulties. It is not our task, however, to explore the theological intricacies of our image: we must rest content with a discussion of the gesture. Yet is is hard to say what specific action the two hands, God's and Christ's, are performing. Does the hand coming forth from heaven simply shake Christ's hand, or does it envelop it? Looking carefully it seems that God's hand reaches further than Christ's, that the thumb grasps Christ's wrist. We are probably not too rash in assuming that the anonymous fifth-century artist was familiar with the ancient gesture of clasping the wrist, in its classical form and meaning. Such an expensive, elegant work as the Munich *Ascension* must have been commissioned by a patron belonging to the upper classes, where polite manners, as learned from Greece, would have been known and respected.

In most later representations of Christ's Ascension the motif of grasping the wrist was not employed, yet it still appears frequently enough to permit us to postulate a continuity of representation, though this continuity is not visible in all its stages. Grasping the wrist was a popular motif in Carolingian and Ottonian representations of the Ascension. In the Drogo Sacramentary the huge hand of God firmly encompasses Christ's wrist and part of his lower arm (Paris, Bibl. Nat., Lat. 9428, fol. 71v; Leroquais, 1924, I, pl. IX, pp. 16ff.); in an ivory in Berlin God's hand holds the horizontally hovering Christ by grasping him at the wrist and lower arm (fig. 70). The Ascension illumination in the Codex Egberti, consisting of sharply outlined, conventional formulae without any intention of creating an optical illusion, shows God's hand gripping the wrist of Christ, who is hovering in a mandorla (Goldschmidt, 1928, II, pl. 30; Kraus, 1879–86, pl. 68). In the tenth-century Missale from St Gereon in Cologne God's hand emerging from the heavens firmly grasps Christ's arm near his wrist (Goldschmidt, 1928, II, pl. 68). After the twelfth century other types of Ascension almost completely replaced the one we have described. Christ, in a mandorla, being carried upward by angels, is now more popular; so is the Christ who travels on a cloud (even having some support from the New Testament text); from the eleventh century the disappearing Christ, of whom only the feet are still visible, becomes common. In spite of these developments, however, Giotto was acquainted with the motif of God, or the Saviour, grasping the hand of the ascending figure or of the man who needs salvation.

Now we return to Giotto, and we ask what was his attitude to the traditional gesture. Did he reject it altogether? Did he quote it as received from tradition? Or did he transform it?

70 Berlin, *The Ascension of Christ*, ivory

Let us first emphasize that Giotto was acquainted with the gesture of grasping the wrist. We have already seen this in his *Descent into Limbo*. Yet it can also be shown in Ascension scenes. In the Peruzzi Chapel in Santa Croce he represented *The Ascension of St John the Evangelist* (fig. 71). The Evangelist is soaring up from his cell to heaven, stretching his hands upwards. In the sky Christ, surrounded by saints (all represented in half-figure), with his right hand grasps the Evangelist's left; but the Saviour is not shaking the other's hand, he is rather placing it on the ascending figure's wrist – a precise repetition of what God's hand did to Christ. There can be little doubt that Giotto took over the motif from earlier renderings of Christ's Ascension. What we see in Giotto's *The Ascension of St John the Evangelist* is traditional both in the configuration of grasping the wrist and in the meaning conveyed: Christ and the saints grasp John to lead him to heaven, into paradise;

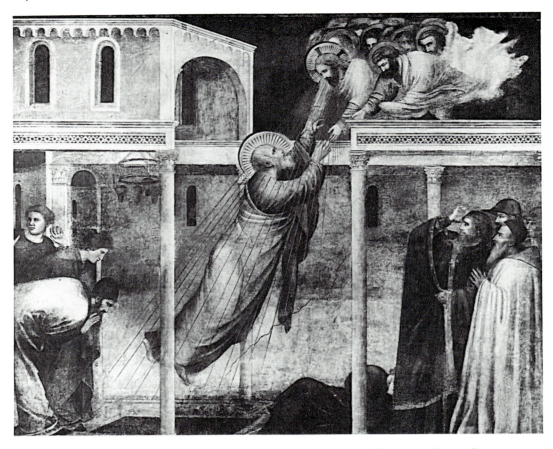

71 Giotto, *The Ascension of St John the Evangelist*, Florence, Santa Croce,
Peruzzi Chapel (detail)

they also 'take hold' of him in the sense that they are about to make another saint
of him.

Secondly we should notice that Giotto did not accept, and repeat, the gestural
motif as tradition handed it over to him; he transforms it and gives it an altogether
new interpretation. As we have seen in many of the ancient and medieval examples,
the gesture of grasping the wrist was essentially static. To be sure, it appeared also
in scenes as tense and full of movement as the dancing maenads following Dionysus,
or Christ hovering horizontally (as if in swift flight). Yet even in these works it is
the broader context which seems to infuse the gesture with life. The gestural motif
itself – in the two works mentioned as well as in all the others in which it is rendered
– is static, or 'symbolic', as we now say. One understands how it could have been
a formal legal gesture – that is, one conveying a meaning and intelligibly performing

an action without even attempting to convince the spectator that he is witnessing a real action.

Giotto, scholars and critics have often maintained, is a 'master dramatist'. His attempt to conjure up the visible world does not stop with the depiction of three-dimensional objects and figures. The human world which he portrays is a world of action. This shows in all scenes, dramatic and tranquil alike, and it is also reflected in the gestures discussed. In medieval representations of the Ascension, no matter how rich in action they may be – and some are very dramatic – the motif of God's hand grasping Christ's wrist always remains a hieratic, symbolic gesture. God's figure is not seen, only his isolated hand is depicted, which, being fragmentary in a world that does not know fragments, has a somewhat abstract character. Christ is grasped by one hand (usually the right), while his other hand has nothing to do with this action. It either holds a cross (often looking like a sceptre) or a scroll or book. In any case, the ascending Christ's left arm and hand are turned away from God's hand. God's hand grasping Christ's thus remains an isolated, abstract motif. Now, what happens to this gesture in Giotto's work? Within the framework of the inherited motif, and without exploding its formal pattern, he actually inverts the iconographic meaning and the expressive character of the gesture. In *The Ascension of St John the Evangelist* Christ and the saints are not an isolated, abstract motif, but a group of real figures emerging from material clouds. It is true that Christ grasps the ascending Evangelist in the traditional gesture, but he also extends his other hand. The anonymous saint next to him also 'lends a hand'. The ascending Evangelist responds in kind. Diverging from all Christ figures in the medieval renderings of the Ascension, John stretches forth both his hands. One, as we know, is already clasped by Christ, but the other is also close to the Saviour's left hand. Giotto clearly suggests that the Evangelist is about to be grasped by both hands.

The gesture of grasping the wrist also acquires a different meaning through the suggestion of physical effort that pervades the mural. John is not climbing up to the sky, like so many figures of Christ in medieval Ascensions; he is also not carried by a cloud. The force of gravity, significant for Giotto in general (Davis, 1974), is here made particularly obvious by the heavy bulk of the Evangelist's figure, which no force visibly counteracts. All this combines to suggest that Christ, grasping the Evangelist's arm, is actually pulling him upwards, an action in which the other saints are ready to join. In sum, then, what was originally a symbolic figuration – God's hand grasping Christ's wrist – now becomes a physical event, an act involving bodily as well as psychic energies.

When Giotto painted *The Ascension of Christ* (fig. 34), it is interesting to notice that he left out God's hand altogether (as he also deviated from accepted compositional patterns). The Saviour is soaring upwards, his feet hidden from sight by

clouds. These clouds, however, are so ethereal that, true to the text, they serve to hide Christ from the apostle's sight rather than to support his weight. He is raising his hands, but he does so lightly: this is not a gesture which can be read as expressing his expectations to be grasped or pulled, it is rather a gesture of praise or prayer. Was Giotto aware of the emphasis theologians placed on Christ ascending by his own power? Medieval theologians even bluntly rejected the idea that Christ was carried up on a cloud. 'Our Lord has no need of the cloud's aid at the ascension' says a tenth-century English preacher.[15] Nor did the angels, as Bede tells us, support him; they only escorted Christ to heaven (Schapiro, 1979, p. 270). Even the *Golden Legend*, close in time to Giotto and accessible in its popular, legendary contents, stresses that Christ ascended by his own powers. This is probably what Giotto intended to visualize in his fresco. In any case, the comparison of *The Ascension of Christ* and *The Ascension of St John the Evangelist* sheds light on how Giotto understood the motif of grasping the wrist. It supports our reading of the gesture as involving the image of physical pulling.

[15] *The Blickling Homilies of the Tenth Century*, edited with a translation by Morris, 1880, pp. 120ff., as quoted by Schapiro, 'Image of the Disappearing Christ', 1979, p. 270.

CHAPTER 9

EXPULSION

Some of Giotto's most concise and powerful gestures – gestures which have profoundly imprinted themselves on European imagery – occur only once in his work. Yet though they are not repeated, they do not suggest that the artist hesitated in rendering them, that he was groping uncertainly towards their final form. In the one case where such a gesture occurs we are instantly convinced of the master's sure grasp; we feel that he is speaking a fully articulate language, which his spectators must have understood.

The very first fresco in the cycle of the Arena Chapel presents us with such a gesture, actually a complex gestural motif; it is the fresco representing *The Expulsion of Joachim from the Temple* (fig. 72). The story, originating in the early stages of Christianity, was already told in the apocryphal Book of James (1. 2). As the childless Joachim brings his offering to the temple, we are told 'Reuben stood over against him saying: "It is not lawful for thee to offer thy gifts first, for as much as thou hast gotten no seed in Israel"' (James, 1926, p. 39; also pp. 73, 79). The refusal to let Joachim bring his offering first became later an actual expulsion from the Temple. In the later Middle Ages, when the cult of the Virgin – and also of her ancestors – became so prominent, the story was often told, in literature as well as in art, and it was embellished by narrative detail as well as emotional quality.[1] The *Golden Legend* turns the episode into a dramatic event, stressing the priest's hatred and the offence given to the god-fearing Joachim. Joachim (who, like Christ, was from Nazareth) makes the pilgrimage to the temple in Jerusalem, to bring his offerings, together with his friends. 'A priest saw him and angrily drove him away, upbraiding him for daring to draw near the altar of God and calling it unseemly that one who lay under the curse of the Law should offer sacrifice to the Lord of the Law, or that a childless man, who gave no increase to the people of God, should stand among men who have sons' (*Golden Legend*, 1969, p. 522).

[1] For the cult of the Virgin's ancestor, mainly in the late Middle Ages and the Renaissance, cf. Kleinschmidt, 1960; Hirn, 1912, pp. 214–49. Interesting insights may be found in Schapiro, 1956, esp. pp. 160ff.

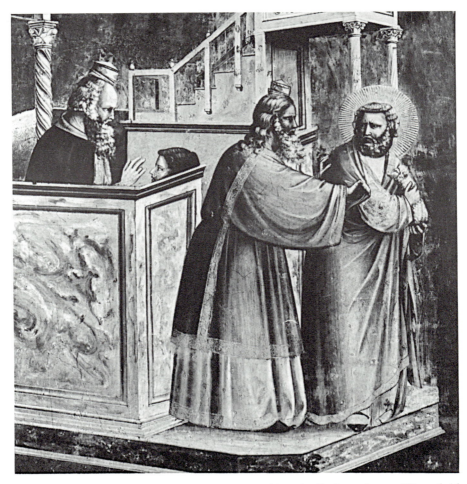

72 Giotto, *The Expulsion of Joachim from the Temple*, Padua, Arena Chapel (detail)

Giotto's picturing of the scene shows how profound his ties were with the emotional trends of his time. The representation of Joachim's expulsion from the temple is full of dramatic tension. The whole composition is focused on an unmitigated juxtaposition of inside and outside, of being protected within and exposed without.[2] Inside, shielded by an encompassing wall, a believer, obviously blessed with offspring, is comfortably seated (or possibly kneeling) while he receives the priest's blessing. Outside, the childless Joachim is expelled from the temple by a priest, who pitilessly pushes him off the platform, literally – and visibly – into nothingness.

[2] Most Giotto scholars commented on this juxtaposition. See, for instance, Toesca, 1941, p. 32, and White, 1966, p. 207.

The expulsion proper is performed by two gestures. The expelling priest touches Joachim's shoulder with his left hand, pushing him to the right, into external space. With his right hand, the rigidly stretched-out arm covered by a majestic sleeve, the priest grasps Joachim's dark, reddish-brown coat, apparently trying to pull it off his shoulder. The fingers of the priest's hand are not seen, they are covered by the mantle which he is pulling. Joachim, clutching his lamb as if it were a son, is thus caught in conflicting movements – pushed out to the right by the priest's thrusting left hand, and turned frontally towards the spectator by the priest's other hand. Joachim completes the spiralling movement by turning his head back towards the angry priest.

An artist around A.D. 1300 about to represent a scene of expulsion must have thought of the two great expulsion themes in the Western tradition, familiar to him and his spectators – Christ expelling the merchants from the temple, and the Angel expelling Adam and Eve from Eden. In these two themes the formulae of expulsion were established and displayed. Did Giotto take his complex gestural formula from this tradition? He himself represented *Christ Expelling the Merchants from the Temple* (fig. 73), in the Arena Chapel, thus affording us an opportunity of exploring his original departures from tradition. In *Christ Expelling the Merchants* the act of expulsion is represented by gestures altogether different from those in *Joachim's Expulsion from the Temple*. Christ's raised right hand, threatening physical violence rather than actually applying it, has no parallel in *Joachim's Expulsion from the Temple*. Christ's left hand, though perhaps pushing, is different in posture and character from the pushing hand of the priest expelling the Virgin's father. The complex relationship between pushing and pulling in different directions is not even intimated in *Christ Expelling the Merchants*.[3]

The other great theme of expulsion in the iconographic tradition of the West, 'The Expulsion of Adam and Eve from Paradise', was not depicted by Giotto. However, we can compare the priest's gestures in expelling Joachim with those of the angel expelling Adam and Eve in the art of Giotto's period. Since the Expulsion from Paradise was such a central scene in late medieval painting, we can be certain that Giotto was familiar with its representations.

In the various versions of the Expulsion of Adam and Eve from Paradise some gestural features recur with remarkable frequency, and they may be of significance in understanding Giotto's depiction of the priest expelling Joachim from the temple. They are, first, the expelling angel touching Adam's shoulder or upper arm (and this

[3] Since we do not have a monographic investigation of this scene in Western art we cannot be definitive about the gestures Christ performs in the representations. Though Adam's and Eve's clothing attracted some attention even in medieval art (see the silver panel on the shrine of St Isidore, A.D. 1063, with a representation of 'God the Father Clothing Adam and Eve') I cannot recall any rendering of the Expulsion from Paradise in which either Adam's or Eve's clothes are pulled.

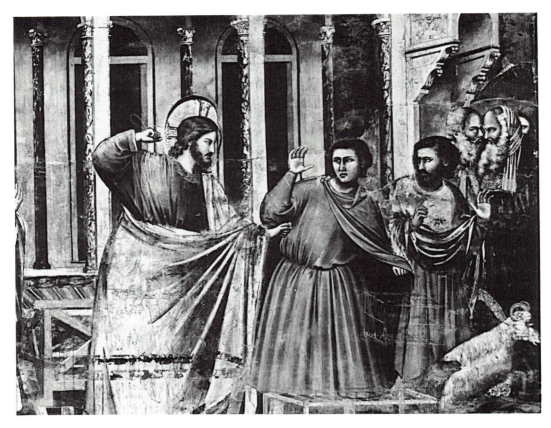

73 Giotto, *Christ Expelling the Merchants from the Temple*, Padua, Arena Chapel (detail)

gesture, in fact, must be understood as the formal execution of the expulsion); and, secondly, the *contrapposto* stance of Adam, who, marching forward, turns his face, or upper body, backwards, to the angel behind him or to the Paradise he is leaving for ever. The latter gesture is less articulate than the former, but in most depictions it is also easily legible. These gestures are already fully developed in Carolingian manuscript illumination, and they belong to the stock of motifs commonly employed in depictions of the scene. Some of the most famous Carolingian manuscripts show the angel's pushing hand with great clarity (Moutier-Grandval Bible, British Museum, Add. MS 10546, fol. 5v; Bamberg Bible, Bamberg A 1.5, fol. 7v); the *contrapposto* of Adam's figure is less outspoken, but also intimated.

In the imagery of the twelfth and thirteenth centuries, it seems, the Expulsion of Adam and Eve from Paradise became an even more popular theme than it had earlier been, and its depictions underwent many variations. Yet the two typical gestures

remained predominant, a general characteristic of the scene. It is not for us here to discuss the many examples. Let us only mention a frieze in Santiago di Compostella: in the representation of our scene (Kingsley Porter, 1923, fig. 675), the Lord (his halo bearing the sign of the cross) is presented in broad frontal position, placing his huge hand on Adam's upper arm; our forefather, walking towards the right, away from the Paradise left behind him, looks back at the Lord, and thus performs a twisted, spiral movement. Adam's instability (maybe an image of the ambiguity of his moral nature) and the conflicting drives of his soul are revealed in this *contrapposto*, and in his crossed, seemingly dancing, legs. The Lord's huge hand, placed on Adam's arm (sometimes on his shoulder), is the central implement of the expulsion – much more so, one should say, than the 'flaming sword' of which the Bible speaks (Genesis 3:24). It should be noted, however, that this huge hand is usually not seen as expressing anger, it does not touch Adam in fierce violence. When medieval artists wished to portray a violent Expulsion from Paradise (and this happened only rarely), they employed altogether different gestural motifs. A twelfth-century capital in Clermont-Ferrand (Kingsley Porter 1923, fig. 1173)[4] intimates how a *violent* Expulsion was pictured: a ferocious angel expels Adam from Eden by pulling at his beard, Adam leads Eve by tugging at one of her braids. The gesture of placing the hand on the expelled man's shoulder is here altogether missing, and the angel's hand plays a subordinate part.

In Italian painting of the Middle Ages, a tradition that Giotto may be assumed to have known, we find interesting variations on the angel's gesture. In the so-called Barberini Giant Bible (a manuscript produced around A.D. 1100) the angel expels Adam with both hands; his left hand pushes at Adam's hip (anticipating the gesture of Christ's left hand in Giotto's representation of *Christ Expelling the Merchants from the Temple* in the Arena Chapel), his right hand – rather traditionally – pushes Adam's shoulder (Ladner, 1931, pp. 52ff.). Another early Italian representation of the scene is the mural in Sant' Angelo in Formis (Bertaux 1904, p. 254; Ladner, 1931, p. 77). Here it is Eve who, looking back, is being pushed out of Paradise by the angel. In Sant' Angelo in Formis, too, the angel pushes Eve with both his hands, but they rest close to each other on Eve's shoulder, and both perform the same action of pushing.

The pushing hand – a shorthand formula of Expulsion – is known not only as a concise feature of biblical iconography, it is also a standard symbolic shape in judicial procedures of the late Middle Ages. Once more we must look at that inexhaustible treasure house of symbolic gestures, the *Sachsenspiegel*. Amira, in his well-known

[4] This type of representation, however, is an exception. As a rule, the angel holds Adam's hand rather peacefully. See, for instance, the capital in Toulouse with the representation of the same scene, Kingsley Porter, 1923, fig. 316.

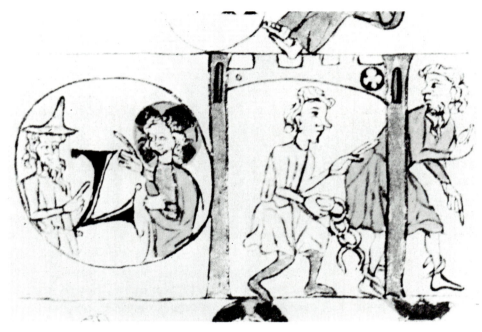

74 Heidelberg, Univ. Bibl., Codex Palatinus Germanicus 164, III, 42, §4

study of hand gestures in illuminated manuscripts of the *Sachsenspiegel*, counts the
pushing hand among the 'representing gestures' (*darstellende Gebärden*: Amira,
1909, p. 253). The gesture, imitating the forceful removal of a figure or an object
from a place, suggests the legal removal of somebody from a right: from access to
an inheritance, a wife, etc. In the illuminated *Sachsenspiegel* manuscripts we do
indeed find various scenes in which the pushing hand, strongly suggesting expulsion,
plays a highly visible and yet symbolic part. In churches and churchyards, for
example, no enfeoffment is allowed to take place. The illuminator illustrates this
prohibition by depicting the church guardian expelling the baron (identified by his
crown) and his accompanying fief from the churchyard gate (*Sachsenspiegel*, ed.
Koschorreck, 1976, fig. 13). He performs the expulsion by pushing the nobleman
off the church territory; the guardian's hand rests on the baron's shoulder very
much as the angel's hand rests on Adam's shoulder. The freeing of a prisoner is
similarly visualized. In the fiftieth year everybody, whether he wants it or not, ought
to be freed. In the Heidelberg manuscript of the *Sachsenspiegel* we see an old prisoner
being freed: his guardian has broken the chains, and is now pushing the prisoner
out of the prison gate by placing his hand on the old man's bent back (fig. 74). These
two examples might still be conceived as representing real events; the third is purely
symbolic: a judge is performing a legal divorce by pushing wife and husband in

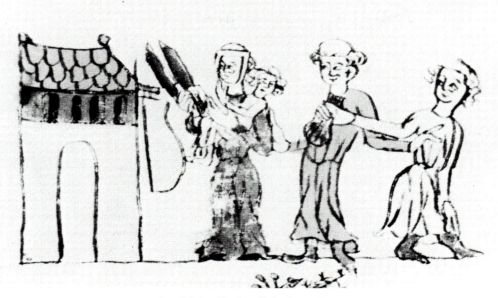

75 Heidelberg, Univ. Bibl., Codex Palatinus Germanicus 164, III, 74

opposite directions (fig. 75). At least in part, the judge performs exactly the same gesture as the angel in the Expulsion of Adam and Eve: he places his hand (which, to attract attention to the legal action it performs, is oversized) on the divorced man's shoulder (ed. Koschorreck, 1976, fig. 100).[5]

Let us now come back to Giotto's fresco, and particularly to the priest's right hand, forcefully pulling Joachim's mantle. Should this movement be read as an attempt to tear off the cloak, perhaps symbolizing the divestment of liturgical rights, or does it only represent the physical effort invested in pushing Joachim out of the temple's precincts? Could we identify the garment itself, the answer to our question might be simpler. But it is not easy to say just what kind of mantle this is. The priest's garment – a green upper dress, comparatively short, with wide sleeves, richly decorated with wide embroidered hems, worn over a long, white under-garment – is easily identifiable as a dalmatic, a traditional liturgical vestment, worn by the priest during Mass.[6] Joachim's dress, however, is not as unequivocally

[5] It is interesting to note that the judge pushes the woman by grasping her upper arm, close to the shoulder, and the man by pushing him at the hip, or slightly above it, thus agreeing with some renderings of the Expulsion of Adam and Eve from Paradise. Is there a hidden tradition behind this correspondence?

[6] For the dalmatic and its history, cf. Braun, 1907, pp. 247ff. In the thirteenth century the length of the dalmatic did not exceed 130 cm (see Braun, 1907, p. 273), a length that would roughly correspond to what can be seen in Giotto's fresco. According to Roman custom the decoration of the dalmatic consisted of embroidered stripes (*paraturae*), also faithfully depicted by Giotto in the priest's ceremonial drapery.

identifiable. He wears a long, sleeveless mantle, more modestly embroidered. It could be read as a (somewhat imprecisely represented) ceremonial prayer dress, but it can equally well be understood as a festive garment, worn on the occasion of the visit to the temple, but not itself a liturgical implement. (It is worth noting, however, that it is purple, the colour prescribed for St Anne's day since the thirteenth century.)[7] The garment itself, one notes, does not offer any definitive solution as to the meaning of the priest's gesture.

Divesting somebody of his garment, especially of his ceremonial cloak, has apparently always been perceived as a symbolic act of great intensity – a degradation, an offence, or a curse. References already abound in the Bible. The prophet Ezekiel (16:39) curses his people: 'And I will give thee into their hand, and they shall break down thy high places: they shall strip thee also of thy clothes, and shall take thy fair jewels, and leave thee naked and bare.' This, and similar, biblical images impressed themselves profoundly on European memory. The cloak became a symbol of religious dignity. At the very climax of the Crucifixion we are told by the Evangelist: 'And they crucified him, and parted his garments, casting lots: that it might be fulfilled which was spoken by the prophet. They parted my garments among them, and upon my vesture did they cast lots' (Matthew 27:35). In late antiquity and in the Middle Ages, the ceremonial robe – both royal and clerical – was not considered as a neutral object; it was invested, as is well known, with symbolic meanings, so much so that the robe could stand for the office or function.[8] The medieval public must have been familiar with the fact that the ceremony of installing somebody in office often was – in form – a ceremony of clothing him.[9] 'Investiture', one remembers, means clothing. The pulling off of a ceremonial cloak was a less familiar sight, but it looms large in the imagery of the late Middle Ages. It was only towards the end of the Middle Ages that the cycle of Christ's Passion was enriched by a scene not conceived earlier as a stage in itself: the divesting of Christ of his robes at the beginning of the Crucifixion. The meaning of the scene is clear: it is an attempt to forcefully take away, together with the mantle, the dignity of the Redeemer. Tearing off the coat thus became an expression of degradation and

[7] Braun, 1907, p. 736. Braun refers explicitly to sixteenth-century sources; so far as I was able to see, earlier sources do not say anything about the subject. Customs of this kind, however, change only slowly, and one may therefore suppose that in earlier times it was also usual to wear purple on St Anne's day.

[8] The right to wear clerical garb was a privilege, reserved for the clergy only. A cleric could be punished by depriving him of his right to wear the garb. During the period of deprival the priest was not permitted to perform any ritual function. The significance of robes is also manifested in the strictly prescribed order in which the priest puts on the individual pieces of liturgical vestment.

[9] See the studies on coronation ceremonies in the Middle Ages. In these ceremonies, to be sure, the robe is only one item among many, and the others (crown, sceptre) may be even more important, yet the robe, too, plays a major part. Cf. Schramm's study of 'Otto I. Königskrönung in Aachen (936)' in Schramm, 1969, III, pp. 33–58, esp. pp. 52ff. And see also pp. 77ff. in the same volume.

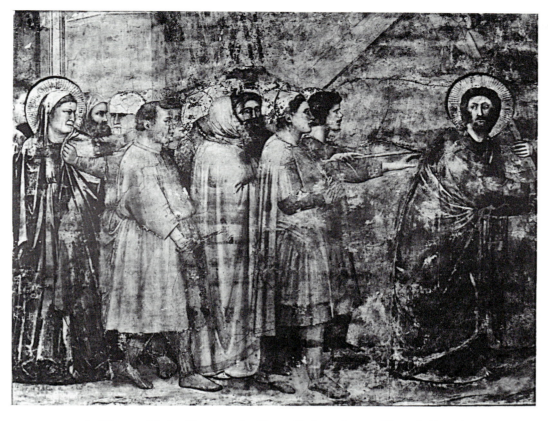

76 Giotto, *Christ Bearing the Cross*, Padua, Arena Chapel (detail)

debasing, a burning offence, in addition to representing the beginning of the tragic process.

In Giotto's work – particularly, it seems, in the frescoes of the Arena Chapel – the large upper cloak often plays an expressive role that has some affinity to gesticulation. In *Joachim Retires to the Shepherds* (fig. 21) Joachim's acceptance of the humiliation he has just experienced is expressed by his hiding his right hand in the fold of his wide cloak; in *The Pact of Judas* (fig. 77) the characters of the devil, the traitor, and the sinister priest are manifested in the colours of their mantles; in *Judas Kissing the Lord* (fig. 59) the enveloping of Christ by the yellowish cloak of the treacherous apostle is a central gestural feature (which is missing in most other contemporary representations of the scene).[10] One is not surprised that our master

[10] In Duccio's rendering of the scene, now in Sienna (see Brandi, 1951, pl. 65), Judas does not embrace Christ. Here the traitor's mantle is hardly seen: it plays only a marginal part.

should have used Joachim's cloak to express thus powerfully the emotional violence done by the priest to a venerated figure.

In the Arena Chapel Giotto once more painted the same gesture of pulling the coat, or a gesture closely related to it. In *Christ Bearing the Cross* (fig. 76), we see the Virgin (at the extreme left of the picture), coming out of the city gate, to follow her son who is bearing the cross, but she is brutally pushed aside by a beardless figure wearing a helmet-like headgear, obviously a Roman soldier. He grasps the Virgin's cloak, and forcefully tugs it towards the left, out of the picture – that is, in the direction opposed to that of Christ bearing the cross. The Virgin, thus suddenly prevented from following her son, turns her head towards Christ. In the corner of this fresco we have, then, a combination of pictorial motifs close to what we have seen in *The Expulsion of Joachim from the Temple* – the pulling at the cloak, together with the *contrapposto* stance of the figure attacked. The Roman soldier's gesture also carries a definite emotional connotation which is not too far removed from that suggested by pulling the Virgin's cloak in the direction opposite to the one she wishes to pursue; it is a brutal vulgar attack on her non-aggressive humility, an exposure of her helplessness, a derision of her inner sanctity. Pulling somebody's coat was clearly an expressive formula for Giotto.

Did Giotto invent this formula? Was he the first to combine it with pushing? The study of gestures is in too initial a state to enable us to give a clear-cut answer. It is only an impression when we say that here Giotto does not seem to have handled established gestural formulae, and that it was his power to create such formulae that produced the movements of the priest evicting Joachim from the Temple.

CHAPTER 10

THE PACT OF JUDAS

'Then one of the twelve, who was called Judas Iscariot, went to the chief priests, and said unto them, "What will you give me, and I will deliver him unto you?" And they covenanted with him for thirty pieces of silver' (Matthew 26:14–15).

The hiring of Judas by the High Priest is reported, or at least alluded to, in all the synoptic gospels (Matthew 26:14–16; Mark 14:10–11; Luke 22:3–6), and the story does not disappear in later periods. It is referred to in the apocryphal writings related to the New Testament in the *Story of Joseph of Arimathea* (James, 1926, p. 162). In the Middle Ages, too, the story was told. The *Golden Legend* portrays Judas as a figure fully befitting a Greek tragedy. Judas, like Oedipus, has unknowingly killed his father and married his mother. To atone for these sins he joined Christ ('Story of the Apostle Matthew'). But he could not overcome his character: his greed for money got the better of him.

Yet, though the story of the High Priest hiring Judas was never forgotten, it remained marginal in the early Middle Ages, an event mentioned but not elaborated. In the eleventh and twelfth centuries, when cities began to grow rapidly and the economy of money became dominant in Western Europe, the story became more popular, both in religious and in secular contexts. As far as the religious context is concerned, the story was considered as the true beginning of the Passion. Judas bargaining with Caiaphas, the High Priest, for the life of Christ was realistically represented in the opening scenes of Passion plays. The Montecassino Passion play is probably the most famous example (Sticca, 1970, p. 63; Ingnanez, 1936, pp. 7–38). It also became popular in the context of sermons against usury, a fearful example of the demonic power of money. Usury, it need hardly be stressed, played a prominent part in the history of the Arena Chapel. The chapel was erected by Enrico Scrovegni (Scardeonius, 1560) to atone for the sins of his father, Reginaldo, who dealt in usury, and was immortalized by Dante (*Inferno*, XVII, 64–75), as suffering for this sin in the Inferno.

155

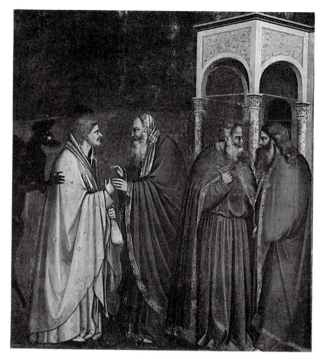

77 Giotto, *The Pact of Judas*, Padua, Arena Chapel

Now let us turn to Giotto's representation of the hiring of Judas in the Arena Chapel. We shall first look at the fresco as a whole, and only after that analyse the individual gestures. *The Pact of Judas* (fig. 77) is remarkable in many respects. The positioning of the scene within the comprehensive iconographic system of the Chapel has in itself given rise to wonder. Scholars have noticed that, in spite of a well-established iconographic tradition, Giotto omitted the hiring of Judas from the chronological sequence of the events represented (Alpatoff, 1974, p. 117; W, p xix). Duccio inserted *The Pact of Judas* between *The Washing of the Feet* and *Judas Kissing the Lord*. Had he followed the story precisely the Pact of Judas would have preceded the Washing of the Feet. As we know, the Washing of the Feet forms part of the Last Supper, and all the Gospels agree that the Hiring of Judas took place earlier. Duccio placed the Pact of Judas in this particular spot of the *Maesta*, probably as some kind of flashback, to prepare the spectator for the next scene, *Judas Kissing the Lord*. Giotto took the scene out of the chronological sequence of events represented, and placed it next to the great arch, on the eastern wall of the Chapel. Above it is the angel of *The Annunciation* and across the arch *The Visitation*. Why did Giotto place *The Pact of Judas* in this unexpected site? Rintelen (1923, pp. 30ff.) and other

scholars who followed him, have suggested what they call 'purely artistic reasons'.[1] When Giotto was about to paint *The Pact of Judas*, *The Visitation*, the companion fresco across the arch, was already completed, and none of the following scenes could, in their decorative structure, be made as similar as is *The Visitation* to *The Pact of Judas*. Though a certain compositional similarity between the two exists, it is difficult to accept such an aesthetic explanation, which may be appropriate for our time but would most likely not be acceptable in the early fourteenth century in Padua. Other explanations suggest themselves, though it would be difficult to prove that they actually provided Giotto's motivation for the placing of the scene. May we not assume that, as the Visitation is the beginning of Christ's real life on earth (as opposed to the Annunciation), so the Pact of Judas is the real beginning of the Passion (as opposed to the Entry into Jerusalem)? One is reminded that, as we have already mentioned, the contemporary Passion plays often begin with Judas and Caiaphas discussing the pact they are about to conclude.

But the network of suggested relationships is even more closely knit. Just behind *The Pact of Judas*, on the left wall, we find the representation of *Christ Expelling the Merchants from the Temple* (fig. 73). The idea of money and commerce as a sin, particularly as one violating the religious sphere, is common to both frescoes, and confers on them a hidden unity. The expression of this attitude towards money begins with *Christ Expelling the Merchants* and reaches a climax in *The Pact of Judas*. As we shall shortly see in detail, the same figures appear in both frescoes, thereby establishing a kind of personal continuity leading from one scene to the other.

Looking at the fresco itself one is struck by the dramatic concision dominating it.[2] Succinctness is characteristic of Giotto's art in general, yet nowhere does this characteristic reach a more incisive expression than in *The Pact of Judas*. It is enough to compare Giotto's representation with that of other masters of the same

[1] Since Giotto did not want to leave the 'narrow walls without decoration', Rintelen, 1923, maintained, he found themes which 'sich auch auf beschränkten Feld wirksam durchführen lassen'. Even Alpatoff, 1974, who deals with an iconographic programme, believes that 'the painter was interested not so much in the meaning as in the visual likeness of these two scenes [the *Hiring of Judas* and *Christ Expelling the Merchants from the Temple*], a likeness heightened by color'.

[2] It is interesting to notice that critics and historians have emphasized either epic breadth or dramatic concision as the feature most characteristic of Giotto. Already Burckhardt, 1869, p. 763, observed that Giotto emphasized in 'every fact its most significant aspect', thus suggesting brevity. Similarly Rintelen, 1923, pp. 11ff., Dvorak, 1927, I, pp. 15, 41) finds that Giotto replaces confusing abundance of detail by a clear arrangement suggestive of the scene taking place on a stage in front of us. Yet later he also finds in Giotto 'epische Seelenschilderung' (p. 31). In *The Resuscitation of Drusiana* Dvorak misses a 'vivid, dramatic element' (p. 41). Oertel, 1953, p. 63 finds in Giotto a juxtaposition of 'Schlichtheit des Legenden-tones' (which suggests epic narrativity) and 'hohe und strenge Monumentaltät' (suggestive of dramatic brevity and concision). White, 1957, pp. 57ff. believes that Giotto's 'story telling' shows less interest in the haphazard detail of the visible world, concentrating on 'dramatic essentials'.

time, say Duccio, to see this instantly. In his *Pact of Judas*, Duccio tells his spectators an extended narrative, rich in details and sidelights, about what happened in the meeting between Judas and the High Priest; Giotto attempts to comprise the whole story in the tense juxtaposition of the two figures, the rest being only marginal.

In Giotto's *The Pact of Judas* all the figures are shown in sharp, crisp profile. It may be worth our while to stop here for a moment, and to look at the use and significance of the profile in Giotto's work in general, and in the Arena Chapel in particular. The frontal and the profile in medieval art have been studied by Schapiro (1973, pp. 37ff.) as 'symbolic forms', that is, as forms which lend themselves particularly well to the representation of certain meanings and are not fit for the depiction of others. Without going into a discussion of the subject it is obvious that these 'symbolic forms', as Meyer Schapiro points out, are complex forms which, without abandoning a general direction, allow for a variety of meanings. The applications of the pure profile reach from the dignified emperor on a Roman coin to the tossed-back head of a dancing maenad on a Greek vase. On the other hand, casual figures, devoid of inherent value and significance, are usually not represented in profile. Pure profile grants significance, it arrests the spectator's attention. One should also add that as a rule the full figure represented in profile view is detached from the viewer; such a representation belongs to a body in action in a space shared with other profiles. For this reason Schapiro (1973, pp. 44ff., and n. 96) believes that the profile face corresponds, broadly speaking, to the grammatical form of the third person in speech, while the frontal face, directly appealing to the beholder, corresponds to the 'I'.

In Giotto's work the pure profile is an important theme, though one that has received little attention. He was deeply attracted by the profile (as can be seen from his frequent use of this posture) and he had a profound understanding of the profile's expressive potential.[3] Certainly he did not apply the profile mould in a mechanical way, yet in looking carefully at the many renderings one reaches the conclusion that a marginal figure, one devoid of internal significance, is not depicted in profile. The rendering of a figure in profile is thus a concealed statement of that figure's significance. Often Giotto had to deviate from established iconographic tradition in order to depict a holy figure in a profile view.

The profile lends weight and importance not only to a figure, but also to a

[3] Scenes of a particularly high dramatic potential are composed mainly (or only) in profiles. See, e.g., *The Sacrifice of Joachim* or *The Annunciation* on the tribune wall. In other scenes, also of great dramatic power, the central figures are juxtaposed in profile, while the less significant figures are depicted in different stances. See, for instance, *The Meeting at the Golden Gate* (W 11; S 96), *The Visitation* (W 24; S 108), *Judas Kissing the Lord* (W 51; S 134), and *The Lamentation of the Dead Christ* (W 62; S 143). Particularly often Christ is represented in profile. See *Wedding at Cana, Christ's Entry into Jerusalem, Christ Expelling the Merchants from the Temple, The Washing of the Feet, The Ascension of Christ.* The other posture favoured for Christ is the full frontal view. See *The Young Christ in the Temple* and *Christ Before Annas and Caiaphas.*

situation. Sometimes a figure insignificant in itself, but of great importance in the evolution of the story, is represented in full profile. A good example is the girl whom Christ addresses in *The Wedding at Cana* (fig. 12).

The Pact of Judas (fig. 77) is characterized by a rare consistency in the use of profile. Never did Giotto so fully exhaust the possibilities inherent in profile. In his *Judas Kissing the Lord* (fig. 59) the juxtaposition of the two profile faces has become one of the classical images of European art, yet the bodies are not seen in profile. Judas' treacherous embrace obscures Christ's figure as well as his own. Only in *The Pact of Judas* does Giotto juxtapose two profile heads as well as figures. This distinction should not go unnoticed.

The two monumental figures of the central group, Judas and Caiaphas the High Priest, face each other closely, a pattern our master employed in several variations. In *The Pact of Judas*, however, he left a small, slit-shaped piece of empty shape between the two figures, and within that narrow space they perform their manual gestures. Only two hand movements occur outside that frame, and they point symmetrically towards the centre – the devil's hand pushing Judas to the right, and the other priest's hand pointing, in a gesture still popular in Italy, towards what is happening between the two principal figures. The four hands of the two central figures, in that split of open space, are the centre of the action. As we shall shortly see, in depicting these gestures Giotto closely followed some of the formalized gestures performed in the courts of his day.

The faces

The faces of the figures are always constant in Giotto's work; we can easily identify the more important personages. Indeed, we are familiar with three of the figures in *The Pact of Judas*, having met them in other scenes in the Arena Chapel; only the dog-headed black devil, to whom we shall shortly return, and the bearded man to the extreme right are unknown. Judas' characteristic profile is famous; it has imprinted itself on Western memory mainly from *Judas Kissing the Lord*. In shaping the traitor's face Giotto relied on the well-known tradition of representing Judas, especially in the Last Supper, in profile. In Giotto's depictions, both in *The Pact of Judas* and in *Judas Kissing the Lord*, the profile is more fully articulate and more clearly seen than in previous representations. The broken contour of Judas' profile is otherwise unknown in Giotto's work. The artist surely meant it as revealing the traitor's character.

That Giotto used the Jewish facial stereotype for the profile of Judas has been noted by modern scholarship. In Western art of the twelfth and thirteenth centuries Jews were designated not only by the well-known physiognomic stereotype; it was

78 Illustration from Giacomo della Porta, *De Humana Physiognomia...Libri IIII*

also preferred to depict them in profile, a view that makes the racial characteristics stand out more clearly.[4]

It is rewarding, we believe, to look at the individual features of Judas' face in the light of physiognomic interpretation, an interpretation that was current in Giotto's time. Judas' forehead is violently squeezed-in at eye level, as if his skull was broken. This unusual shape is particularly manifest in *Judas Kissing the Lord*, but it is also fully visible in *The Pact of Judas*. Physiognomists, those strange professionals who tried to read the human face scientifically, noted this feature in reality, and commented on it. Giacomo della Porta, writing almost three centuries after Giotto, but summarizing ideas that had been alive for two millennia, is aware of the *depressa frons*. 'According to Polemon [the second-century A.D. physiognomist]', della Porta writes, 'the squeezed-in forehead is not enjoyable. Adamantius [a fourth-century A.D. physiognomist] says more clearly: a deeply depressed forehead cannot be praised because it indicates the effeminate man.'[5] Della Porta (1593, p. 147) also mentions Albertus Magnus. That medieval sage believed that a man with a depres-

[4] For an early example of representing the heads of Caiaphas and of the other Jews in profile (in contrast to Christ, whose face is represented in full frontal view), see the *Hours of Salisbury*, of *c.* A.D. 1280 (cf. Millar, 1926, pl. 97). In a later twelfth-century Bible (Paris, Bibl. Nat. lat. 16746, fol. 80v – see Schapiro, 1973, n. 97), the apostle 'Paul addressing the Jews, sits in profile with crossed legs, but his head is a beautiful full face, while the Jews are sharply characterized in their profile heads.' Schapiro also mentions a mid-fourteenth-century manuscript of Canon Law juxtaposing 'the picture of Christians in three-quarters view arguing with heretics and Jews who have strictly profile heads with caricatured features' (for a reproduction see Blumenkranz, 1966, p. 33, fig. 26.

[5] Della Porta, 1593, p. 118. Since the original text is not always easily available I shall quote the pertinent passages. Here it reads: 'Polemon: Depressa frons non laudabilis viri signum. Adamantius dilucidius loquitur: Valde depressam frontem ne velim laudes; nam effeminati viri signum.'

sed forehead tends to cunning and anger. Yet della Porta himself 'would rather interpret it [the squeezed-in forehead] as a poor constitution of the senses and the imagination'. The whole tradition, then, considers such a forehead negatively. In the original edition of della Porta's *De Humana Physiognomonia...Libri IIII* (1593) there is a woodcut illustrating this particular feature (fig. 78). The face shown (p. 73 of the edition quoted) has a surprising similarity to Judas in Giotto's fresco.

Another individual feature may also be worth our attention. Judas' long, slanting nose, a prominent, conventional feature of his Jewish race, has also received the physiognomist's careful attention. Let us again refer to della Porta's classic text: 'Slanting noses allow us to infer a crooked intelligence and a crooked soul, say Polemon and Adamantius.' In another brief section he maintains that 'the nose curved at the beginning' indicates shamelessness; the crows, the most thievish of all birds have such beaks. People with such noses, della Porta says (p. 149), are to be taken as 'thieves and robbers'.[6] Out of this physiognomic tradition Giotto created his powerful image of the traitor: sly and demoniacally smiling in *The Pact of Judas*, passionate and sinister in *Judas Kissing the Lord*.

The two priests – the one who is negotiating with Judas, the other who stands with another bearded figure but points towards the centre – we already know; we have met them in *Christ Expelling the Merchants from the Temple* (fig. 73), the fresco next to *The Pact of Judas*. In the Temple scene the two priests stand in the background, in the right corner, looking suspiciously at what Christ is doing, putting their hands together and whispering to each other. In the *Pact of Judas* the two are brought to the front, and though they are now split into different groups they clearly belong together as representatives of a class. We shall look more closely at the features of the priest negotiating with Judas. His face, older and softer than Judas', also has a 'depressed forehead'. His round, vaulted forehead indicates, if we are to believe the physiognomic tradition, a stupid person. He has an ass's forehead. But such a big, round, fleshy forehead also fits a coarse person (della Porta, 1593, p. 117).[7] This interpretation is derived not only from classical authors. It was known in the Middle Ages, and della Porta (p. 112) writing on this type of forehead, adduces as his sources also medieval authors. Giotto, as usual, applies this shape of forehead consistently. Not only in the aforementioned Temple scene does the priest have this forehead, but the wicked priest outside the Temple has the same physiognomic feature. Look at the figure at the extreme left in *Christ before Annas and Caiaphas* (W 52; S 136). Is it only a matter of chance that when the priest carries less pejorative

[6] 'Ego hos omnes fures & rapaces dicerem. est enim propria corvorum, & aduncorum rostrorum avium rapacitas...'

[7] Della Porta refers to Aristotle's *Physiognomics*, without however quoting. He may have had in mind the passage 811b26ff., though the precise formulation does not occur.

connotations, his forehead is still high, but is not so round and protruding? We cannot prove that Giotto was indeed aware of the connotations of this particular shape, yet his consistency is striking.

The priest's fleshy cheeks would also be interpreted in a pejorative sense by any spectator familiar with the physiognomic tradition. Such cheeks, physiognomists believed, primarily indicate feeble-mindedness. They are also characteristic of sluggish people, and of such as are given to drinking (della Porta, 1593, p. 184: 'Carnosae genae inertiam & vinolentiam arguunt.').

Is this priest's head-dress a Jewish prayer shawl? It is hard to say. The decoration could be that of a ritual prayer shawl. Yet the way it is worn (wound around the neck) does not agree with the tradition. By the late thirteenth century Jews were apparently visiting Florence, though there was not yet an established Jewish community in the city. But these visits must have made some impression. As early as 1304 a sermon was preached in Florence warning against contacts with the visiting Jews[8] (who were of course merchants, related to money). Did Giotto have some vague notion of Jewish liturgical implements and use the prayer shawl as an identification mark of the Jewish priest who negotiates the treacherous deal with Judas? We shall probably never be able to give a definitive answer. It is noteworthy, however, that in all the scenes painted in the Arena Chapel only this one priest has his head covered with this unusual shawl.

The 'face' of the black devil, who is pushing Judas into the hands of the treacherous priest, also deserves attention. In the Arena Chapel Giotto painted the devil twice; each of the representations derives from a different tradition and emphasizes different aspects. In *The Last Judgment* the big, bulky Satan resides in Hell. His fat body has full, protruding volume, his legs, depicted in foreshortening, jut out from the depth. He wears big horns on his head, and he is devouring the damned. What Giotto emphasized in this figure is Satan's bestiality. In *The Pact of Judas* the devil's character is altogether different. He is only a black shadow, devoid of bulk and body. Although his head and legs are those of an animal and he is provided with wings (probably bat's wings), his slender body and restrained behaviour lend him an almost noble character. In the thirteenth and early fourteenth centuries, different features were often combined in the devil's figure. Duccio, to give one obvious example, in *The Temptation of Christ* in the Frick Collection, New York (Brandi, 1951, pl. 50) (a scene not painted by Giotto) also represented the devil as a black shadow (with some minimal modelling), but in the shape of an old man, with much hair; the devilish characteristics are rather subdued. In Duccio's depic-

[8] See mainly Cassuto, 1918, pp. 8ff. But see also Davidsohn, 1927, pp. 103ff. Davidsohn has also collected documents concerning Jews in San Giminiano in the early years of the trecento. See his *Forschungen*, 1900, pp. 327ff.

tion of the *Descent Into Limbo*[9] the vanquished devil does not much differ from the one in the *Temptation*. Giotto's devil, though also black and flat, is different.

The devil's head in *The Pact of Judas* is that of a wolf or a dog. After the twelfth century, the devil's face was sometimes represented as that of a wolf, a fox, or a dog.[10] Since the representation was usually not naturalistic or aiming at correctness, one frequently cannot say to which of these three beasts the face actually belongs. As regards the wolf one should remember what Matthew (7:15) says: 'Beware of false prophets, which come to you in sheep's clothing, but inwardly they are ravening wolves.' Is this the reason why the devil in our picture has this face? The combination of wildness and deceit, against which the Evangelist warns us, is particularly appropriate for Judas.

The devil's glowing, fiery eyes are a well-known topic in folk-lore and literature, and Giotto did not omit this feature. We cannot make out what this devil is wearing on his head. Is it a kind of crown? An object singling out the figure? Whatever it is, the shape does not carry any bestial connotations, such as horns.

Colours

How profoundly influenced Giotto was by symbolic traditions, and how much his work was determined by them, we can learn from an analysis of his colours in our scene.

The Judas Group, so clearly spread out before the beholder and yet so intricately interwoven in composition and gestures, is composed of three colour areas. Each hue is distinct from the others, each colour is completely and exclusively assigned to one figure only: the devil is black, Judas is yellow (note that not only his dress, but also the moneybag and even his hair are yellow), and the priest negotiating with Judas wears a long reddish-purplish robe that covers his whole figure. It is immediately obvious that each of the three figures is characterized by his colour no less than by the shape of his body and face. In the present study it is not our task to analyse the colours in detail; we should only mention that in assigning a specific colour to each figure Giotto moves within firmly established conventions. The sinister black is one of the characteristic features of the devil, prevalent in literature, folk-lore, and

[9] Sienna, Opera del Duomo. See Brandi, 1951, pl. 87. Here, too, the devil is covered by hair. The hairy devil is probably related to the so-called 'Wild Man', who made his appearance in the late Middle Ages. Cf. Bernheimer, 1952.

[10] For the devil's image in general, cf. Erich, 1931, pp. 64ff. For the earlier period in the history of this image, cf. Russell, 1977. The appearance of the devil as a dog has a venerable history. For the early stages see, e.g., *The Acts of Andrew*, 6 (See James, 1926, p. 339): 'He thanked God and commanded the demons to appear; they came in the form of dogs.' For the characterization of vices and sins as dogs in medieval literature, cf. Bloomfield, 1952, pp. 131, 145. See also p. 89, with a reference to Roger Bacon.

art (Russell, 1977, pp. 246ff.; Wackernagel, 1872, pp. 168ff.). Judas' yellow is of course the well-known colour of the Jews. In addition it is the colour of corruption and disgrace. In many places in the thirteenth century prostitutes had to wear yellow shawls or yellow shoes (Wackernagel, 1872, pp. 187ff.). The reddish purple worn by the priest in Giotto's period carried the connotation, in addition to royal symbolism, of sinister foreboding; it could indicate a 'dark heart', and particularly in Italy it was also the colour of mourning and distress. The many connotations of red also included sinfulness.[11]

A careful study of Giotto's use of colours as conventional means of communication is still lacking. What is important in our context is that his selection of colours in this group clearly testifies to his familiarity with accepted conventions and his intention of using these conventions for getting his message across to the beholder. Indirectly this may also shed some light on his use of conventional gesture.

Dimensions of the theme

Giotto's faithful adherence to tradition – in posture, physiognomy, and colour – sheds some light on how he conceived the general character of the scene. Judas negotiating his deal with the priest had carried powerful religious connotations for many centuries; it was also a vivid illustration of good and evil. For somebody living in Tuscany or the Veneto around A.D. 1300 – whether he was an artist, a patron, or a spectator – the scene still carried these traditional connotations. In addition, however, it had new suggestions, provided by contemporary life. Two such connotations seem to be of particular significance in our context.

First is the concern with wealth, especially in the new form of money, and the moral dangers inherent in it. Incipient capitalism, so manifest in the Florence of the period, posed problems both for the Church and for the system of beliefs and attitudes inherited from the earlier Middle Ages. In thirteenth-century Italy religious traditions formed the background for formulating an attitude to this new phenomenon. Money wealth was firmly rejected, though in reality it was precisely the money economy which was rapidly replacing all other economies and forms of wealth. In the intellectual and emotional life of the period the ideal of poverty experienced a stronger revival than in most former trends.

Under the pressure of economic developments the system of sins changed. Avarice came to be considered as the major sin, and was placed at the head of

[11] For red as a colour of sin (in addition to the many other meanings attached to it), see Wackernagel, 1872, pp. 172ff. Medieval interpreters could derive the evil connotations of red from the New Testament itself. The Book of Revelation tells us that one of the dread horses is red (6:4), the beast that the Whore rides is scarlet, she herself is clad in red (17:3–4), and the great dragon with seven heads and ten horns is red (12:3). I hope to present a detailed analysis of colour conventions in medieval and Renaissance culture in the future.

the seven deadly sins. From the twelfth century Dives was regarded as a prime sinner.[12]

The visual symbol of the new form of wealth, the aggressive, destructive money economy, became the moneybag. To give but a few examples: in the Cathedral of Amiens, Avarice, carved in stone, sits on a bench putting moneybags in an open chest (is this a reference to the God-forsaken new institution of the bank?). In manuscripts Avarice is represented as a hooded man (monk?) seated on a bench, gathering coins from a chest and putting them into a bag. The pejorative connotations of the bag are sometimes made clearly visible. Sometimes the Dives is weighed down by a huge moneybag, as can be seen in some of the major medieval monuments.[13]

In *The Pact of Judas* Giotto makes the treacherous apostle hold a moneybag. In other representations the moneybag is often lacking. Duccio (Brandi, 1951, pl. 63), for example, seems to be closer to the text of the Gospels; he shows the High Priest, surrounded by other priests, counting the pieces of silver into Judas' hand. Giotto did not tell the story in narrative detail; he designed the huge figure of Judas almost without action, but he made him hold the contemporary symbol of the new wealth, the moneybag. Whoever in the first decade of the fourteenth century represented a figure conspicuously holding a moneybag was making a statement in terms of contemporary life, and of the Church's attitude towards evolving capitalism.

The second concern is with legal procedure. An early fourteenth-century spectator looking at Giotto's fresco is likely to have noticed that the treacherous pact that Judas concluded with the High Priest is a contract; like all contracts, it is subject to meticulously established conventions. From the twelfth century on, much attention was devoted in Western Europe to articulating fine points of law – in content as well as procedure. The teaching of law attests to this. In Florence legal teaching began in the mid-twelfth century, and rapidly expanded in the city as well as in its surroundings. In the early thirteenth century close-by Pistoia was a centre of legal studies. In the same years, some of the most famous buildings in the city, such as Santa Maria Novella, became the seat of law schools. In the university of Bologna, the major centre of legal studies in Europe, students from Florence formed a prominent group.[14]

[12] Cf. Bloomfield, 1952, pp. 90ff. tracing the process of placing avarice at the head of the sins. The classic study of the subject in general – Katzenellenbogen, 1939 – does not discuss the changes in the systems of virtues and vices, or sins. Schapiro, especially in his well-known study 'From Mozarabic to Romanesque in Silo', 1977, esp. pp. 36ff., has made penetrating remarks on the subject.

[13] For the relief in the Cathedral of Amiens and for Avarice as a hooded figure, possibly a monk (see British Museum, Add. MS 28, 162 fol. 9v), see Bloomfield, 1952, p. 199.

[14] The intensification (often called Revival) of legal studies after the twelfth century has of course been thoroughly studied. Still very useful for our purpose is the rapid overview given by Haskins, 1927 (many reprints), chapter VII ('The Revival of Jurisprudence'). Davidsohn, 1927 (IV, p. 3) brings much information, with particular emphasis on Florence.

Legal procedure became a model for creation in various intellectual and artistic fields. Let us here mention only one example – the trial of man before God, after the pattern of lawsuits, with the devil as an accuser, is a theme particularly frequent in sermons and in the vernacular literature of the thirteenth century. It is not surprising that this subject, rich in dramatic possibilities, was used on the medieval stage. What strikes the modern reader is the seriousness characteristic of the imitation of the external legal procedures.[15]

Giotto's *Pact of Judas*, in the same way as it reflects an attitude towards money, also reveals an appreciation of legal actions and procedures.

Gesticulation of hands

Noticing the legal connotations of *The Pact of Judas*, one should not be surprised to see that Giotto used legal gestures. These gestures, whatever their intuitive origin and psychological explanation, were partly formalized in the conventions prevailing in thirteenth- and fourteenth-century courts. Even the shadowy, black devil submits to the omnipotent conventions of the legal procedure. He pushes Judas towards the High Priest by putting his dark hand, the fingers ending in claws, on Judas' upper arm or shoulder. One remembers that the literary tradition does not know of Satan *bringing* Judas to the High Priest. What Luke (22:3), the most detailed of the Evangelists, as well as the later sources say is that the devil *entered* Judas. Giotto did not represent the devil entering Judas, but in the fresco he commented on the meaning of the metaphor used by Luke. The devil 'entering' somebody means that he takes possession of him, so that the person can do nothing but what the devil within him commands him to do. Giotto applied the conventional gesture of legally taking possession of somebody. For instance, to make the arrest of a person legally valid, the representative of authority had to grasp the person's arm or place a hand on his shoulder. In the later Middle Ages the official term was *manus injicere*. In German '*Antasten*' was used in this context.[16]

Not less important in our context is the procedure, used in the courts, of the party laying hands on the shoulder, or arm, of the attorney who speaks on his behalf. Particularly when the attorney had to confirm or accept an offer made by the other party, the client would place his hand on, or grasp, the attorney's arm or shoulder.

[15] The best-known examples come from France. Bloomfield, 1952, pp. 92ff., calls attention to the fact that the tribunal image and the legal procedure in the trial of man also enters late medieval sermons. In Italian literature, also, we find this motif. In a poem by Jacopone da Todi (see Beaufreton, 1921, pp. 164ff.) the sinner, God, the devil, and an angel (who helps defend the sinner) debate in legal manner.

[16] Examples are collected by Amira, 1909, pp. 264ff. Du Cange, 1883–7, s.v. 'arrestare', translates *arrestare* by *manus in aliquem injicere*. In Roman law it was customary to assert one's right over a living creature (of any kind) by putting one's hand on it. See Sittl, 1890, p. 129, n. 3.

Sittl has noticed that this gesture, which was sometimes mistaken for adoration, had Roman origins. Its high point, however, was reached in the thirteenth and fourteenth centuries, when Giotto was painting his frescoes in the Arena Chapel.[17]

Another version of the gesture, retaining the same basic meaning, is also legalistic in a sense. In ancient wedding processions the bride was urged towards the bridegroom with similar gestures. Outside the courts, transference of a child into the tutelage of his protector, or the manifestation of conjugal or parental relationship was performed by bringing the ward, grasping his shoulder or upper arm, to the guardian. Such friendly grasping was often called *confirmare* (Sittl, 1890, pp. 131ff.; Amira, 1909, p. 247).

We do not know if Giotto was aware of the meanings attributed to this gesture in law and ancient custom, and if so, what his sources were. The one thing we can maintain is that in applying the gesture in *The Pact of Judas* he was in full agreement with these traditions and customs.

The centre of manual gesticulation is the empty space between Judas and the High Priest. Here one gesture stands out. It is isolated, the hand does not touch anything, nor does it do anything that has a direct, narrative meaning; the symbolic character of the gesture is manifest. The High Priest raises his right hand, palm downwards and fingers half curved; he holds this hand above Judas' right hand, which he touches with his left; the apostle's left hand, which holds the moneybag, is at the base – in other words, the High Priest's right hand is domed above the two hands concluding the pact and above the moneybag. This gesture performed by the priest's right hand is a well-established act proclaiming protection. Homer already knew it. Agamemnon, rebuking those who shrink from the gruesome business of war, exclaims: 'Are you waiting for the Trojans to threaten...in the hope that Zeus will put his hand out and protect you then?' (*Iliad* IV.249, IX.419ff., XXIV.374; *Odyssey* XIV.184). In the second century A.D. Lucian (*Timon*, 10 – Loeb Classical Library, II, pp. 337ff.) tells of somebody who is not hurt because Pericles holds out his hand to shield him. Divine protection was also symbolized, in word and image, as the hand held above the head of the protected (frequent in city images) without, however, touching him.

As happened with so many gestures, particularly those belonging to the legal realm, the protecting hand disappeared from medieval imagery. The hand now often touched the emperor's head, and the gesture of protection became an impo-

[17] For Roman sources, mainly artistic motifs, see Sittl, 1890, pp. 292ff. Sittl also mentions that in some representations of an *adoratio* (an act in which everybody had to raise his hand) the figures standing behind place their hand on the figures in front of them, thus forming a unified political demonstration. For the Middle Ages, Amira (1909, p. 247) showed that the 'messenger-relationship' (*Botenverhältnis*) is expressed by the person sending the messenger (or figuratively endowing him with a function) placing his hand on the messenger's upper arm or shoulder.

sition of the hands. This can be seen with particular clarity in monuments representing God (or Christ) holding his hands above, or imposing them on, the king and queen. It is not surprising that in the twelfth and thirteenth centuries our gesture of protection reappeared. In the thirteenth-century illuminations of legal manuscripts the gesture often occurs. Amira, the student of the *Sachsenspiegel* manuscripts, makes his readers realize how frequently and how consistently the gesture is applied in the illuminations of this legal text (Amira, 1909, pp. 225–7).[18] The protective hand, with the same characteristics as those of the High Priest's in *The Pact of Judas*, is held by the feudal lord over the head of his vassal, by the father over the heads of his children (particularly after their mother has died and he is placing them under his exclusive tutelage), by the judge over women legally under his tutelage. Amira is aware that many representations of the gesture precede the *Sachsenspiegel*, and he admits the possibility that the motif of the protective hand entered the *Sachsenspiegel* manuscripts from artistic traditions rather than from actual procedures in the courts. I do not feel competent to decide this question, which does not seem to have been taken up by more recent scholars. But although we cannot precisely identify the source of the protective hand, Amira believes that the gesture still has value in studying the history of legal procedures. In medieval imagery the holding of the hand above one's head in the posture described was generally interpreted as a sign of protection. What can be said about the meaning of the gesture in general is also true for Giotto. The High Priest is protecting Judas, or the deal concluded between them, by holding his hand over the area of manual gesticulation and the moneybag.

[18] The protection gesture, Amira (1909, p. 226) believes, is so clear that artists didn't feel the need for other gestures to support it and clarify its meaning. For this reason, when a figure is making the gesture of protection with one of his hands, if with the other he also performs an expressive gesture, that gesture will have no relation to protection, but will be totally independent.

'NOLI ME TANGERE'

One of the most powerful images Giotto created is the scene in which Mary Magdalen encounters the risen Christ, the *Noli me tangere* (fig. 5). It is a mural that has struck many observers and attracted much attention. The story, as we know, was transmitted in two versions, and the difference between them was sometimes obscured in the particular character of a depiction. Matthew (28:9) tells us how Christ, after his resurrection, appeared to the Marys. He greeted them with the traditional 'All hail' (*Chairete*), the women come up to him, and, taking hold of his feet, adore him. The Gospel of John gives (20:17) a more specific, though not always a clearer, version. At the beginning of the story (20:11ff.) we do not know precisely who the woman called Mary is. Later the story reveals her identity. 'Jesus saith unto her: "Touch me not, for I am not yet ascended to my father. But go to my brethren, and say unto them..." Mary Magdalen came, and told the disciples that she had seen the Lord...'

Within the mural Giotto changes the mode in which the story is told. The description of the events begins (at the left) in an epic narrative mood: the soldiers sleep, the angels, sitting on the edge of the sarcophagus, wait. On the right the tone changes: the encounter between Christ and Mary Magdalen is a dramatic scene of rare intensity. Here everything is informed by a consistent duality; the scene is a sharp encounter of opposites. The Magdalen is kneeling, Christ is standing. She is wearing a dark mantle, he is clad in a white robe. Her posture is altogether consistent, his stance is ambiguous. She stretches out her hands without any hesitation, he is one of the important early *contrapposto* figures: leaning towards her he also withdraws.

In spite of this duality, however, the group is firmly knitted together. Christ's repelling arm, Rintelen has noticed (1923, pp. 53ff.) fits the diagonal of the Magdalen's back, and the two figures are thus welded together and form a huge triangle. This line, invisible yet clearly felt, crosses another indicating the top of the

rocks, a line that begins with the wing of the sitting angel and flows into Christ's leg, indicated under his robe. Together these two diagonals form a huge X, and subtly, invisibly, enhance the tension prevailing in the group.

'Noli me tangere' in medieval art: a glance

Representations of *Noli me tangere* in painting and sculpture have not yet been systematically studied; we have no monograph investigation of this theme. Its history, while not *terra incognita*, is a territory that has not yet been mapped. Panofsky (1953) has outlined some of the main features of this history in a wonderful passage (pp. 365ff., n. 5 to p. 22), but a thorough study is still a desideratum. I cannot attempt such an investigation here. We shall only briefly look at some earlier depictions of the encounter between the risen Christ and Mary Magdalen, and we shall consider only such features as may help us to better understand, and properly identify, the sources of Giotto's mural.

The core motif of our scene – a kneeling, pleading woman and a standing man, attracted to her and withdrawing from her at the same time – may have been derived, as Panofsky (1953, p. 22) suggests, from sarcophagi depicting Achilles leaving the daughters of Lycomedes.[1] Another source may be found in Roman political imagery. Coins again are the medium, a medium that ensures the wide circulation and popularity of the image. In casting a pattern for the *restitutio* motif, which we discussed in chapter 8, the artists created a compositional mould which Giotto may well have used, even if only indirectly. The emperor Galba, for instance, as seen in a posthumous coin (Bernhart, 1926, pl. 83.13; Brilliant, 1963, fig. 2.85), wearing a cuirass, holds in his left hand a large lance, and with his right he lifts up the kneeling figure of Roma herself. Another variation of this motif may be seen in a coin of Domitian (fig. 79). The emperor, upright, clad in his cuirass, a spear or sceptre in his left hand, is receiving the surrender of Germany. The personification of Germany is a female figure, kneeling and offering, with outstretched arms (though one hand is higher than the other), her implements of war to the conqueror. There are, of course, obvious contradictions between these coins and the *Noli me tangere*. Galba grasps the hand of Roma and raises her, whereas Christ wants to avoid Mary Magdalen's touch; the Germania is defeated, whereas Mary Magdalen loves the Lord and wishes to touch him. Yet we know of many instances where a model acquired a meaning directly opposite to the one it originally had, and yet no radical changes occur in its overall formal pattern. Here, too, we may have a case of 'energetic inversion'.

[1] A particularly beautiful sarcophagus, now in The Fitzwilliam Museum, Cambridge, is adduced by Panofsky, 1953, text illustration 19. For this sarcophagus cf. Roberts, 1890, II, pl. XVIII, no. 27; and see also Reinach, 1909–12, II, p. 442, fig. 2.

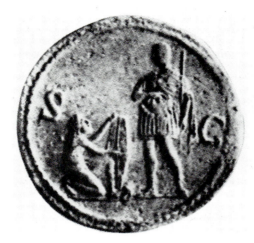

79 Roman coin, Domitian

In the pictorial representation of *Noli me tangere* in medieval art a dichotomy developed between East and West which is significant for our purpose. The Byzantine East focused on Matthew's version. In other words, the *Noli me tangere* was not represented at all. Instead, Byzantine artists represented Christ encountering the two Marys. As Millet has shown in his concise outline of our theme in Eastern art (1916, pp. 540–50), the attitude of the artists conformed to that of Eastern interpreters of Scripture. Informed by the spirit of hierarchy that prevailed in Byzantine culture neither commentators nor artists could admit that the resurrected Christ had seen anybody before he saw the Virgin (Millet, 1916, pp. 541ff.).[2] By eliminating the scene as told by John, Byzantine artists and commentators also excluded the drama of the story, the tension of the scene, and the tension in Christ's personality. Instead of depicting a passionate and tense encounter between the two figures, the Eastern artists presented the spectator with yet another icon of adoration. John Chrysostomus, the great teacher of Eastern Christianity, describes the scene: '...with infinite joy...they grasped his feet, and, by touching them, got the proof of his resurrection' (*Homilia in Sanctum Mattheum Evangelistam*, 89.3, quoted by Millet, 1916, p. 541). A twelfth-century commentator, Theophanes Kerameus, still takes it for granted that both Marys encountered the risen Christ together. 'With the other Mary, she [Mary Magdalen] saw the beloved face, grasped the beautiful feet, and listened to the sweet voice.'[3]

[2] Millet, 1916, here follows the *Golden Legend*. In the *Meditations on the Life of Christ* (p. 362 of the English translation) the risen Redeemer appears first to the Virgin in her home. A fourteenth-century Byzantine theologian, Gregory Palamas, further elaborates that only the mother of Christ had the privilege of touching her son's 'incorruptible feet' (Homily 18, Migne, *Patrologia Graeca*, vol. CL cols. 237ff. – adduced by Millet, 1916, p. 542).

[3] Migne, *Patrologia Graeca*, vol. CXXXII, col. 660. Millet, 1916, p. 541, notes that the author, who lived in

In the early Christian period artists were already searching for a visual formula to represent our scene. Among the earliest representations is that on the front panel of the fourth-century Brescia Lipsanotheca (Kollwitz, 1933).[4] Here only two figures participate in the event. In Christ's youthful, beardless figure one already feels the beginning of a *contrapposto*. He is rendered in a beautiful Polycletan stance, but though his body has a slight turn to the right, he turns his head and hand to the left, where Mary Magdalen is kneeling. Christ extends his hand towards her, yet the movement does not indicate any rejection; it rather looks as if Christ is blessing her. Mary Magdalen herself, though kneeling and looking up to Christ, does not express any kind of extreme tension. Her arms are bent, her head raised in a melodic movement.

The most important development of our theme in Byzantine art is that Christ encounters the two Marys, and not only Mary Magdalen. As we have already said, this is a profound change in the character of the whole scene. To represent this redefined scene Byzantine art developed, as Millet (1916, pp. 542ff.) has shown, two types of composition. In the one the women are clustered together and Christ addresses them, in the other the frontal Christ is placed between two symmetrically arranged kneeling female figures. The first type is appropriate for a narrative rendering, the second is of monumental, hieratic character.

A fine example of the first type can be seen in the Laurentian Tetraevangeliary (Millet, 1916, fig. 582).[5] Christ stands in the centre of the illumination, to the left are an angel (probably guarding the tomb) and a sleeping soldier, to the right the two Marys, kneeling in *proskynesis* and raising their covered hands towards Christ. Christ, in whose figure there is no *contrapposto* to indicate an internal conflict, holds his blessing hand over the two women. In another Laurenziana manuscript (Millet, 1916, fig. 592), the two women prostrate themselves from left to right (seen almost in profile); Christ, in three-quarter view, inclines towards them and extends his blessing hand. Byzantine art, however, also knew the image of Christ in a mild *contrapposto* without changing the general composition. As an example it will be sufficient to remind ourselves of an illumination in a manuscript now in Leningrad

Sicily, probably had contacts with Western Christianity, and emotional attitudes, characteristic of Western Christian culture of the period, may have found their way into his text. As examples of such Western attitudes Millet adduces the statements in the *Golden Legend*, in the story of the Resurrection of Christ, and Pseudo-Bonaventura's *Meditations on the Life of Christ*, chapter 88 (pp. 361ff. in the English translation).

4 Morey, 1942, p. 222 (note to fig. 146) interprets the group as Christ Healing the Woman with the Issue. Recently Grabar (1968, p. 138) came back to the traditional reading as *Noli me tangere*. This hesitation in reading may well have been caused by the posture of Christ's hand, which does not demonstrate rejection. The hand is seen from the inside, showing the palm, and could be read as a gesture encouraging the kneeling Mary Magdalen to stand up.

5 Millet, 1916, mentions (pp. 543ff.) the most important examples. A closely related version may be found in the Rabula Gospel (Florence, Bibl. Medicea-Laurenziana, Syriac 1. 56, fol. 13v).

(Millet, 1916, fig. 582). The two Marys on the left of the page adore Christ in Oriental fashion (*Proskynesis*) with covered hands; but he, blessing them with his right hand, turns his head away from the women. There is no visible reason for Christ's unexpected movement, yet one suspects that even in Byzantine art the intrinsic connection between Christ in a *contrapposto* stance and the story of his encounter with Mary Magdalen was felt.

The second type, transmitted in a variety of versions, is an altogether hieratic image, in which nothing happens. In a fresco in the church in Marko, Serbia, painted in the mid-fourteenth century, the two women kneel in prayer on either side of Christ, and he spreads both arms over them (Millet, 1916, fig. 584). His hands perform the *benedictio latina*. By the mid-fourteenth century, one should remember, this gesture had long lost its original meaning – an indication of speech – and had become a well-established gesture of liturgical benediction, a gesture that everybody understood as such. In another monumental depiction of the scene, a mosaic in San Marco in Venice, the huge Christ is flanked by the two miniature Marys who kneel on either side of his feet (Millet, 1916, fig. 588). Christ does not bless; he places his right hand on his chest, in his left he holds a scroll, and his gaze is directed towards the beholder. Nothing in this composition suggests that Christ is even aware of the existence of the two Marys. It is a perfect image of timeless adoration, detached from any specific narrative context.

The West concentrated on the story as told by John. Christ meets only Mary Magdalen. From the beginning the visual representations of the story have a dramatic quality which is missing from Byzantine depictions. In the course of the centuries Western art produced and formalized certain expressive gestures in the representation of our story which are of significance for Giotto, and can help us to locate his sources.

Two gestural features, typical of Western representations of Christ encountering Mary Magdalen, crystallized in Romanesque art: the outstretched arms of Mary Magdalen, and the emphasized *contrapposto* in Christ's figure.

An early Spanish ivory, now in the Metropolitan Museum in New York (Kingsley Porter, 1923, fig. 709; also p. 42), which is closely related to late eleventh-century sculpture in the region of Toulouse, is an interesting document in the development of our theme. The artist who carved this ivory seems to have been unaware of the Byzantine tradition. Here the scaling is not hierarchic. Mary Magdalen is of the same size as Christ. She does not kneel or prostrate herself, she rather stands up, though with bent knees. Her outstretched arms are altogether straight, a gesture expressive of great tension. Christ, though seen from the front, lacks the detachment characteristic of that posture in Byzantine art; though he does not move in a three-dimensional space, his body seems twisted and contorted; it is torn in opposite

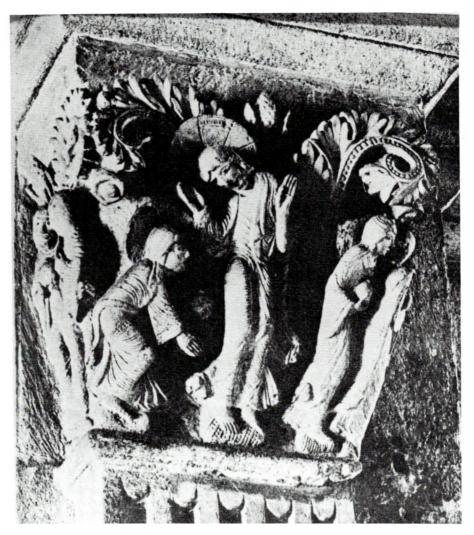

80 Autun, capital with *Noli me tangere*

directions. Christ's left hand points to Mary Magdalen, his right is aggressively thrust out towards her, with a huge hand performing the *benedictio latina* directly in front of her shrinking face. The ivory has been felt as 'coarse', sometimes as 'diabolic'. Does this elemental quality of the carving suggest that we have here one of the beginnings of our story in the West?

A capital in Autun (fig. 80), though perhaps not later in date than the Spanish ivory, represents a new stage in the history of the theme. Here the scaling is

hierarchic: a small Magdalen faced by a large Christ. She is rendered in pure profile; her arms, lowered, are stretched out in a perfectly straight line, nothing reminds the spectator of the arm's ability to bend at the elbow. Facing her is a huge Christ, seen in three-quarter view. As against her tense, angular movements, his are flexible and soft, an image of the power of continuous transformation. The *contrapposto* is now manifest, yet it is connected with organic movement. Christ's feet are directed to the right, but his head turns, in a gentle movement, towards the Magdalen, who is at the left. Both the slanting feet and the turning movement of the body make Christ appear as if he were hovering (though his feet tread on a solid piece of ground). He raises both hands in an ancient prayer gesture, the gesture of the *orans*.

The *Noli me tangere* on a capital in Saulieu (Kingsley Porter, 1923, fig. 55), though produced a generation later, is very close to the representation in Autun. In style they differ from each other: Saulieu is more linear, Autun more pictorial. In the interpretation of the scene, however, and in individual iconographic features they are almost identical. A difference is that in Saulieu Mary Magdalen looks up at the Saviour, while in Autun she looks straight forward, possibly even down. Yet the other features, the outstretched arms of the Magdalen (a little damaged), the hovering and twisted posture of Christ are the same.

Western art, of course, also knew somewhat different versions in the depiction of the scene; one detail or another is closer to the Byzantine tradition. Yet the pattern we have seen in the examples adduced was clearly the dominant one in the West. As even a cursory glance at the mural in the Arena Chapel shows, Giotto's depiction of *Noli me tangere* is firmly rooted in the Western tradition.

Mary Magdalen

In Giotto's period, so far as we know, the story of the risen Christ's encounter with Mary Magdalen was not a much discussed theme, and no new interpretations of the event were offered. A look at how the heroine of the story was understood may also shed light on the story.

Mary Magdalen was one of the popular saints of the Middle Ages, particularly so after the mid-thirteenth century. She was not an anaemic saint, an abstract projection of pure virtue, without fault and sin. On the contrary, she is one of the few complex, ambiguous saints, imagined as a figure of great internal conflict and struggle. The grace bestowed on her does not make us forget that she was a sinner. She is the prototype of the repentant sinner, the patron saint of all sinners. Her image is shaped by the awareness of her sinfulness, on the one hand, and by her being closer to Christ than anybody else, on the other. Her sinfulness always

remained linked to carnal love, to seduction. In the thirteenth-century play *Ludus de passione*, the devil influences Mary Magdalen to buy cosmetics to entice her lover (Sticca, 1970, p. 139). Love – carnal and spiritual – is the central theme of Mary Magdalen. Jacopone da Todi's *laude* for her are the statement of his views on love.[6] Bonaventura presented his philosophy of love in a sermon on Mary Magdalen (the 'Sermo di Maria Magdalena', esp. section 2; cf. Prentice, 1957). This is the motif which characterizes this saint in late medieval literature, legends, and (most important) stage plays.

Her leaning to sensual love may perhaps explain her desire for physical touch, a desire emphasized in literary descriptions as well as in pictorial depictions. She dries Christ's feet with her hair; at the crucifixion she is closest to the cross, touches it, and is often seen embracing it; during the lamentation she supports the dead body of Christ, usually holding his feet in her hands; when Christ appears to her after his resurrection she wishes to touch him. The desire for physical touch is not usually characteristic of saints, and in no other saint, so far as we know, is it so overwhelming as in Mary Magdalen. This desire is, of course, an important feature in the background of *Noli me tangere*.

An important and significant record of Christ's apparition to Mary Magdalen is found in the *Golden Legend* (in the story of the resurrection of Christ). It deserves to be quoted *in extenso* (p. 221).

For the first time he appeared to Mary Magdalen; as is written in John chapter 20; and in Mark in the last chapter where it reads: 'But he rising early the first day of the week, appeared first to Mary Magdalen' (Mark 16:9); she signifies the repentant. But why he appeared first to her, for this there are five causes. The first is that she ardently loved; Luke 7:47 'Many sins are forgiven her because she hath loved much.' In addition he wished to show that he died for the sinners. Matthew 9:13 'For I am not come to call the just, but sinners.' Thirdly he wanted to show that whores will get into the kingdom of heaven rather than the wise. Matthew 21:31 'I say to you that the publicans and the harlots shall go into the kingdom of God before you.' Fourthly: as a woman was the announcer of death, so a woman should also be an announcer of life, as the *Glossa* says. Fifthly, where sin has overflowed, so grace should be overflowing. Such we read in Romans 5:20.

Reading this text – particularly in a popular, widely diffused work such as the *Golden Legend* – one cannot help being struck by the leitmotif of the story. Mary Magdalen was a sinner; Christ met her first after his resurrection, precisely for this reason (to show that his sacrifice was for the sinners); she will come into heaven

[6] A careful reading of the *Laude* suggests a much greater significance of Mary Magdalen's figure than could be guessed from the mentions of her name. Thus Lauda CI (See *Laude de Frate Jacopone da Todi*, ed. Ferri, 1910, pp. 165ff.) would seem to deal with problems and emotions usually attributed to Mary Magdalen, though her name is not mentioned.

because whores get there earlier than the wise and sophisticated. Jacobus de Voragine, who collected stories and legends current in Europe and wrote them down in the *Golden Legend*, does not tell his readers explicitly of what the Magdalen's sins consisted, yet he suggests with sufficient clarity that they were related to carnal love, whore's love bought for money. But this sin, we are somehow made to understand, is not only a fault; in a mysterious way it seems to carry in itself the seeds of redemption. 'Many sins are forgiven her because she has loved much.' What a striking statement about a woman whom the author just one sentence earlier called a 'harlot' and a 'whore'. And she was the first to whom Christ appeared because 'she ardently loved'. How does Giotto interpret her in our scene?

In the Arena Chapel Giotto has represented Mary Magdalen three times – in *The Crucifixion* (W, pl. 59), *The Lamentation over the Dead Christ* (fig. 19), and the *Noli me tangere* (fig. 5). A comparison of the three depictions may help us to see more clearly how he understood her figure in the mural here discussed. Giotto, as we know, is consistent; sites, buildings, and people retain their identity. A person has the same features wherever he is depicted. We easily recognize them, as we recognize a familiar face. Now, in both the *Crucifixion* and the *Lamentation*, Mary Magdalen is easily identified by her light-coloured, flowing, abundant hair. No other figure in the whole of Giotto's work is endowed with such an abundance of hair as is Mary Magdalen. This, of course, was not Giotto's invention. In the traditional image of the Magdalen her hair plays an important and distinctive part. With her hair she dried Christ's feet; this detail, recorded in the Gospels, was never forgotten; it inspired the imagination of story-tellers, writers, and painters. Hair traditionally carried various connotations. To a woman, says St Paul (1 Corinthians 11:15), hair is given as a covering; she is therefore not to be blamed for taking care of it. But a woman's long hair can also be an implement of seduction, the demonic woman can use it to lure men into the caves of the devil.[7]

Giotto strongly emphasized Mary Magdalen's hair, and it is easy to see how much effort and skill he invested in depicting it. In the *Crucifixion* Mary Magdalen alone kneels in front of the cross, and touches – or perhaps caresses – Christ's feet, which are nailed to the cross. Her undulating hair flows down on her body, forming a kind of half-transparent robe. In all of Giotto's work (including his workshop, even if we conceive of it in the broadest possible way) such an amount of work and technique was never lavished on the representation of any other half-transparent medium. Not even in the depiction of the Jordan waters, through which Christ's body appears in the *Baptism* (Fig. 61), do we see such care and such exertion. In the *Lamentation*

[7] Once more we refer to the legal tradition of the late Middle Ages as reflected in the *Sachsenspiegel*. Amira has shown (1925, II, part 1, pp. 166ff.) that the abundance of open hair may identify a woman as unmarried, and her actions as unchaste.

Mary Magdalen sits low on the ground, weeping, while she holds Christ's feet. Her hair, collected in a great mass on her head, does not cover her whole body, it only falls over her breast. But again we notice the careful brushwork which portrays the half-transparent nature of the thin layer of hair. Giotto, one feels certain, would not have invested so much effort and attention in the representation of the braids had the hair not carried a particular significance for him.

There is another rendering of *Noli me tangere* in the Lower Church of St Francis in Assisi (W 180).[8] Both in overall composition and in many details it is a close imitation of the *Noli me tangere* in the Arena Chapel. However, here Mary Magdalen's dark garment is not drawn over her head and her hair (though not flowing down to her body) is visible. The juxtaposition of the Magdalen's bright hair and dark mantle is, in fact, one of the strongest colouristic effects in the whole mural. Only in the Arena Chapel *Noli me tangere* is Mary Magdalen's hair concealed, and one would like to know why Giotto here hid her most striking characteristic.

Mary Magdalen in the *Noli me tangere* mural of the Arena Chapel differs also in dress from her image in other frescoes. In both the *Crucifixion* and the *Lamentation* she wears an ordinary dress that does not attract any attention. In the *Noli me tangere* she wears unusual clothes: a large brown cloak, with borders embroidered in gold, and a dark (bluish) lining. The cloak covers her whole body. Beneath the cloak she wears a pale dress (of which the sleeves are visible) which is probably meant to be grey. The dress, and particularly the cloak, were well-known pieces of costume in thirteenth- and fourteenth-century Florence, and probably in large areas of central Italy. This was the conventional dress of mourners, and its colours were firmly fixed (Davidsohn, 1927, pp. 376ff.). This convention also served a definite aim. The colour of the mourner's dress showed his or her relationship to the deceased. Widows always wore plain, solid black, only the *benda*, the scarf on neck and head, being white. Other mourners usually wore brown. For women the established convention was particularly strict. Only the widow had to, and only she was entitled to, wear black. For other women – sisters, daughters, or other persons closely related to the deceased – black was specifically forbidden; instead they were supposed to wear *bruno*. Brown, as we know from other sources, is a general representation of dark; it could include many shades (Borinski, 1918 and 1920). In thirteenth-century Florence a deep red could also be considered brown. Sometimes purple, too, is

[8] Opinions of scholars differ widely as to who painted this mural. Yet whoever he may have been, he was immersed in the Giotto tradition in general, and in the tradition in which Mary Magdalen shows her open hair in particular. (Cf. W 237, and Rintelen, 1923, pp. 212ff. for a comparison of the *Noli me tangere* in the Arena Chapel and in the Upper Church of St. Francis.) If indeed he was a follower of Giotto, a follower 'who learned much in Padua, but not more than what is external', it is all the more remarkable that he deviated from Giotto in this particular feature of Mary Magdalen's hair.

mentioned as a mourning colour.[9] But whatever the specific shade, the overall colour is obvious. A contemporary spectator would certainly have understood what the brown colour of Mary Magdalen's cloak meant.

The figure of Christ

We now come to Christ's figure. He is represented in full movement. Mary Magdalen's thrusting out her arms happens in a split second; it is a climax, and it strikes us as timeless; we find it hard to imagine what she will do next. Christ, on the other hand, seems to perform a continuous movement. He withdraws, and, in spite of conflicting tendencies within his figure, he moves in *one* direction, out of the picture.

In Byzantine art, as we remember, Christ addressing the Marys does not move. Whether the Marys are placed in front of him or whether they flank him symmetrically, Christ himself remains without motion. Even when he is cast in a *contrapposto* mould, there is no movement in the sense of locomotion. In Western art, especially in the Romanesque and Gothic periods, Christ in the *Noli me tangere* often conveys a strong sense of movement, in addition to *contrapposto*. When he seems to be hovering, one gets the impression that he is about to ascend. In making Christ appear to move from one spot to the other, Giotto, in this respect as well as in others, follows the Western image of this scene.

More important than Christ's moving out of the picture is the internal movement in his figure, the *contrapposto*. All the forms of his figure are designed in sustained opposition. The movements of his body lay bare an unmitigated, impassioned logicality of direction. The axis of the prominent leg is sharply broken at the hip, the diagonal of the torso (strengthened by the folds leading to the shoulder) is opposed to that of the leg, while the head again takes up the axis of the leg. In his *contrapposto* the Christ in *Noli me tangere* is unique in Giotto's work.

The term *contrapposto*, it is worth remembering, is taken from the Latin *contrapositum*, in turn translated from the Greek *antithesis*, a rhetorical figure in which opposites are set directly against one another.[10] The concept was also known in

[9] In a forthcoming paper (given at the symposium on 'Color in the Renaissance', arranged by Prof. Marcia Hall at Temple University, Fall 1980) I have collected some instances of ambiguity in the meaning of colours, and particularly of purple.

[10] For the original meaning of the term in the theory of rhetorics, see Quintilian IX.3.81. As Shearman, 1967, p. 83, remarked, *contrapposto* in art became 'one of the most typical reconquests of the earlier Renaissance' and was much favoured by Petrarch as a figure of speech. But already in late antiquity *contrapposto* was believed to possess more than just aesthetical significance. St Augustine, in the *City of God* XI.18, says, 'For what are called antitheses are among the most elegant of the ornaments of speech', but then refers to 2 Corinthians 6: 7–10, and concludes: 'As, then, these oppositions of contraries lend

medieval literary theory, and the technique was practised in medieval literature (though possibly in a less developed form). Whether Giotto was familiar with this literary heritage or not – and it seems likely that he did not know it at first hand – in the Christ of *Noli me tangere* he painted a perfect *contrapposto* figure. It should be remarked, however, that this early fourteenth-century *contrapposto* is different from the spiral torsions of Renaissance art. In Giotto's figure the parts of the body – the torso, the legs, the head – preserve an independent rigidity, the opposed movements are mainly parallel to the background, and the contrasted elements are clearly set off from each other. The *contrapposto* of Christ's body reveals the struggle of his impulses – the attraction to Mary Magdalen, and the desire to withdraw and avoid her touch. The outstretched hand of Christ is typical in its ambiguity: it is rejecting, but it also has features of blessing.[11]

A prominent individual feature in Christ's *contrapposto*, the crossed legs, is particularly revealing. Crossed legs represent an attitude evoking different connotations. In a sitting figure this is a deliberate action or stance, and as such it is particularly fitting for rulers and judges. We know indeed many medieval images of rulers or judges who in premeditated repose cross their legs. It could also be the posture of dignified religious figures, as we know, for example, from the apocalyptic elders in the tympanum of Moissac (Tikkanen, 1912; Schapiro, 1977, pp. 56ff.; 91ff.; Barasch, 1971, pp. 113ff.).

When a standing figure crosses his legs, the mood suggested seems to be different. The precariousness and instability of the stance in general appears inappropriate for

beauty to the language, so the beauty of the course of this world is achieved by the opposition of contraries, arranged, as it were, by an eloquence not of words, but of things.' Isidore of Sevilla also extends the meaning of the term beyond the merely rhetorical. For medieval literary theory see the discussion by Matthieu de Vendome, printed in Faral, 1924, pp. 173ff. In general see the recent article by Summers, 'Contrapposto: Style and Meaning in Renaissance Art', 1977, and the older study by Hedicke, 1931.

[11] That Christ's right hand performs a gesture of rejection – trying to prevent Mary Magdalen from touching him – seems obvious, yet it is not easily said which particular features fulfil this function. In the fresco representing the same scene in the Lower Church of St Francis in Assisi (W 180) the gesture is slightly, but significantly changed: Christ's hand is not shown in profile, rather the back of his hand is fully exposed, with all fingers extended. He thus seems to protect Mary Magdalen from something emerging from the depth of space. This detail shows, we believe, that there was not full awareness as to the specific shapes in the gestures to be employed in this scene. To see how ambiguous such gestures are it is enough to compare Christ's rejecting hand in the *Noli me tangere* in the Arena Chapel with the announcing hand of the hovering angel in *The Annunciation to St Anne*, also in Padua (W 8; S 90). The two hands seem almost identical, and probably one does not go too far when one assumes that Giotto used the same model for both gestures. Moreover, the configuration of the fingers in a hand seen in profile – showing only the thumb, the index and ring finger – vividly reminds one of a blessing hand; if the thumb of Christ's hand (in the Paduan *Noli me tangere*) were a little closer to the other figures, an uninformed spectator would have little doubt that he is seeing a blessing gesture. Another possible reading could be that Christ's hand, held above the outstretched hands of the Magdalen, suggests a gesture of protection (as we have seen in *The Pact of Judas*, above, pp. 167–8ff.). It would be tempting to speculate as to how far Giotto was aware of this variety of meanings, and whether he used it in intensifying the emotional pitch of the motif. Unfortunately we cannot arrive at any definite knowledge.

dignified figures, and in fact it was deemed particularly suited to jugglers and other kinds of coarse virtuosos. In a *drôlerie* of the Psalter of Alfonso, done in 1284 (British Museum, Add. MS 24686, fol. 17v; Zarnecki, 1975, fig. 429), to give one example, a dancing musician paradoxically advances with crossed legs; moreover, even the dancing, jumping monkeys that belong to his primitive show cross their legs (Janson, 1952, pp. 171ff.). However, especially in Italian art, we also have serious figures, endowed with nobility and intrinsic worth, who cross their legs. Such figures are usually in a state of intrinsic conflict. In Duccio's *Thomas Touching Christ's Wounds* (Brandi, 1951, pls. 92, 93), the sceptical apostle approaches Christ with crossed legs, an image of the struggle between beliefs and doubts. It is worth noting, however, that it is never the principal, the most holy, figure who is rendered in this stance.

In Giotto's work, the situation is reversed. Giotto represented this posture only twice, but on both occasions it is Christ who is thus rendered. The thematic context of both pictures is of significance. Giotto first represented Christ crossing his legs in the *Baptism* (fig. 61). In late Byzantine art, close to our master's time, we find several representations of the Baptism where Christ crosses his legs. Some icons were also produced in regions close to Italy in which Christ is so rendered (Millet, 1916, figs. 139, 140, 144).[12] Did Giotto know this tradition? We cannot tell. Millet (p. 182) suggests that similar representations, found in the Baptisteries of Parma and Florence, could have served as Giotto's models. But whatever the origin of his representation, Christ's crossed legs express the *contrapposto* of two natures, of two stages in the story of redemption. The religious, symbolic imagery of baptism, it need hardly be stressed, abounds in antithetical statements, in dialectical contrasts. The baptismal font, the church fathers kept insisting, is 'the tomb and the mother' of the baptized. In baptism the 'old man' dies, the 'new man' is born in the waters of the font. It does not seem too bold to assume that Christ's chiastic post in Giotto's *Baptism* reflects the clash and instant transformation that takes place in the Jordan.

The other instance in which Giotto depicted Christ with crossed legs is the *Noli me tangere*. The situation was described as ambivalent by the New Testament itself and Giotto was not the first to use the posture for Christ in this context. Late thirteenth-century Western illuminators, influenced by Byzantine models of the middle and late period, also employed the motif: '...a feeble Bavarian miniature of

[12] Millet, 1916, suggests (pp. 178ff.) three new features of twelfth-century representations of the Baptism: the number of angels, the Baptist's dress, and Christ's stance, that is, his crossed legs. As early Italian examples he mentions, e.g., the Salerno ivory (Bertaux, 1904, pl. 19 – this ivory was dedicated in A.D. 1084) and the wooden sculpture of Alatri (see Venturi, 1901–40, III, fig. 368). In Millet's view, the motif of Christ's crossed legs is of oriental origin, and he even speculates as to who might have invented it.

c. 1275 could bear a curious resemblance to Giotto's fresco in the Arena Chapel', says Panofsky (1953, pp. 365ff.). It is quite possible that an illumination such as this was known to Giotto, though we cannot prove a definite connection. But whatever Giotto's sources, he perceived and brought out the connotations of the posture, and he applied it with the consistency so characteristic of him as an artist.

BIBLIOGRAPHY

Alberti, L. B., 1950, *Della Pittura*, critical edition by Luigi Malle, Florence.
 1956, *Leon Battista Alberti on Painting*, transl. by J. R. Spencer, New Haven.
Alföldi, A., 1934, 'Die Ausgestaltung des monarchischen Zeremoniells am römischen Kaiserhof', *Mitteilungen des Deutschen Archäologischen Instituts*, II, pp. 1–118.
 1935, 'Insignien und Tracht der römischen Kaiser', *Mitteilungen des Deutschen Archäologischen Instituts*, L, pp. 1–171.
Allport, G. W., and Vernon, Philip E., 1933, *Studies in Expressive Movement*, New York.
Alpatoff, M., 1974, 'The Parallelism of Giotto's Paduan Frescoes', in L. Schneider (ed.), *Giotto in Perspective*, pp. 109–21 (originally published 1947 in *Art Bulletin*, XXIX, pp. 149–54).
Altona, J., 1883, *Gebete und Anrufungen in den altfranzösischen Chansons de Geste*, Marburg.
Amira, K., 1902, *Die Dresdener Bilderhandschrift des Sachsenspiegels*, I, Leipzig.
 1909, 'Die Handgebärden in den Bilderhandschriften des Sachsenspiegels', *Abhandlungen der Bayerischen Akademie der Wissenschaften*, philos. – philolog. Kl., XXIII, pp. 163–263.
 1925, *Die Dresdener Bilderhandschrift des Sachsenspiegels*, II, Erläuterungen, T.1, 2, Leipzig.
d'Ancona, A., 1872, *Sacre rappresentazioni dei secoli 14, 15 e 16*, 3 vols., Florence.
Apuleius: The Golden Ass, 1928, transl. by W. Adlington (Loeb Classical Library).
Ayrton, M., 1969, *Giovanni Pisano Sculptor*, London.
Barasch, M., 1971, *Crusader Figural Sculpture in the Holy Land*, New Brunswick.
 1976, *Gestures of Despair in Medieval and Early Renaissance Art*, New York.
Bauch, K. 1976. *Das Mittelalterliche Grabbild*, Berlin–New York.
Beaufreton, M., 1921, *Anthologie franciscaine du moyen âge*, Paris.
Behm, J., 1911, *Die Handauflegung im Urchristentum*, Leipzig.
Berenson, B., 1927, *Italian Painters of the Renaissance*, New York.
Bernhart, M., 1926, *Handbuch zur Münzenkunde der römischen Kaiserzeit*, Halle.
Bernheimer, R., 1952, *Wild Man in the Middle Ages*, Cambridge, Mass. (reprinted New York 1970).
Bertaux, E., 1904, *L'Art dans l'Italie méridionale*, Paris.

Bieber, M., 1961, *The Sculpture of the Hellenistic Age*, New York.
 1977, *Ancient Copies: Contributions to the History of Greek and Roman Art*, New York.
The Blickling Homilies of the Tenth Century, 1880, edited with a translation by the Rev. R. Morris, London.
Bloomfield, M., 1952, *The Seven Deadly Sins*, Michigan.
Blumenkranz, B., 1966, *Le Juif mediéval au miroir de l'art chrétien*, Paris.
Bonifacio, G., 1616, *L'Arte de Cenni con la quale formandosi favella visible, si tratta della muta eloquenza, che non e altro che un facondo silentio*, Vicenza.
Borinski, K., 1918, 'Braun als Trauerfarbe', *Sitzungsberichte der Bayerischen Akademie der Wissenschaften*, philosophische–philologische und historische Kl., x.
 1920, 'Nochmals die Farbe Braun', *Sitzungsberichte der Bayerischen Akademie der Wissenschaften*, philosophische–philologische und historische Kl., i.
Brandi, C., 1951, *Duccio*, Florence.
Braun, J., 1907, *Die liturgische Gewandung im Occident und Orient*, Freiburg im Breisgau (reprint Darmstadt, 1964).
Brilliant, R., 1963, *Gesture and Rank in Roman Art* (*Memoirs of the Connecticut Academy of Arts and Sciences, XIV*), New Haven.
Browe, P., 1933, *Die Verehrung der Eucharistie im Mittelalter*, Munich (reprinted Rome 1967).
de Bruyne, L., 1943, 'L'Imposition des mains dans l'art chrétien ancien', *Rivista di archeologia cristiana*, xx, pp. 113–266.
Bühler, K., 1933, *Ausdruckstheorie: Das System an der Geschichte aufgezeigt*, Vienna.
Bulwer, J., 1644, *Chirologia: or the Naturall Language of the Hand, Composed of the Speaking Motions, and Discoursing Gestures thereof. Whereunto is added Chironomia: or the Art of Manuall Rhetoricke, by, J. B. Gent Philochirosophus*, London.
Burckhardt, J., 1869, *Der Cicerone*, Leipzig.
Cabrol, F. and Leclerq, H. M., 1913–53, *Dictionnaire d'archéologie chrétienne et de liturgie*, Paris.
Calisse, C. 1928, *A History of Italian Law*, Boston, Mass.
Cassuto, U., 1918, *Gli Ebrei a Firenze nell'Eta del Rinascimento*, Florence.
Coopens, J., 1925, *L'Imposition des mains et rites connexes dans le Nouveau Testament*, Paris.
Cothenet, E., 1978, 'Gests et actes symboliques du Christ dans le IVe Evangile', in *Gestes et Paroles dans les diverses familles liturgiques*, Conférences Saint-Serge XXIVe sémaine d'études liturgiques, Paris, 28 juin – 1 juillet 1978, Rome (Centro Liturgico Vincenziano), pp. 95–116.
Crichton, G., 1938, *Nicola Pisano and the Revival of Sculpture in Italy*, Cambridge.
Cumont, F., 1896, *Textes et monuments figurés relatifs aux Mystères de Mithra*, 2 vols., Paris.
 1932–3, 'L'Adoration des mages et l'art triomphal de Rome', *Atti della Pontificia Accademia Romana di Archeologia, Memorie III*, pp. 81–105.
Curtius, E. R., 1953, *European Literature and the Latin Middle Ages*, Princeton (original German edition, Bern, 1948).
St Cyril of Jerusalem's Lectures on the Christian Sacraments, 1951, ed. F. L. Cross, London.

Dalton, O. M., 1911, *Byzantine Art and Archaeology*, Oxford.

Daniel, H. A., 1841–56, *Thesaurus Hymnologicus*, Halle.

Davidsohn, R., 1900, *Forschungen zur Geschichte von Florenz*, Berlin.
1927, *Die Geschichte von Florenz*, Berlin.

Davis, H., 1974, 'Gravity in the Paintings of Giotto', reprinted in L. Schneider (ed.), *Giotto in Perspective*, Englewood Cliffs, N. J.

Delbrück, R., 1926–9, *Die Consulardiptychen und verwandte Denkmäler* (Studien zur spätantiken Kirchengeschichte, II), Berlin.
1932, 'Der spätantike Kaiserornat', *Die Antike*, VIII, pp. 1–21.

Delius, W., 1963, *Die Geschichte der Marienverehrung*, Munich–Basle.

Dieterich, A., 1911, *Kleine Schriften*, Leipzig–Breslau.

Dölger, F. J., 1959, 'Beiträge zur Geschichte des Kreuzzeichens', *Jahrbuch für Antike und Christentum*, II.

Die Dresdener Bilderhandschrift des Sachsenspiegels, 1902, ed. K. Amira, Leipzig.

Duchesne, L., 1902, *Origines de culte chrétien*, 3rd ed., Paris.

Durandus, W., 1614, *Rationale divinorum officiorum*, Antwerp (first published 1509, frequently reprinted).

Dvorak, M., 1927, *Geschichte der italienischen Malerei im Zeitalter der Renaissance*, 2 vols., Munich.

Ebersolt, J., 1926, *La Miniature byzantine*, Paris.

Eisenhofer, L., 1932, *Handbuch der katholischen Liturgik*, Freiburg im Breisgau.

Eitrem, S., 1966, *Some Notes on the Demonology in the New Testament* (Symbolae Osloenses, fasc. supplet. 20), 2nd ed., Oslo.

Engel, J. J., 1785, I, 1786, II, *Ideen zu einer Mimik*, Berlin.

Erich, O., 1931, *Die Darstellung des Teufels in der christlichen Kunst*, Berlin.

Faral, E., 1924, *Les Arts poétiques du XIIe at du XIIIe siècle*, Paris.

The Little Flowers of Saint Francis, 1910, trans. T. W. Arnold, London.

de Francovich, G., 1952, *Bendetto Antelami*, Milan–Florence.

Franz, A., 1902, *Die Messe im deutschen Mittelalter*, Freiburg, im Breisgau (reprint Darmstadt, 1963).

du Fresne du Cange, C., 1883, *Glossarium mediae et infirmae Latinitatis*, Graz (reprint 1954).

Fulgentius the Mythographer, 1971, translated from the Latin, with Introduction by C. G. Whitbread, Ohio.

Garnier, F., 1982, *Le Langage de l'image au moyen âge. Signification et symbolique*, Paris.

The Attic Nights of Aulus Gellius, 1961, transl. by J. C. Rolfe, 3 vols. (Loeb Classical Library).

The Golden Legend, 1941, New York (reprint New York 1969).

Goldschmidt, A., 1914, *Die Elfenbeinskulpturen aus der Zeit der Karolingischen und Sächsischen Kaiser*, I, Berlin.
1928, *Deutsche Buchmalerei*, 2 vols., Munich.

Gombrich, E. H., 1965, 'Ritualized Gesture and Expression in Art', *Philosophical Transactions of the Royal Society of London*, Series B, Biological Sciences, no. 772, vol. CCLI, pp. 391–401.
1972, 'Action and Expression in Western Art', in R. A. Hinde (ed.), *Non-Verbal Communication*, Cambridge, pp. 373–93.

Gosebruch, M., 1962, *Giotto und die Entwicklung des neuzeitlichen Kunstbewusstseins*, Cologne.

Grabar, A., 1936, *L'Empéreur dans l'art byzantin*, Strasbourg (reprint London, 1971).

1968, *Christian Iconography; A Study of Its Origins*, Princeton.

Grabar, A., and Nordenfalk, C., 1957, *Early Medieval painting*, Geneva.

Grant, M., 1968, *Roman History from Coins*, Cambridge.

Gronau, H., 1937, *Andrea Orcagna und Nardo di Cione*, Berlin.

Gutberlet, H., 1934, *Die Himmelfahrt Christi in der bildenen Kunst*, Strasbourg.

Hamann-McLean, R., 1951, Merovingisch oder frühromanisch? *Jahrbuch des Römisch-Germanischen Zentralmuseums*, Mainz, IV, pp. 161–99.

Haskins, C. H., 1927, *The Renaissance of the Twelfth Century*, Cambridge, Mass.

Hedicke, R., 1931, 'Der Begriff des Kontrapost', *Deutsche Vierteljahrsschrift für Literatur und Geistesgeschichte*, IX, pp. 186–200.

Heiler, Fr., 1923, *Das Gebet*: *Eine religionsgeschichtliche und religionspsychologische Untersuchung*, 5th ed., Munich.

Helbig, W. and Amelung, W., 1912, *Führer durch die öffentlichen Sammlungen klassischer Altertümer in Rom*, Leipzig.

Hetzer, T., 1981, *Giotto. Grundlegung der neuzeitlichen Kunst*, Stuttgart.

Hirn, Y., 1912, *The Sacred Shrine: A Study in the Poetry and Art of the Catholic Church*, London.

Hodgson, K. W., 1953, *The Deaf and Their Problems. A Study in Special Education*, London.

Hodgson, K. W. and Norman, H. N., May, 1943, 'John Bulwer the Chirosopher', *Proceedings of the Royal Society of Medicine*, pp. 598–602.

Honorius, *Sacramentarium seu de causis et significata mystico*, in Migne, *Patrologia Latina*, vol. CLXXII, cols. 738–806.

Ingnanez, D. M., 1936, 'Un drama della Passione del secolo XII', *Miscellanea Cassinense*, XII, pp. 7–38.

Jacob, H., 1954, *Idealism and Realism*: *A Study of Sepulchral Symbolism*, Leiden.

James, M. R., 1926, *The Apocryphal New Testament*, Oxford.

Janson, H. W., 1952, *Apes and Ape Lore in the Middle Ages and the Renaissance*, London.

1981, *Pars pro toto. Hands and Feet as Sculptural Subjects before Rodin*, in *The Shape of the Past, Studies in Honor of Franklin D. Murphy*, ed. G. Buccelatti and Ch. Speroni, Los Angeles.

Jeremias, J., 1960, *Infant Baptism in the First Four Centuries*, Philadelphia (appeared originally in German, as *Die Kindertaufe in den ersten vier Jahrhunderten*, Göttingen, 1958).

Jones, L. W., and Morey, C. R., 1930–1, *The Miniatures of the Manuscripts of Terence*, 2 vols., Princeton.

Joseph, B. L., 1951, *Elizabethan Acting*, London.

Jungmann, J., 1962, *Missarum Sollemnia, Eine genetische Erklärung der römischen Messe*, 5th ed., Vienna.

1951–5, *The Mass of the Roman Rite: Its Origins and Development*, transl. by F. Brunner, 2 vols., New York.

Kantorowicz, E., 1946, *Laudes Regiae. A Study in Liturgical Acclamations and Medieval Ruler Worship*, Berkeley–Los Angeles.

1956, 'The Baptism of the Apostles', *Dumbarton Oaks Papers*, IX–X, pp. 204–51.

Katzenellenbogen, A., 1939, *Allegories of Virtues and Vices in Medieval Art*, London (reprint 1964).

Kehrer, H., 1908–9, *Die Heilingen Drei Könige in Literatur und Kunst*, Leipzig (reprint Hildesheim–New York 1976).

Kennedy, L., 1940, 'The Franciscan *Ordo Missae* in the Thirteenth Century', *Medieval Studies*, II, pp. 211–15.

Kingsley Porter, A., 1923, *Romanesque Sculpture of the Pilgrimage Roads*, Boston, Mass. (reprint New York 1966).

1927, 'The Tomb of Hincmar and Carolingian Sculpture in France', *Burlington Magazine*, L, pp. 75ff.

Klauser, T., 1959, note in F. J. Dölger, 'Beiträge zur Geschichte des Kreuzzeichens', *Jahrbuch für Antike und Christentum*, II, p. 29.

1959–60, 'Studien zur Entstehungsgeschichte der christlichen Kunst', *Jahrbuch für Antike und Christentum*, II, pp. 115ff.; III (1960), pp. 112ff.

Kleinheyer, B., 1962, *Die Priesterweihe im römischen Ritus: Eine liturgiegeschichtliche Studie* (Trierer Theologische Studien, XII), Trier.

Kleinschmidt, B., 1960, *Die Heilige Anna: Ihre Verehrung in Geschichte, Kunst und Volkstum*, Düsseldorf.

Klibansky, R., Panofsky, E. and Saxl, F., 1964, *Saturn and Melancholy*, London.

Knowlson, J. R., 1965, 'The Idea of Gesture as a Universal Language in the XVIIth and XVIIIth Centuries', *Journal of the History of Ideas*, XXVI, pp. 495–508.

Kollwitz, J., 1933, *Die Lipsanotheka von Brescia*, Berlin–Leipzig.

Kraus, F. X., 1879–86, *Real-Encyclopädie der christlichen Altertümer*, Freiburg im Breisgau.

Künstle, K., 1908, *Die Legende der drei Lebenden und der drei Toten und der Totentanz*, Freiburg im Breisgau.

Ladner, G., 1931, 'Die italienische Malerei im 11. Jahrhundert', *Jahrbuch der Kunsthistorischen Sammlungen in Wien*, N.F., V, pp. 33–160.

1961, 'The Gestures of Prayer in Papal Iconography of the Thirteenth and Early Fourteenth Centuries', in *Didascaliae: Studies in Honour of Anselm M. Albareda*, ed. S. Prete, Rome pp. 247–75.

Laude di Frate Jacopone da Todi, secondo la stampa fiorentina del 1490, con prospetto grammaticale e lessico, 1910, ed. Giovanni Ferri, Rome.

Leidinger, G., n.d., *Das Perikopenbuch Kaiser Heinrichs II*, Munich.

Leonardo da Vinci: Treatise on Painting, 1956, transl. by P. McMahon, Princeton.

Leroquais, V., 1924, *Les Sacramentaries et les missels des bibliothèques publiques de France*, Paris.

Lietzmann, H., 1908, *Kleine Texte*, 2 vols., Bonn.

Loeschke, W., 1961, 'Der Griff ans Handgelenk', *Festschrift für Peter Metz*, Frankfurt am Main, pp. 46–73.

L'Orange, A. P., 1953, *Studies on the Iconography of Cosmic Kingship in the Ancient World*, Oslo.

Lorenz, K., 1963, *Das sogenannte Böse: Zur Naturgeschichte der Aggression*, Vienna.

Lucchesi Palli, E., 1963, 'Der syrisch-palästinensische Darstellungstypus der Höllenfahrt Christi', *Römische Quartalschrift*, LVII, pp. 250–67.

The Works of Lucian of Samosata, 1905, 4 vols., transl. by H. W. and F. G. Fowler, Oxford.

Mâle, E., 1949, *L'Art religieux de la fin du moyen âge*, 5th ed., Paris.

 1953, *L'Art religieux du XIIe siècle en France*, Paris.

Mattingly, H., 1923–50, *Coins of the Roman Empire in the British Museum*, London.

Meditations on the Life of Christ, 1961, transl. by Isa Ragusa and Rosalie Green, Princeton.

Meiss, M., 1951, *Painting in Florence and Siena after The Black Death*, Princeton.

Michel, C., 1902, *Gebet und Bild in frühchristlicher Zeit*, Leipzig.

Migne, J. P., 1844–64, *Patrologiae cursus completus; seu bibliotheca universalis...omnium ss. patrum, doctorum scriptorumque ecclesiasticorum, sive latinorum, sive graecorum*, Paris.

Millar, E. G., 1926, *English Illuminated Manuscripts from the Tenth to the Thirteenth Century*, Brussels.

Millet, G., 1916, *Recherches sur l'iconographie de l'Evangile*, Paris (reprint 1960).

Morey, C. R., 1942, *Early Christian Art*, Princeton.

Muratori, L. A., 1728, *Rerum Italicorum scriptores*, XII, Milan.

Nonnus: *Dionysiaca*, 1962–3, transl. by W. H. D. Rouse, 3 vols. (Loeb Classical Library).

Oakeshott, W., 1959, *Classical Inspiration in Medieval Art*, London.

Oertel, R., 1953, *Die Frühzeit der italienischen Malerei*, Zurich–Vienna.

Ohly, F., 1977, *Schriften zur mittelalterlichen Bedeutungsforschung*, Darmstadt.

Ohm, T., 1948, *Die Gebetsgebärden der Völker und das Christentum*, Leiden.

Omont, H., 1929, *Miniatures des plus anciens manuscrits grecs de la Bibliothèque Nationale*, Paris.

von der Osten, G., 1933, *Der Schmerzensmann*, Berlin.

Ovid: *Metamorphoses*, 1946–68, transl. by F. J. Miller, 2 vols. (Loeb Classical Library).

Paeseler, W., 1941, 'Giottos Navicella und ihr spätantikes Vorbild', *Römisches Jahrbuch für Kunstgeschichte*, V, pp. 50–162.

Panofsky, E., 1924, *Die deutsche Plastik des elften bis dreizehnten Jahrhunderts*, Munich.

 1939, *Studies in Iconology*, New York.

 1953, *Early Netherlandish Painting*, Cambridge, Mass.

 1960, *Renaissance and Renascences in Western Art*, Uppsala.

 1964, *Tomb Sculpture*, New York.

Pauly–Wissowa, 1894–1937, *Realencyclopädie der klassischen Altertumswissenschaft*, Stuttgart.

Peterson, E., 1926, *Eis Theos. Epigraphische, formgeschichtliche und religionsgeschichtliche Untersuchungen.* (Forschungen zur Religion und Literatur des Alten und Neuen Testaments, XLI), Göttingen.

Odes of Pindar, 1968, transl. by J. Sandys (Loeb Classical Library).

Plautus: *Amphitryo*, 1966, transl. by P. Nixon (Loeb Classical Library).

Polybius: *The Histories*, 1922–4, transl. by W. R. Paton (Loeb Classical Library).

Pope Hennessy, J., 1972, *Italian Gothic Sculpture*, 2nd ed., London.

Constantini Porphyrogeniti imperatoris de ceremoniis aulae Byzantinae libri duo Graece et Latine [...] e recensione J. J. Reiskii, 1820–30, Bonn.

della Porta, G., *De Humana Physiognomonia Ioannis Baptistae Portae Neapolitani Libri IIII*, 1593, Hanover.

Prentice, R. P., 1957, *The Psychology of Love According to St Bonaventura*, New York.

The Rabula Gospels, Fascimile Edition...ed. by Carol Ceccelli, Giuseppe Furlani and Mario Salmi, 1959, Olten–Lausanne.

Rambach, A. J., 1817, *Anthologie christlicher Gesänge aus allen Jahrhunderten der Kirche*, I, Altona–Leipzig.

Reinach, S., 1912, *Répertoire de Reliefs Grecs et Romains*, 3 vols., Paris.

Apollonius Rhodius: Argonautica, 1912, transl. by H. C. Seaton (Loeb Classical Library).

Richter, G., 1967, *Die Fusswaschung im Johannesevangelium*, Regensburg.

Righetti, M. 1964, *Manuale di Storia Liturgica*, I, 3rd ed., Milan.

Riis, P. J., 1953, *An Introduction to Etruscan Art*, Copenhagen.

Rintelen, F., 1923, *Giotto und die Giotto Apokryphen*, Basle.

Roberts, C., 1890, *Die antiken Sarkophag–Reliefs*, Berlin.

Rosenthal, E., 1924, *Giotto in der mittelalterlichen Geistesentwicklung*, Augsburg.

Rötzler, W., 1961, *Die Begegnung der drei Lebenden und der drei Toten*, Winterthur.

Ruperti Tuitiensis liber De divinis officiis. Edidit Hrabanus Haacke (*Corpus Christianorum. Continuatio medievalis, No. 7*), 1967, I, Turnholt.

Ruskin, J., 1900, *Giotto and His Works in Padua*, London (original edition 1854).

Russell, J. B., 1977, *The Devil: Perceptions of Evil from Antiquity to Primitive Christianity*, Ithaca–London.

Der Sachsenspiegel in Bildern, Aus der Heidelberger Bilderhandschrift, 1976, ed. W. Koschorreck, Frankfurt am Main.

Sacre Rappresentazioni..., 1872, a cura di Alessandro d'Ancona, 2 vols., Florence.

Sapegno, N., 1967, *Compendio di Storia della Litteratura Italiana*, Florence.

Sauer, J., 1902, *Die Symbolik des Kirchengebäudes und seiner Ausstattung in der Auffassung des Mittelalters*, Freiburg im Breisgau.

Saxl, F., 1954, *English Sculpture of the Twelfth Century*, London.

Scardeonius, B., 1560, *De antiquitatibus urbis Patavii*, Basle.

Schapiro, M., 1956, 'Leonardo and Freud: An Art-Historical Study', *Journal of the History of Ideas*, XVII, pp. 147–78.

 1973, *Words and Pictures*, The Hague.

 1977, *Selected Papers I: Romanesque Art*, New York.

 1979, *Selected Papers III, Late Antique, Early Christian and Medieval Art*, New York.

Schefold, K., 1943, *Die Bildnisse der antiken Dichter, Redner und Denker*, Basel.

von Schlosser, J., 1896, *Quellenbuch zur Kunstgeschichte des abendländischen Mittelalters* (Quellenschriften fur Kunstgeschichte, N.S., VIII), Vienna.

 1927, *Präludien*, Berlin.

Schneider, L. (ed.), 1974, *Giotto in Perspective*, Englewood Cliffs, N.J.

Schrade, H., 1930, 'Zur Ikonographie der Himmelfahrt Christi', *Vorträge der Bibliothek Warburg 1928/29*, Leipzig–Berlin, pp. 66–190.

Schramm, P. E., 1969, 'Otto I. Königskrönung in Aachen (936)', in his *Beiträge zur allgemeinen Geschichte* III, Stuttgart.

Shearman, J., 1967, *Mannerism*, Baltimore.

Sicardus Cremonensis Mitrale sive Summa de officiis ecclesiasticis (Migne, *Patrologia Latina*, vol. CCXIII, cols. 13–434).

Siren, O., 1905, *Don Lorenzo Monaco*, Strasbourg.

 1917, *Giotto and Some of His Followers*, Cambridge, Mass. (second edition New York, 1975).

Sittl, C., 1890, *Die Gebärden der Griechen und Römer*, Leipzig (reprint Hildesheim–New York, 1970).

Stenzel, A., 1958, *Die Taufe*, Innsbruck.

Sticca, S., 1970, *The Latin Passion Play: Its Origin and Development*, Albany.

Straub, J., 1939, *Vom Herrscherideal in der Spätantike* (Forschungen zur Kirchen- und Geistesgeschichte, XVIII), Stuttgart.

Strzygowski, J., 1885, *Ikonographie der Taufe Christi*, Munich.

Summers, D., 1977, Contrapposto: Style and Meaning in Renaissance Art, *Art Bulletin*, LIX, pp. 336–61.

Suntrup, R., 1978, *Die Bedeutung der liturgischen Gebärden und Bewegungen in lateinischen und deutschen Auslegungen des 9. bis 13. Jahrhunderts* (Münsterische Mittelalter-Schriften, Band 37), Munich.

Swarzenski, G., 1926, *Nicolo Pisano*, Frankfurt am Main.

 1931, *Vorgotische Miniaturen*, Königstein.

Tenenti, A., 1957, *Il Senso della Morte e l'Amore della Vita nel Rinascimento*, n. p.

Thode, H., 1934, *Franz von Assisi und die Anfänge der Kunst der Renaissance in Italien*, Vienna (first edition 1885).

Tikkanen, J. J., 1912, *Die Beinstellung in der Kunstgeschichte: Ein Beitrag zur Geschichte der künstlerischen Motive*, Helsingfors.

Toesca, P., 1941 *Giotto*, Turin.

Toynbee, J. M. C., 1944, *Roman Medallions* (Numismatic Studies, 5), New York.

 1934, *The Hadrianic School*, Cambridge.

Treitinger, O., 1938, *Die Oströmische Kaiser- und Reichsidee nach ihrer Gestaltung im höfischen Zeremoniell*, Jena (reprint Darmstadt 1956).

Van Marle, R., 1923–38, *The Development of the Italian Schools of Painting*, The Hague.

 1932, *Iconographie de l'art profane*, 2 vols., The Hague.

Vasari, G., 1878, *Le Vite de più eccelenti pittori, scultori ed architetti*, I, Florence.

Venturi, A., 1901–40, *Storia dell'arte Italiana*, Milan.

Vigo, P., 1901, *Le danze macabre in Italia*, 2nd ed., Bergamo.

Vöge, W., 1911, *Die Elfenbeinbildwerke*, Berlin.

Volbach, W. V., and Hirmer, M., 1961, *Early Christian Art*, New York.

Wackernagel, W., 1872, 'Die Farben- und Blumen-sprache des Mittelalters', in his *Abhandlungen zur Deutschen Altertumskunde und Kunstgeschichte*, Leipzig.

De Wald, E. T., 1915, 'The Iconography of the Ascension', *American Journal of Archaeology*, XIX, pp. 277–319.

Weisbach, W., 1948, *Ausdrucksgestaltung in der mittelalterlichen Kunst*, Zurich.

Weise, G. and Otto, G., 1938, *Die religiösen Ausdrucksgebärden des Barock und ihre Vorbereitung durch die italienische Kunst der Renaissance* (*Schriften und Vorträge der Württembergischen Gesellschaft der Wissenschaften*), Geisteswissenschaftliche Abteilung, Heft 5), Stuttgart.

Weitzmann, K., 1948, *The Joshua Roll*, Princeton.

 1961, 'The Origins of the Threnos', *De Artibus opuscula XL: Essays in Honor of Erwin Panofsky*, ed. M. Meiss, Princeton.

White, J., 1957, *The Birth and Rebirth of Pictorial Space*, London.

 1966, *Art and Architecture in Italy: 1250–1400*, Baltimore (Pelican History of Art).

Wilpert, J., 1916, *Die römischen Mosaiken und Malereien der kirchlichen Bauten vom IV. bis XIII. Jahrhundert*, Freiburg im Breisgau.

Winkes, R., 1969, *Clipeata Imago*, Bonn.

Wolff, C., 1948, *A Psychology of Gesture*, London (first ed. 1945).

Wundt, W., 1921, *Völkerpsychologie I: Die Sprache*, 4th ed., Stuttgart.

Zarnecki, G., 1975, *Art of the Medieval World*, New York.

INDEXES

1 NAMES AND TITLES

193

2 SUBJECTS